MORE JOY OF WATERCOLOR

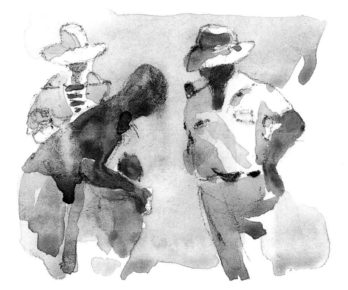

MORE JOY OF

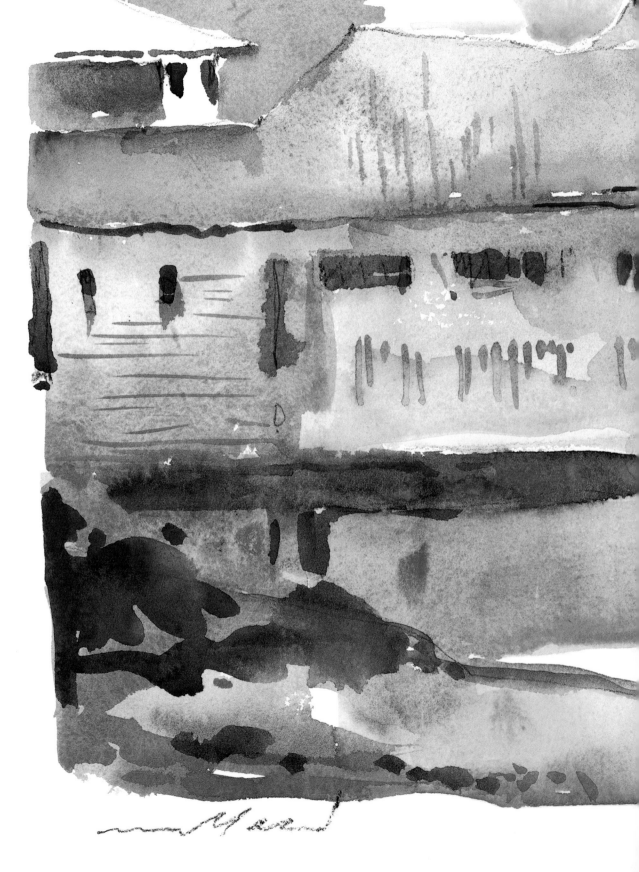

WATERCOLOR

BY DAVID LYLE MILLARD

WATSON-GUPTILL PUBLICATIONS/NEW YORK

Warning

Many of the paintings reproduced here are on loan from private and corporate collections or the collections of the artist and his wife. Therefore, these paintings and drawings are meant for you to copy in practice exercises only. You are forbidden to exhibit your copies publicly or to enter them into an art competition of any sort. Making prints or reproduction copies in any form is also prohibited. These paintings are for instruction purposes only!

Watson-Guptill Publications

Acknowledgements

I want to thank:

Our children, Nadine, Peter, and Wendy (the cheering section).

My mother who started me at the Montclair Art Museum in sixth grade.

My many artist friends for their warmth and exchange of knowledge over the years.

My editors, David Lewis for his sound advice and guidance,
Bonnie Silverstein for her astounding ability in assembling this vehicle,
and Robin Goode for her careful editing,
and my art director Bob Fillie.

First published 1984 in New York by Watson-Guptill Publications, a division of Billboard Publications, Inc., 1515 Broadway, New York, N.Y. 10036

Library of Congress Cataloging in Publication Data

Millard, David, 1915-
 More joy of watercolor.

 Bibliography: p.
 Includes index.
 1. Watercolor painting—Technique. I. Title.
ND2420.M55 1984 751.42'2 84-12014
ISBN 0-8230-3126-8

Distributed in the United Kingdom by Phaidon Press Ltd., Littlegate House, St. Ebbe's St., Oxford

Manufactured in Japan

2 3 4 5 6 7 8 9/88 87 86

This book is dedicated to
my best friend, my wife
Edith Carol Millard, who has
nurtured a creative climate with
enthusiasm and encouragement
for these thirty-one years.

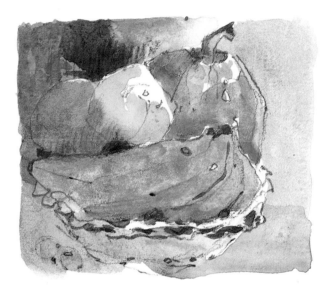

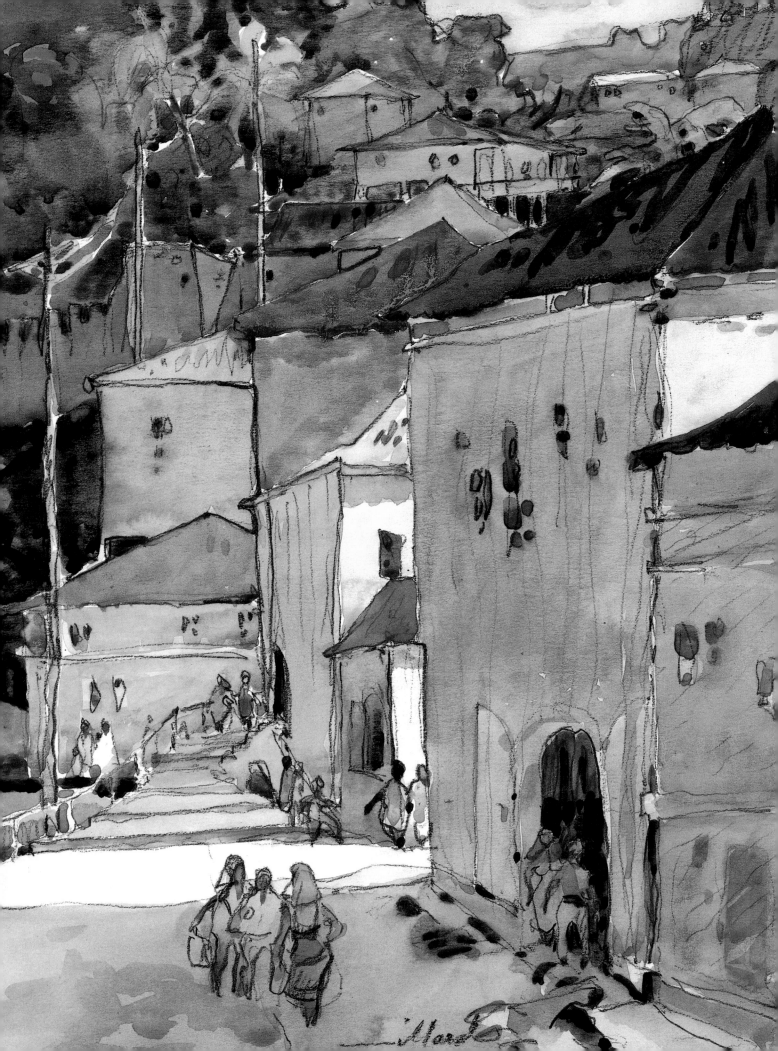

CONTENTS

Introduction 9
Drawing . . . Begin with the Design 10
Start with the Linear Pattern 12
Emotional Speed Sketching 14
Free Yourself from Reality 16
Change Your Point of View 18
Drawing People 20
Drawing People . . . a Moving Target 22
Design with Black and White Shapes 24
Paint with Carbon Pencil 26
Drawing Like a Painter Thinks 28
Capture the Mood 30
Look for the Geometric Understructure 32
Geometrics of the Old Masters 33
Applying Pythagorus 36
Using the Sketchbook as a Tool 38
Designing the Page 40
Working from Memory at the Marketplace 42
Turn Your Sketches into Paintings 43
Treat Figures and Subject as One Shape 44
Let Figures and Subject Repeat a Pattern 45
A Color Symphony . . . the 40-Color Palette 46
Mixing Color 48
Granulation Tests 51
Color Permanency Tests 52
Watercolor Papers and How to Stretch Them 53
Brushes and Assorted Extras 55
Painting People and Light 56
Work Gradually into Color 58
Single out Major Shapes 60
Using Wet Washes 62
Use Color and Light in Wet Washes 64
Make Your Paintings Luminous 66
Get the Best Angle on a Still Life 68
Search Out the Forms within the Patterns 69
Repaint the Scene . . . and Vary One Element 70
Experiment with Harbors 72
Experiment with Townscapes 74

Lessons in a Trip to Chinatown 76
Let Your Emotions Help You Create 77
Explore Color in Your Paintings 78
Create Impact with Color 80
More "Color Talk" 82
Think "Design" 84
Making Your Choices Work 86
Comparing Three Essential Factors 88
Try Different Viewpoints of a Scene 90
Painting Bottlescapes 91
Paint Bottlescapes to Study Form, Lighting, and Color 94
Developing an Idea into a Painting 96
Working from Your Mind's Eye 98
Practice Color and Design 100
Learn to "See" with Florals 102
A Series of Three Irises 104
More Variations of a Theme . . . Conch Shells 106
Cropping . . . How Much Should You Include? 108
Keep Probing for a Painting 110
Let One Painting Inspire Another 112
Work Up to a Special Painting 114
Let a Mundane Subject Inspire a Great Painting 118
Discover a New Way to Express Light 122
Transfer the Technique to Other Subjects 124
How to Think and Feel Like an Artist 126
How Do You Search with Line and Tone? 128
Summary of Basic Painting and Drawing Lessons 132
Approach Complementary Color 133
Try Unusual Colors in Your Sky 134
Invent Color in Still Lifes 135
Create the Feeling of Light 136
Try Painting Direct 137
How Close Do You Want to Approach Reality? 138
Turn Off the Left (Reality) Side of Your Brain 139
Put on Your Fauve Hat . . . Get Out Your Wings! 140

Bibliography 142
Index 143

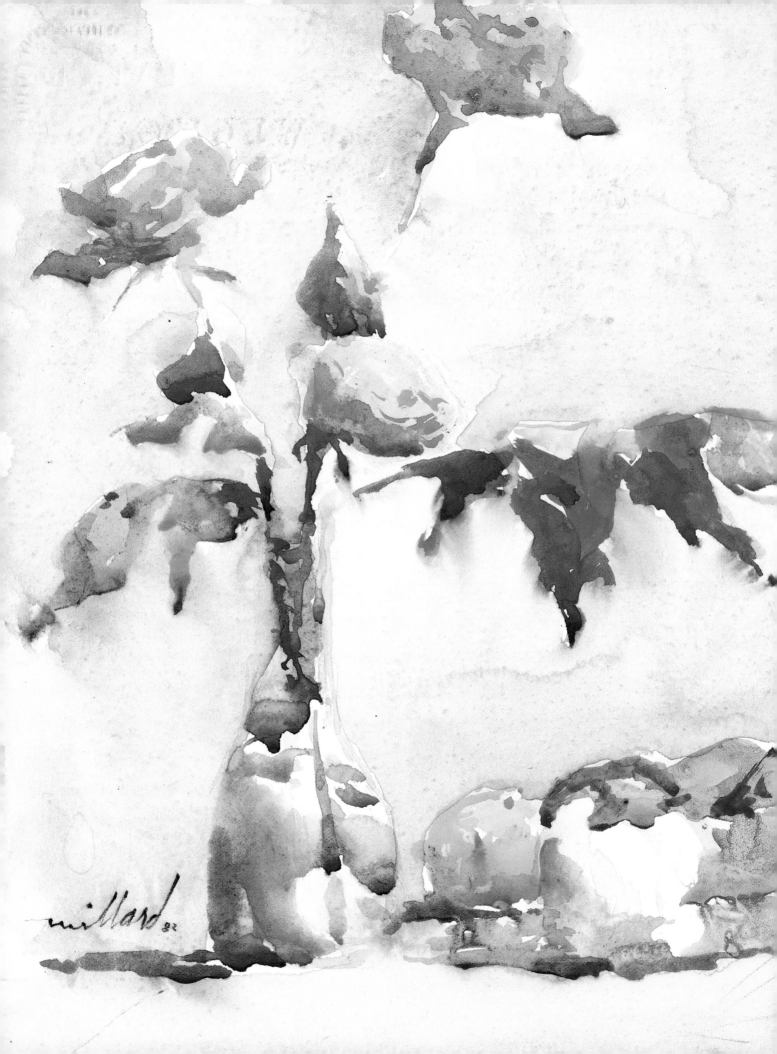

ntroduction

More Joy of Watercolor is a new trip. Moving from the 24-color palette of *Joy of Watercolor* to a 40-color palette should open new avenues of excitement for the *intermediate and advanced watercolorist* by expanding your use of color and extending a summer's song to a full-blown symphony . . . more instruments . . . more range . . . more growth, not only in color, but in thought (plus more horsepower for this trip!).

For the novice or beginner, this book allows you a look at what's for dinner in the years ahead. There's no harm in taking a fling with some of these new colors, with some of this advanced material. It might just spring you ahead in longer strides toward your goal and along the way, help you establish a more professional outlook and working habits. Give it a try!

I'm not so much interested in trying to teach new tricks and techniques as I want to invite a more expansive point of view. Your techniques or style will evolve quite naturally just by the act of painting a lot, constantly. A little every day.

How can I tempt you into a more active program of growth? . . . By showing ways of exploring! This is not so much a teaching book as it is a viewing book . . . a way of seeing things through your mind's eye, which comes from thinking and seeing at the same time, before you put paint to paper. For instance, it is natural to set up a still life on a table and pull up a chair to paint it. But I am concerned that there may well be a much more exciting arrangement waiting for you, if you just slide your chair over three feet or perhaps around to the other side of the table to paint it. We'll take a look at this through "Working in Series" . . . gaining an intimacy with your subject . . . exploring a still life set-up in depth . . . even combining another medium (pastel) with watercolor.

You'll work in your sketchbook with toning, edges and luminosity . . . the way a painter sees . . . more intuitively and less academically. Gathering material to paint from your sketches, learning to create your own color and not feeling bound to copy nature . . . getting into the habit of art, listening to your inner self rather than relying on the camera. Sketching produces food for your creative mind.

Each of you will come up with your own personal manner of sketching and an inner rhythm will intuitively grow within your sketches that will find its way into your paintings. Rapid sketching produces an intuitive inner structure . . . sometimes freeform, sometimes of a geometric nature, as we shall see.

Painting "Bottlescapes" may help you become more aware of how to capture and paint light. They may also aid in the art of arranging objects. Your ideas on lighting objects, as well as placing them will get an assist from a stage "show biz" influence . . . as you practice inventing of color and light. We'll also talk about a "pro" approach, where you'll keep 25 to 50 paintings unfinished, and under active study for lengthy incubation periods.

Design, music, poetry, color . . . finding yourself as an artist . . . finding a better way than duplicating what's in front of you, finding new thoughts and new subjects to help you grow on your own. Really, this game of painting is pretty much based on self-motivation . . . and on an *active* participation in your own education.

Remember, you have to put in the time. You have to push the paint. *You* have to get the feel of it. You can't watch "The Road to Successful Painting" on TV . . . you have to put on your walking shoes and make the trip yourself. And it's a great trip.

How This Book Works

As you peruse the pages of this book, you'll find yourself moving gradually from one subject to another through a series of lessons and practical experiences designed to increase your creativity. (If you'll recall, in *Joy of Watercolor,* and the same advice holds here, I recommended that you read the book through first, then go back and begin the exercises.) Because of the flow of the lessons, you may find it hard to see a general movement, but this is how it works.

We begin by reviewing basic, essential ideas on drawing, including hints on drawing people and on using geometric divisions to help place objects in your paintings. Then we look at the many ways to use the sketchbook as a place in which to practice design and work out ideas.

Next we move on to our palette of colors. In *More Joy* it's been enlarged to forty colors. We'll learn how to set it up and look at some mixing exercises and color tests to check permanency and explore the granularity of the paints. Since we'll be working on "good" paper now (as well as in our sketchbook), there's a section on papers and new materials you'll need.

Now we're ready to paint. Beginning with one color at first, we work into forty colors gradually, practicing on still lifes with various types of wet washes. Then we move out of the studio and into the neighborhood, using our sketchbook to record an endless array of subjects that excite us to later work up into formal paintings. All that we've learned about drawing and painting will come into play in these sketching excursions as we continue to build our technical ability, explore our palette, and practice working quickly, with a minimum of errors.

Perhaps the best way to find yourself as an artist, to discover your own style, is by working in a series. After all, almost all the great artists have done this. They've taken a few favorite subjects and explored them in depth, each time trying out a new idea, a new way of seeing the subject to gain a new insight in a gradual movement of growth. There's Degas, with his ballerinas and women in the bath . . . Cassatt, with her mothers and children . . . Rembrandt, with his biblical subjects and steady stream of self-portraits throughout his life . . . Chardin, with his still lifes of simple, humble, everyday objects. Think about it. Didn't your own favorite artist paint in a series? This section begins with a simple set of bottles and goes through an assortment of other subjects to show you how working in a series can help you to learn on your own, to explore your hidden artistic self.

More Joy of Watercolor concludes with a summary of basic drawing and painting ideas and a list of books for you to read in order to continue this process of growth.

DRAWING... BEGIN WITH THE DESIGN

Using the Carbon Pencil.
I like to draw. It makes me feel good. The sketching process nimbles up my fingers and mind to draw and to see paintings in pencil form. It helps me feel that I am my own person and it gets me out from under the influence of all the wonderful, awe-inspiring great artists of the ages whom I revere and have studied and continue to study . . . the "how-they-did-it" stuff. Of course, you need to study all the greats in drawing. But when you draw in your own sketchbook, you are being yourself . . . or you're certainly on the road to developing your own style or technique.

I respect those artists who are happy using an ordinary graphite pencil to draw, but there are many reasons why I prefer and recommend carbon pencil.

Carbon pencil can give you a range of blacks like no graphite pencil can . . . from the gentle, light sounds of a soft snare drum to the loud black darks of the tympani in Tchaikovsky's *1812 Overture,* while graphite is just a street drum offering a very limited range of blacks. And if you want velvety black tones, carbon pencil can give them to you with just a touch of your fingertip, or you can use a piece of soft chamois cloth or a tortillon to smudge the pencil. And if you wish, you can partially dissolve the carbon with your watercolor washes for extra richness. Just scrub the pencil lines lightly with your brush to loosen them and hold your paper at an angle so your washes settle as they run downhill. You can't do that with graphite! And in tones 6B or darker, graphite is greasy — which means it repels the watercolor.

My favorite carbon pencils, in order of preference, are:

1. *Hardtmuth Carbon Pencil 190A, no.3, U.S.A.* I like the consistency of the carbon and the diameter of the lead. It sharpens well with a single-edge razor blade or a penknife of good steel, and it doesn't shatter or break under the sharpening process as many others do.

2. *Rowney Carbon Pencil, 3B, England.* This fat number is a sturdy delight to use.

3. *Conté Extra Fine Drawing Pencil, no. 2, French.* This one is also a bit fatter than the Hardtmuth.

There are many other makes of carbon pencil, too. Test them all to see which ones you like. Be sure to check out how they sharpen to a point — some shatter easily!

The following are some examples of drawing techniques on what to look for in a painting subject, and how to capture feeling and mood . . . to help you "see" your way into a painting each time. It's all done with the carbon pencil, but the "mind's eye" is the guide to interpreting this elusive quarry. You want to achieve a poetic or musical stance in your interpretations from the reality. You want to see how you can design your pictures *away* from realism and still maintain a contact for the viewer.

As you're drawing, remember:

1. There is a design pattern in everything you sketch. Look for it, and put it in.

2. Every sketch should be thought of as a plan or structure for a future watercolor.

3. Your sketches reveal your initial responses to your subject. This emotion, and each of your interpretations, will inspire future paintings.

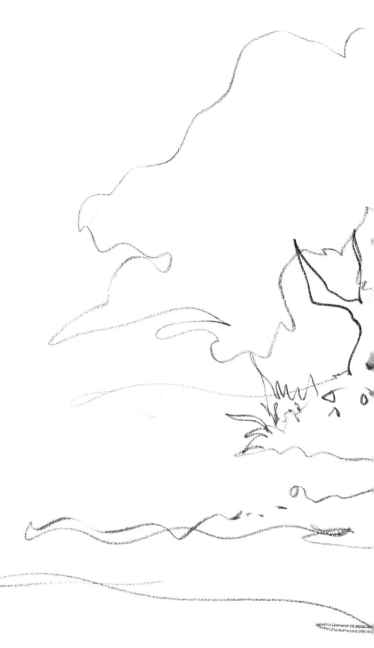

Start with the Linear Pattern

loss on
birdhouse
roofs

Create Intricate Two-dimensional Shapes by making a light, rapid contour sketch of your subject. Modify the shapes you see in nature and try to improve them as you draw. Make each segment relate to its adjoining shape.

Let's look at the variety of shapes here: The top edge of the foreground is an intricate pattern of plant life. The bottom of the sky has an interesting shape that relates to the buildings. The central section is a feast of delicious shapes . . . interlocked, interwoven, exciting and contrasting pieces . . . like Byzantine art. Again, the darks . . . but not too many . . . are added last, arranged in a sweeping, curved pattern for an overall two-dimensional effect.

12

Add Subdued Tones.

Be sensitive to the light. Use a searching line . . . a nervous touch. Don't be too exact! Invent your design as you place your "telling black shapes" into this remarkable street setting. Orchestrate your white pattern and shapes of gray. Don't respond to what you see . . . follow how you feel! The location and size of the figures is paramount in this sketch and influences the placement and depth of the blacks. The sensitive quality of the light of the Riviera is in this carbon pencil drawing. It will get into the painting, too. It's 11 AM . . . and the light is imaginary.

13

EMOTIONAL SPEED SKETCHING

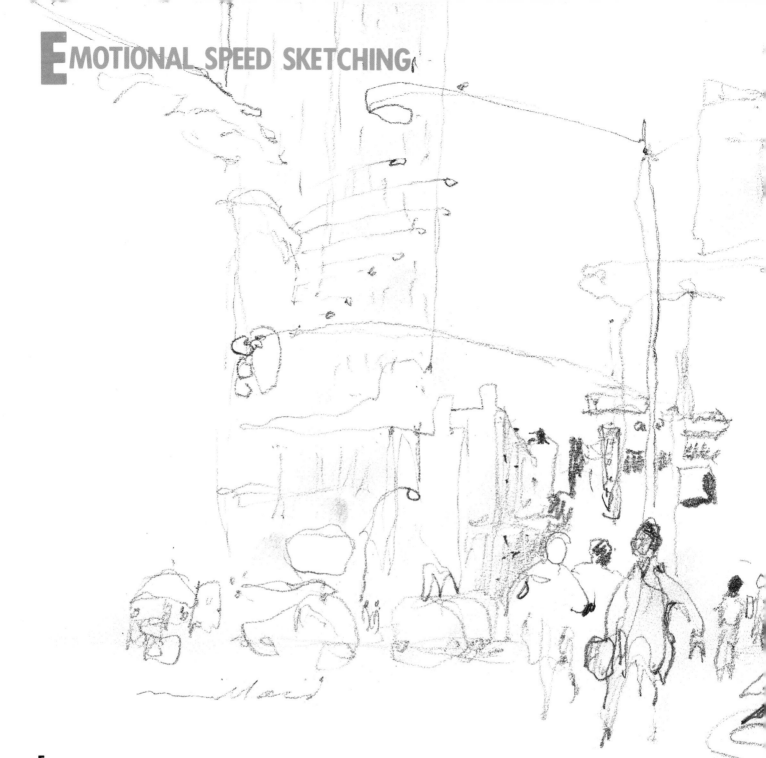

Five-minute Sketching.
This is the first of many sketches in New York City handled like a five minute pose in life class. You want to capture the essence of the subject here. Don't get bogged down in the details.

Your first impression is of the contrast between the enormous volumes rising vertically . . . creating various angles of perspective according to the height at which the horizontal signs and roofs occur. Your second thoughts reflect on the marvelous monochromatic sym-

phony of warm and cool grays in the city's great background of buildings. This is like a stage setting in a vast country landscape with skyscrapers replacing the mountains or trees.

Start this sketch in the left-hand corner following the curve of the marquee lights as they sweep your eye into the street scene. Just build your way from left to right as you move across the ever changing variety of signs, buildings, and taxis. Be aware of the "canyon" effect you're creating as you build this stage setting and prepare to put

in your characters. Figures are scattered all along the streets, but you decide to concentrate on one group and make it your center of interest. Put this group in front of a simplified area to create a nice spotlighted effect.

Place your darks in a very carefully thought out design pattern before you make your first deep carbon accents . . . on selected heads only and on a piece of the curb. That's all it takes. If you place dark streaks and smudges all over the place at random, following what your eyes see, you will likely pro-

duce a drawing that has been done to death. When placing darks, less is more. Make color notes along your margins if you want, to help you remember some of the colors for your paintings.

Be excited . . . let your emotion show in your style of line. Hold yourself to that five minutes. This sketch is rapid, but note the good spotting of the black accents. Note also the balance of that dark angled cornice. It leads the viewer's eye into the strong vertical and then down to the figure group.

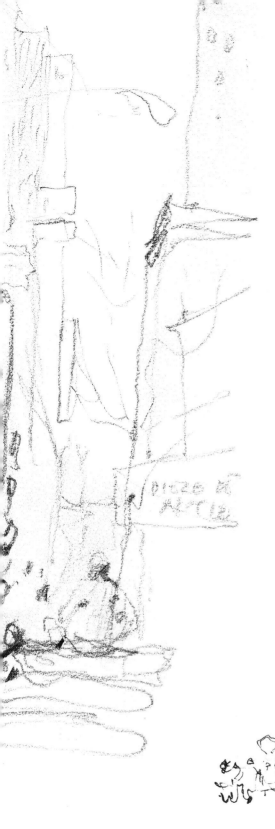

Emotional Sketching . . . in Pen.

You're still speed sketching, but this time in pen, with a Papermate black ink fine point felt tip pen. The multi-layered effect of fan-shaped negatives and that odd-shaped piece of white, six stories high, stopped me at this scene. Would it have stopped you?

Do the two cranes first, then go down the right side of "Calcutta" and "Live Girls XXX," to the varied signage, then to the bus, car, and two pedestrians. Next, locate the top floor and verticals and fan out from there with the negatives and other darks around the several white segments. Finish your sketch as the light changes to "walk," with the little flood of vaguely suggested people and car shapes. A fast five minutes. I'm anxious to make a painting based on this sketch.

I like the angles of the cranes, counter to the flow of the white shape, repeated in the flow of the signage and the bus and people. I could title this sketch *Broadway Angles* (not *Angels*), or *New Hotel . . . Going Up?* Get in the habit of naming your paintings at the sketch stage . . . it helps your paintings incubate in your mind . . . and it's part of the stage setting.

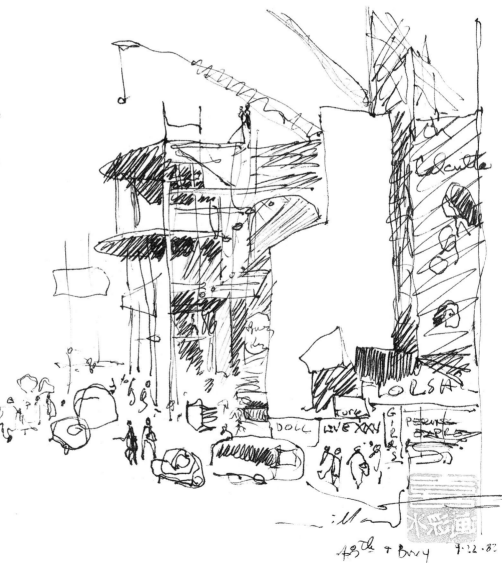

FREE YOURSELF FROM REALITY

Create Drama.

It is a roasting hot day. You're sketching in the forest, quietly. Suddenly, thirty girls from an up-river camp are floating along in front of you. You quickly sketch in these figures in a freehand-contour style, making them seem minute beside the giant monoliths of granite in Jackson Falls, New Hampshire. You're being dramatic. (As Degas used to say, "Lie a little.") Turn the picture upside down to see this abstract black spotting.

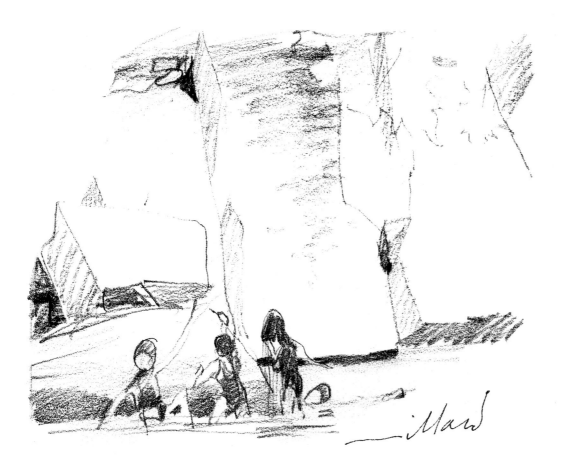

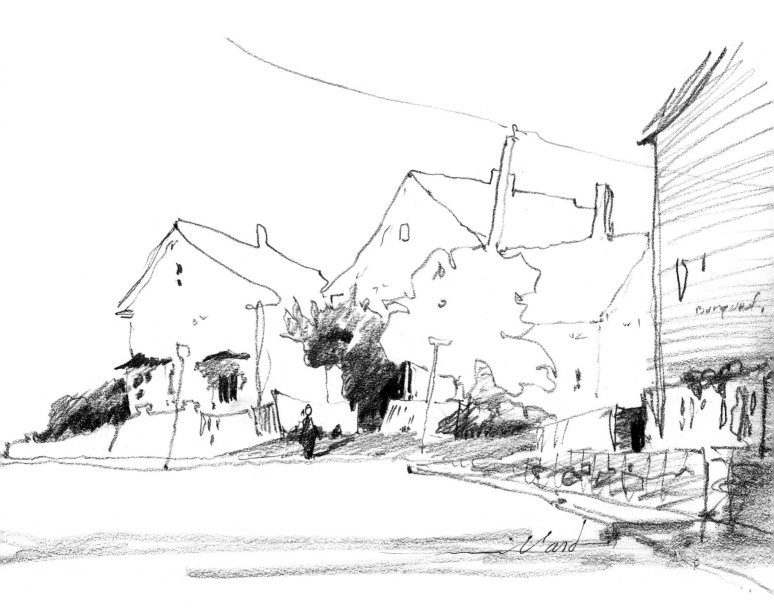

Organize a Busy Scene.
You're sketching at noon on King Street in Rockport, Mass., in the heat. Get the image in your mind's eye before you start. Leave out the huge trees to create an excellent sky shape. Catch the flat, two-dimensional pattern of the houses with your contour freehand sketch. Crosshatch a tone on the house at the right. Then begin to state your telling black shapes and watch your rich tone poem grow, right before your eyes. Add color and light direction later.

CHANGE YOUR POINT OF VIEW

You're Out Looking
for Material
and you find an excellent subject, a house on a hill. The shape of the house is good, plus it's sitting among a thousand yellow irises. Think out your color changes as you draw, and make a note of them in the margin of your sketch. Then, sketch in your corner house in the foreground for scale, and shade it in. And place the curb and telephone poles to show the curve of the hill. Finally, locate the figures as accents, the frosting on the cake.

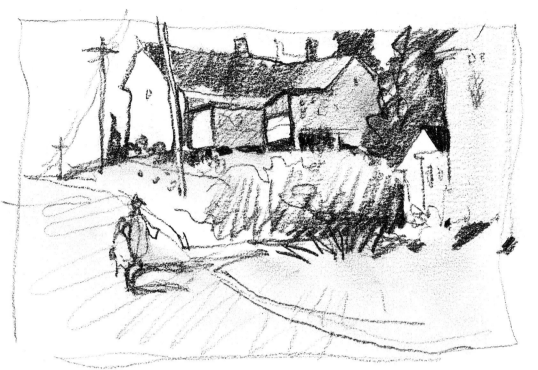

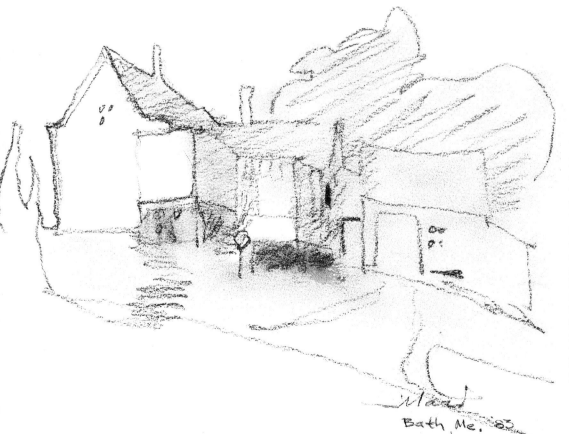

Try Another Point of View.
Keep the feeling of the hilltop, even though you're now up on the ridge. Keep the sweep of the descending curbside, driveway, and staggered stepdown of the building complex. Keep the emphasis on those radically changed shapes of white. Diminish the importance of that barn . . . lose it in those trees. Smudge clear gray tone into the shadow sides of the house, then right across the trees and barn in a single swipe. Don't overwork your drawing. Those building shapes are so exciting, you don't need figures!

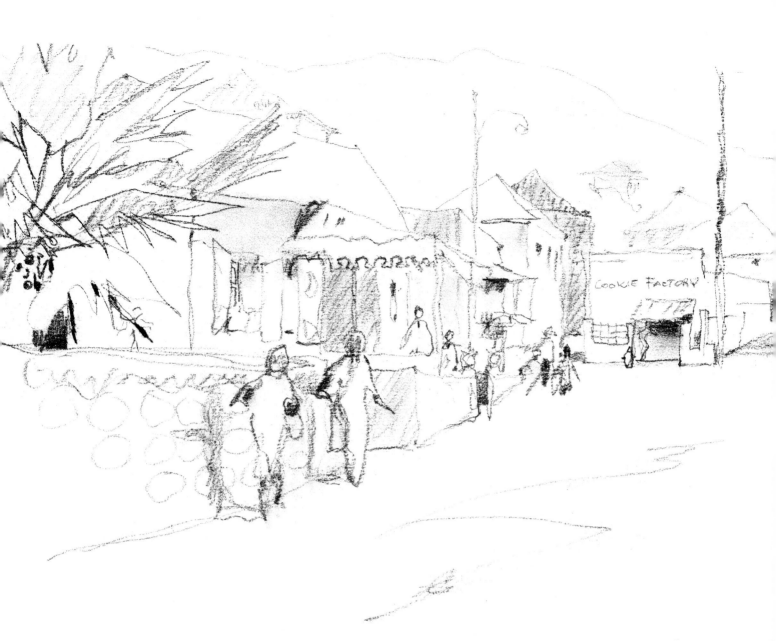

Lead the Eye Down the Street.
The decreasing size of the figures and buildings follows the law of perspective. Don't be too precise. Guess at the vanishing points. Notice the three-dimensional effect you get from alternating shapes and well-designed pieces of clean gray tones. That line in the street is a caprice. But block it out and see how you lose the magic.

DRAWING PEOPLE

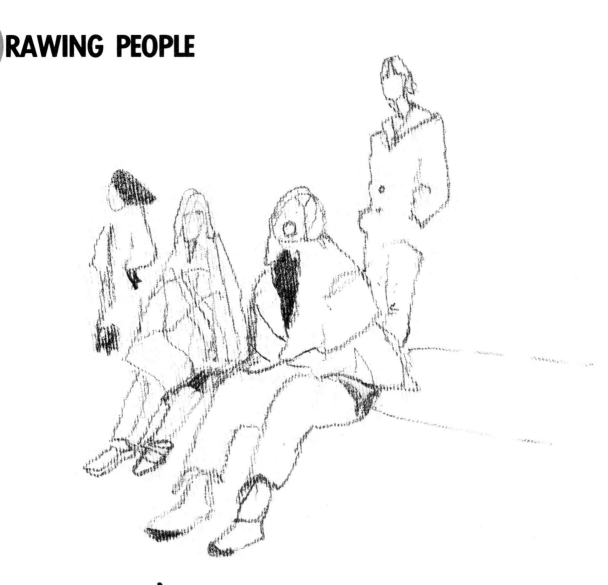

A Lesson in Being Alert.
The New York City drawings
were an exercise in speed
sketching. This time it's a wait-
ing game. You're sitting in your
car in the first parking space at
the Museum of Fine Arts in
Boston. You're here to observe
and sketch the people who
come early and sit along the
steps waiting for the museum to
open. This is going to be an
intuitive venture, so stay loose.

The first person to sit on the
second step, with the dark
sweater, is your center of inter-
est. You draw her in, using a
contour style with a fairly fast
line. You don't want a lazy, la-
bored line and you want to be
ready for the next figure . . .
here she comes . . . just down
the step a short way. You
quickly decide to move her
closer to your first figure so she
is touching, almost growing out
of the first shape.

Look for the linear pattern in
the way you place your figures

and select them according to the
interest in their gestures and the
design of their clothing. Here
comes the next one . . . walk-
ing in the background . . . she
isn't even going to the museum,
but her walking position fits
right in as you draw her to just
touch your second drawn figure.
You're positioning these human
forms to get the most exciting
negative shapes you can invent!
It's what's *between* the figures
that's important!

The pointed 'V' of the dark
sweater repeats the sharp down-
ward points of the negative
shapes between your figures.
Two black shadows under the
two toes of the seated figure
and in the hair of that passing
figure, plus the first dark, cre-
ates a triangle. This pattern
organizes the exciting negative
shapes you've created by an-
gling the heads and legs of the
figures. Turn this sketch upside
down and look at what you've
captured. Design!

Draw . . . and Design.

Start your composition with the three standing figures. Position them in a spot that you intuitively feel will make this arrangement work . . . they are about fifty feet away from the steps and the single seated figure. Draw in these four figures. The three are busy talking and there is some moderate movement, but you can train yourself to remember their gestures and then select the poses that give you the most interest and the best negative shapes. You are making pieces of light and dark . . . only the pieces you like as they are moving about. Just hatch in the pieces . . . this is not Bridgeman's anatomy class at the League.

The negative shapes you'll create will help you decide where to put your next figures. You watch and wait until the lad with the striped sweater and very dark bushy hair sits down by the huge bronze door. Using the long step he's sitting on, you relate him to the neck of your previously seated figure. Your continued waiting is rewarded by the nicely dressed woman in the long coat . . . and you position her so as to repeat the vertical action of the back of the middle seated figure. Repeat the slight angle of this last upright figure by angling the bronze door. Feel free — if a slanting door edge will give you a better design — slant it!

You are intuitively designing with people here, same as a still life . . . arranging objects to get the best patterns of negative shapes. This composition is actually a *study* of designing negative shapes. It is also a good example of how you can purposely design your darks in an exciting arrangement . . . after your drawing has been completed.

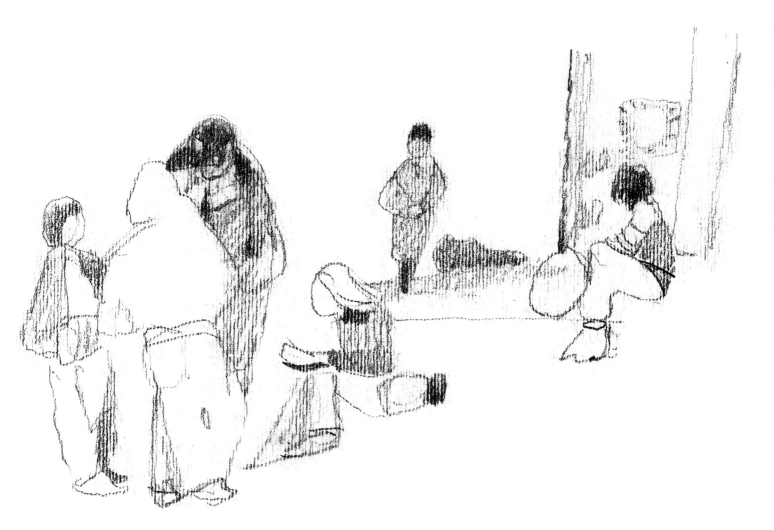

DRAWING PEOPLE... A MOVING TARGET

Let Your Pencil Fly.
Draw in a combination rapid contour line/freehand sketching technique, since these bathers in France are moving about freely. You'll be working from memory here . . . there will be short gaps between a look with the eye and a stab with the carbon.

Freeze in your mind the image of the group under the two umbrellas. Stare a quick stare . . . then go to your sketchbook and place the after image that's in your inner eye! Your first few pages can be warm-ups. You'll get it with repetition. And what models! Next the hunched seated figure . . . then, quickly, the little group beyond. When you're working with an active target, as with animals, catch the gesture . . . keep trying. Much of this is memory sketching. When you see a pose you like, remember it and put it in!

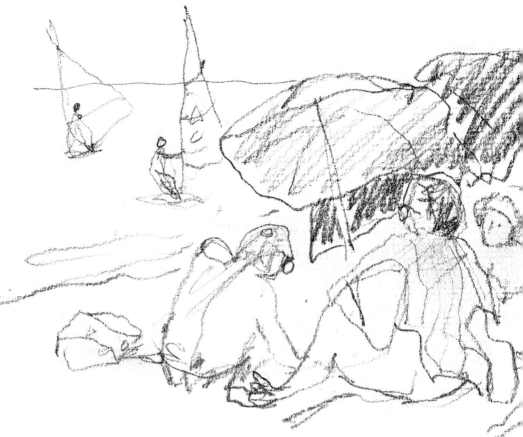

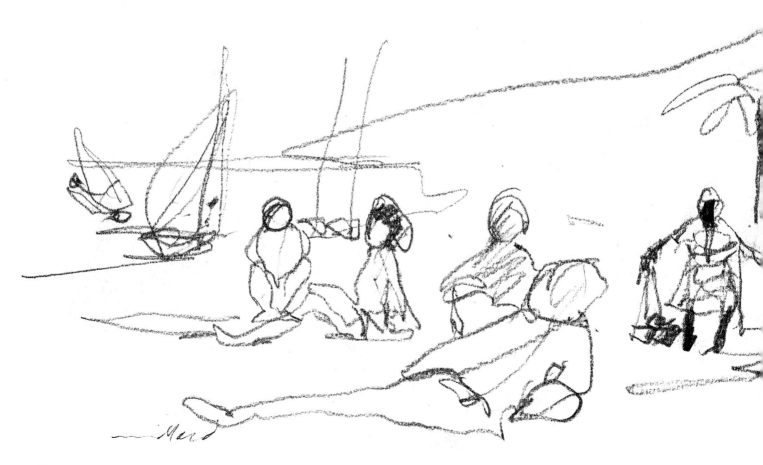

Try Abstracting Your Work.
This is *Central Park Library* —
again, title your sketches. Use
the pieces of tree, feet, bench
slats, and shadows to abstract
your work.

**Set Your Stage
Like a Still Life.**
You're doing about forty
sketches a day for a week at the
beach. This time a little guy
from Dakar is moving up the
beach, hawking his handmade
leathers and woolens. He is
black as a cinder, standing out
as he moves among the nudies
on the Riviera.

Place your two groups at the
left. Select poses that suit your
imagined composition . . .
leave room to the right. Re-
member the size and the gesture
as he comes on your "stage."
Bang, in he goes! Now put in
the two figures leaning to the
right. Compose your sketch like
the Italians doing the frescoes
. . . classic . . . get the
rhythm. Be free! Drop in the
beach huts and palms for "set-
ting." All these moving figures
keep a constant glow of ges-
tures. Try figure groupings like
these in your own locale.

DESIGN WITH BLACK AND WHITE SHAPES

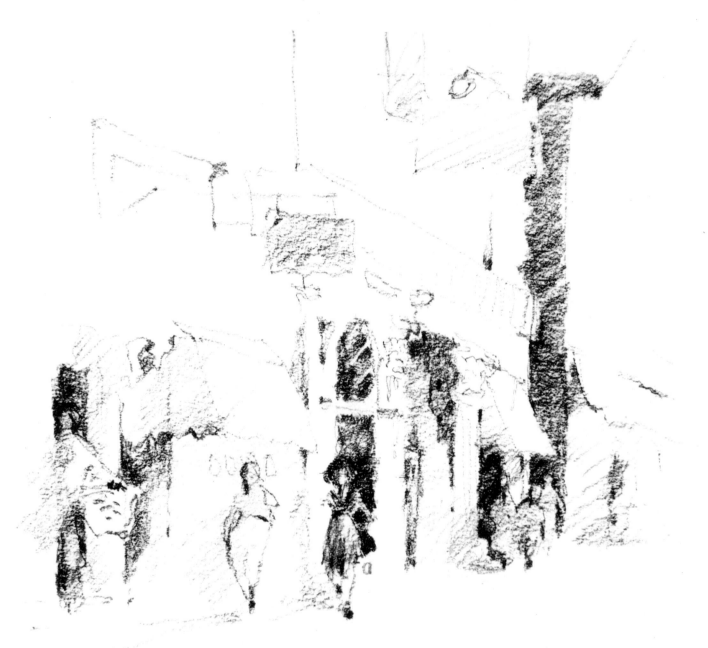

Design Your Blacks as Major Shapes.
A tall vertical slice of a building and the deep tones under an awning, plus dark doorways behind figures, adds up to an interesting design of black spots.

Interlock Black and White Shapes.
The white sky piece meshes with the earth piece in this central story of old Greek mills. Note the carefully designed black pieces. Turn the sketch upside down to better study the white shapes of the figures and sky pieces between the buildings. See how this game of pattern is being played between white bits and black pieces? Checkmate!

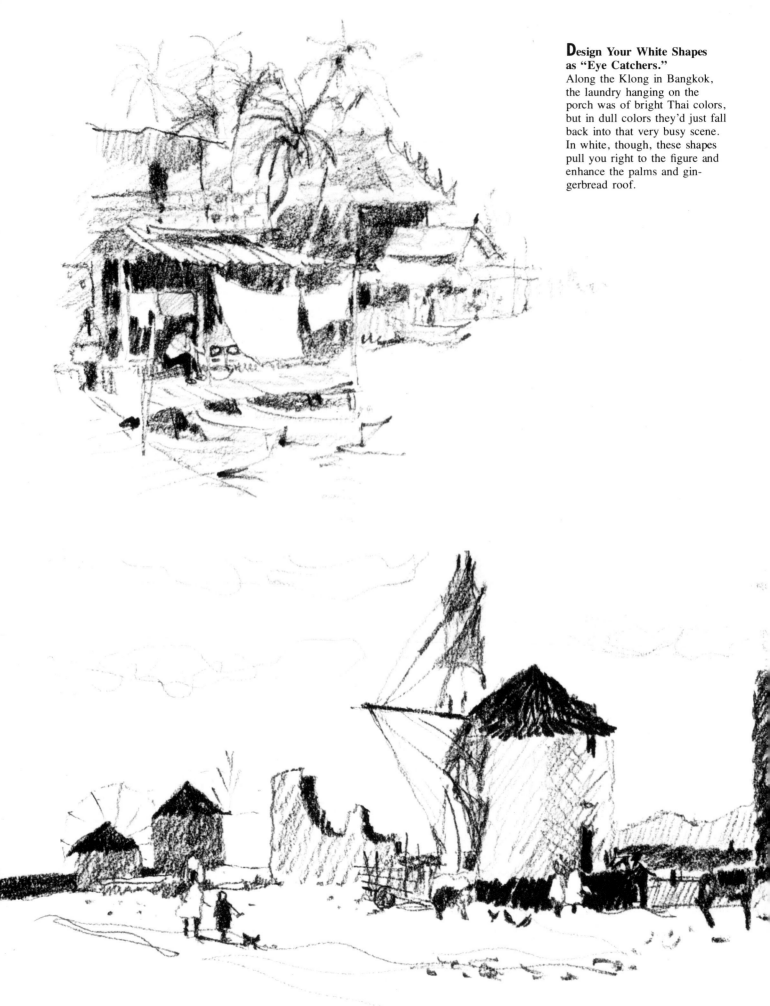

Design Your White Shapes as "Eye Catchers."
Along the Klong in Bangkok, the laundry hanging on the porch was of bright Thai colors, but in dull colors they'd just fall back into that very busy scene. In white, though, these shapes pull you right to the figure and enhance the palms and gingerbread roof.

"PAINT" WITH CARBON PENCIL

Spot and Smudge in Tone.
We are taking a lesson from Turner here, attempting to gain that great English watercolorist's luminosity:

1. Use a dull point. (It gives a soft edge to your line.) Draw your harbor scene in fast, working freehand, holding your pencil flat. Really let it fly!

2. Next, select and save your whites by finger-toning soft halftones around them.

3. Finally, put extra power into your rich black spots, but don't overdo it!

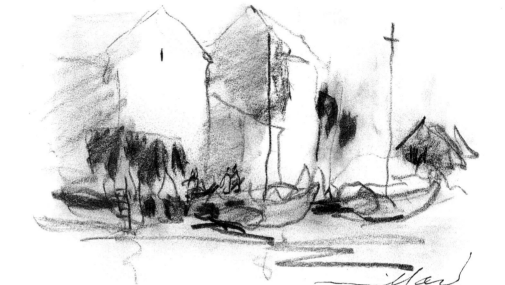

Use Rich Darks, Smudge Tones.
There's a late afternoon light . . . just a shirt or two in the sun. Let that line bite in. Get excited about what's happening. Think like a painter when you draw!

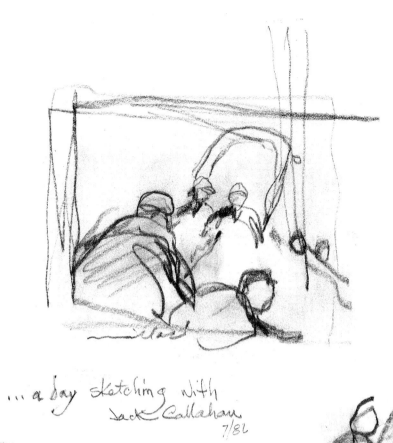

Place Singing White Spots,
Powerful Black Shapes.
These two-minute freehand/contour drawings are small tone poems. There is an intimate, dramatic light and telling blacks . . . it feels like a painting. All you need is color. These are little figure groups like the ones Henry Moore would sculpt. Get their shape. Scout out small groups of figures like these in your own hometown.

. . . a day sketching with
Jack Callahan
7/82

"Joe"

gloucester
mass

Carbon Black Makes Magic.
Try taking a simple subject like this and whip in fast outline shapes, contour/freehand style. Don't try for a prize, just draw as a guide for your "carbon painting." Then smudge over everything . . . lightly, but fast . . . no whites. Just paint your black magic . . . place one dark negative after another. It's the *shape* of each piece that counts!

DRAWING LIKE A PAINTER THINKS

Isolate the Light Pattern.

1. Basic painting rule: Pull all your darks together into one gray mass.

2. Pull all your whites into a single large unit . . . here, the big negative that includes the roofs of three houses. (Keep your ridge line very light so the sky piece locks down into these buildings.)

3. These figures have a staccato quality, coming in and out of the light. Design your black accents with care.

This sketch was done on toned paper.

"Martha & Lou"
Bear Skin Neck
Rockport, Ma. '81

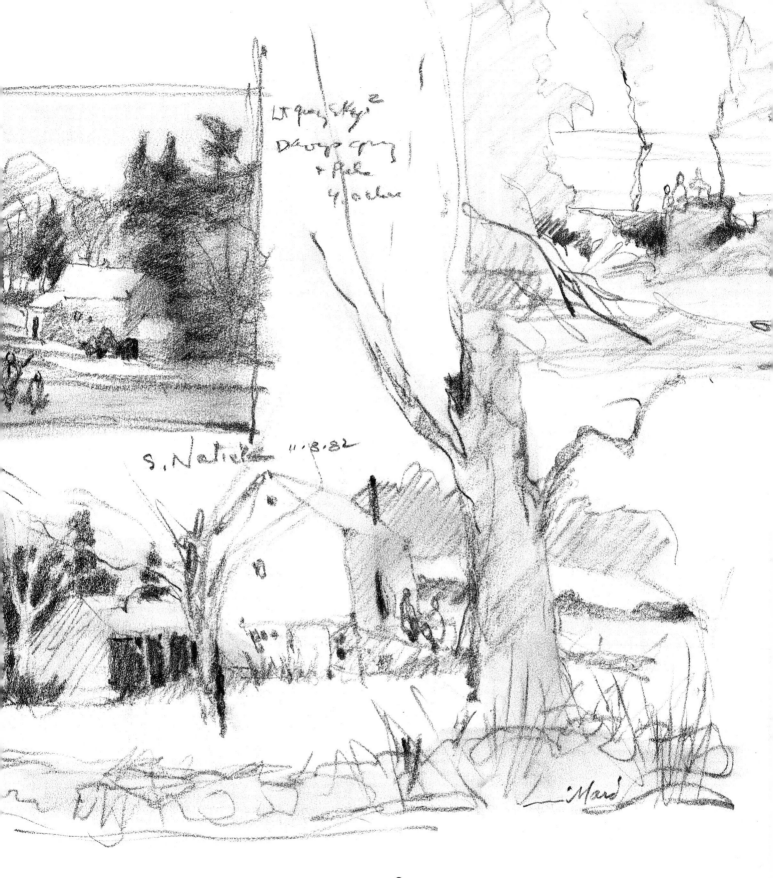

S. Natick 11·8·82

Special Use of Dark Negatives.
Make this a fast contour/free-hand drawing. Push yourself to work freely! Keep all the dark negatives to the left . . . the carriage house interior, all the trees and bushes. Don't just dash them in willy-nilly, design them with affection. Note the snow pattern on the right . . . the two figures in sun and shade. Look at Andrew Wyeth's beautiful pencil studies, like *Pig Pen* or his Kuerner Farm drawings . . . and be inspired!

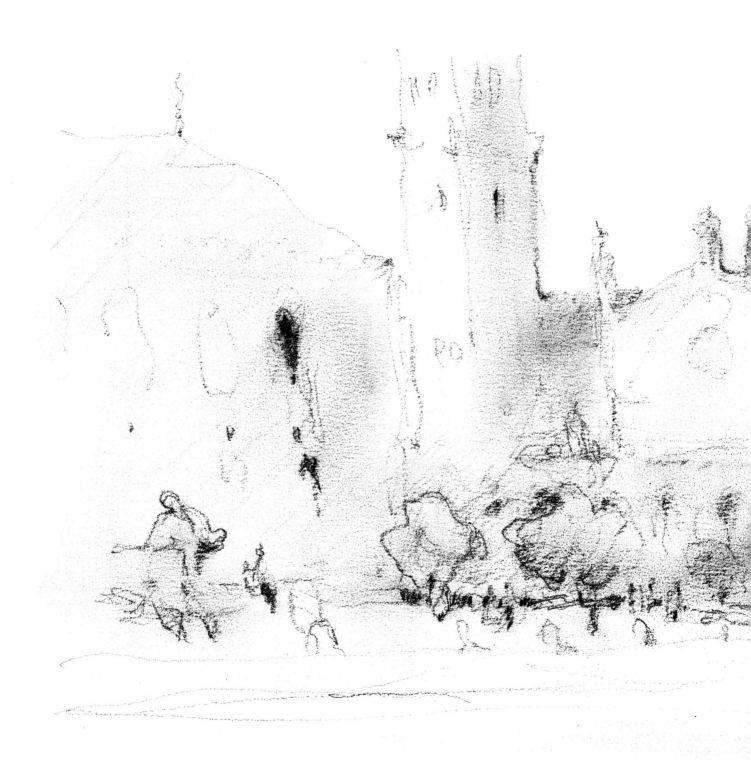

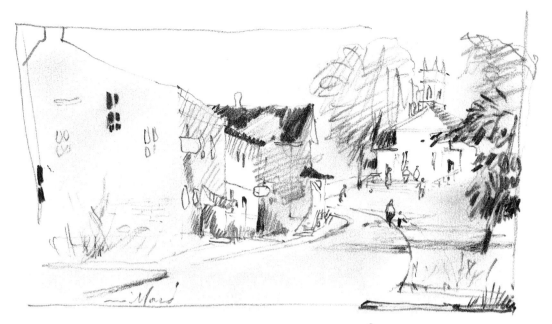

Stand Back and Get the Scene as a Whole.

You're doing a carbon drawing, an eighth of a mile from your subject, a Maine village. It's 95°F outside . . . too hot in the sun so you're in the shade. Remember your values . . . draw crisply, for a contemporary feeling. Smudge tones into your outlines . . . keep them clean. Deepen the tones as you work into the buildings on the left. I deliberately let the large house at front left dwarf the little figures. (Try another drawing with larger figures and you'll see why.) Again, as always, design with your black shapes . . . design with your eyes!

Get the Glow of a Painting.

You're in front of a collection of Venetian-style buildings in Boston. The fog is just burning off from the sea. This is mood . . . this is a painting! Get the pattern in your mind's eye before you touch carbon to paper. There are just hints of form here. Barely touch the paper as you smudge in the form. Watch your edges . . . the separation of light and shade is very soft . . . this tends to make a luminous quality. Keep your shadows open, don't make them dirty smudges. Touch in your darks with a painterly, poetic feeling. Be sensitive. If your darks are too sharp and strong, you'll lose this luminous feeling. Get that inner glow of the fog. Here the fog put me in the mood. Could you have done without the fog? Try it and see.

LOOK FOR THE GEOMETRIC UNDERSTRUCTURE

The Old Masters Used Geometric Structuring.
The Greek philosopher-mathematician Pythagoras (582-500 B.C.) discovered recurring rhythms or patterns in nature and used them as the basis of formulas to measure space and time. His work had implications for art and for musical timing — full, half, and quarter notes. In fact, a common division of a painting (and a favorite of Chardin's) — of nine segments in height by twelve segments in width — relates to three-quarter time in music.

You'll find Pythagoras's divisions in the work of many famous artists, beginning with Piero della Francesca (1420-1492). The work of the Italian master who was an ardent student of Pythagorian theories is a good place to start uncovering these geometrical painting structures.

Francesca used an understructure called the "rabatment of the rectangle" to divide his painting and position important elements. The rabatment is formed by dropping the shorter side of the rectangle onto the longer one and drawing a vertical line up from this point (see first example below). You can also take the rabatment from the opposite side of the rectangle,

giving you two verticals. If you then draw diagonals from the outer corners of the rectangle, forming a large X, the spots where the diagonals cross the verticals become strong points on which to hang important compositional elements. You can further subdivide the rectangles formed by the rabatments with more diagonals for progressively smaller and more numerous intersecting points.

Another famous geometric understructure is known as the "golden section." It refers to the repetition of the mathematical ratio of 1:1.618. Look at the second example below. Line BC is in the same proportion to line AB as line AB is to line AC or, phrased more broadly, the smaller line is to the longer as the longer line is to the whole. What this means to the artist is that by following a certain set of proportions, you can set up a rhythm or repetition that is visually satisfying. Of course, these rules are never to be applied rigidly. They're just aids to composition. And they don't have to be exact—an approximation will serve.

Francesca's understructures strongly influenced Puvis de Chavannes (1824-1898), a French artist who in turn was studied by Vuillard and Villon

in our present century. Even Gauguin, who is often pictured as a rebel in Tahiti, was actually very learned in geometric structures, as you can see in my diagram of his painting *The Idol* (Museum of Fine Arts, Boston). Rembrandt also used an understructure of parallelograms, as in this sketch of *Doctor Nicolaes Tulp Demonstrating the Anatomy of the Arm* (Mauritshuis, The Hague, Netherlands). And you'll see the secret measurement Botticelli used in *Primavera* in the breakdown diagrammed on these pages. Cézanne, Degas, and Renoir are a few of the 19th-century old masters who were all very adept at the use of geometric structuring in their paintings. Too much can give your work an academic, stiff look. But don't toss it out with the dishwater . . . hang in there and you'll see several examples of structural design in paintings later in this book. Geometric structure similar to that used by the old masters has been a strong element in many of my paintings that have won major awards. I fight the stiff, artificial look by really freewheeling with my 2-inch brush in the field and doing very little touching-up in the studio. Speed of application in watercolor is

where it's at!

Study the diagrams here, then take a look at the paintings of your favorite old masters and see how many of their structural patterns you can record in your sketchbook . . . and later apply to your own paintings.

How to Decipher the Geometry of the Old Masters:

1. Get a color reproduction of a favorite painting. Color postcards from museums are an ideal source.

2. Place your reproduction on a lazy Susan and slowly rotate it, keeping your eyes a few inches above and about a foot away from the painting. As you slowly turn it, look for alignments and spacings. You'll be surprised how easy it will be to find them. As you look, you'll find many variables, but you'll discover that many of the old masters used similar geometrics, too.

3. Keep track of your findings in your sketchbook, recording them as diagrams like the ones shown here. And if you're not afraid of being pegged a nut, take your lazy Susan to your local or city library and twirl away! Then apply what you've learned to your own paintings.

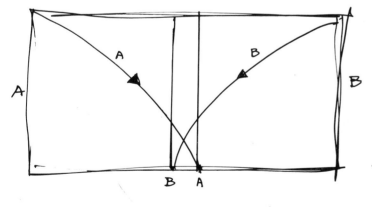

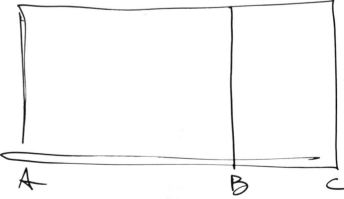

GEOMETRICS OF THE OLD MASTERS

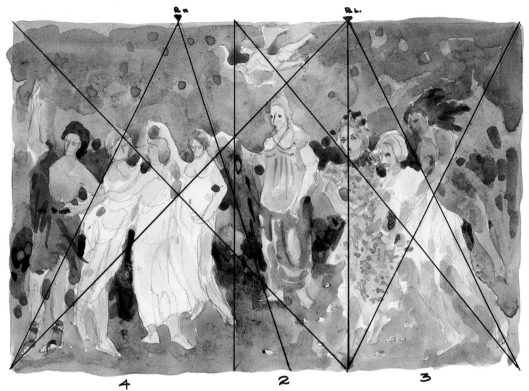

Basing an Understructure on Measurement.

In *Primavera,* Botticelli used a nine count multiple across the width of the painting. He hints at this by using four figures in the first four spaces, two figures in the next two spaces, and three figures in the remaining three spaces; (geometrics were top secret in those days).

From the four corners he runs diagonals to the top and to the bottom of the rabatment (or width) of the short sides, Rr and R1, and arranges his figures following these delineations stemming from Pythagoras. Get busy sketching and arranging figures in your work. It can be very rewarding.

Using Parallelograms.

Rembrandt has structured his *Anatomy Lesson* on two parallelograms using a nine count spacing and changing his spacing counts from five to three in the vertical and horizontal accents. Connect A to B and see how he arranged his figures. What a marvelous arrangement! Rembrandt really knew his groceries when it came to figure grouping. Take a look at (or better yet, add to your library) the paperback two volumes called *Rembrandt Drawings* by Dover. It's inexpensive and the material is gorgeous!

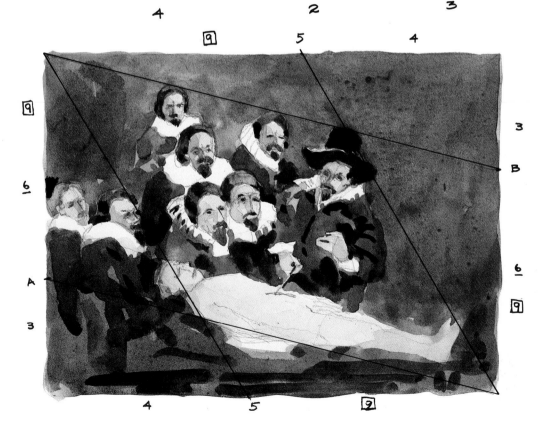

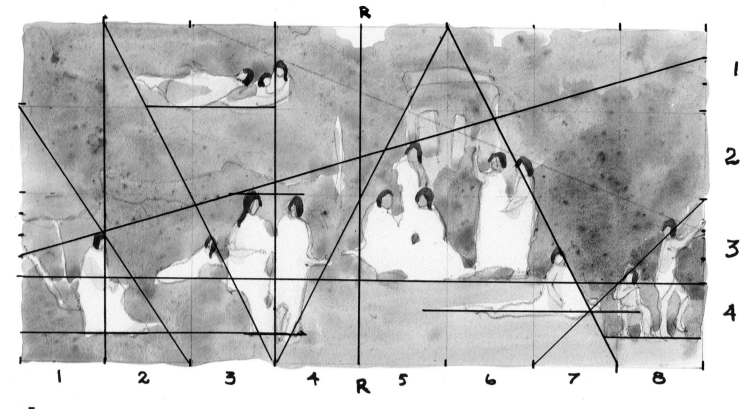

Freewheeling Figures Within a Structure.

Puvis de Chavannes's *Sacred Grove* uses twice the height of the short side for the width of the painting, but does not use the rabatment for any accenting. Instead it has a four count high and an eight count wide dividing the sides into quarter and third units within the single counts, then the figures are arranged in a freewheeled manner.

Using Splayed Lines.

In Chardin's *Copper Pot, Pepper Box,* etc., an understructure of splayed lines, an effect similar to when you spread your fingers, is in A, B, C. He is aligning edges of objects for his arrangements along these and other lines.

Those country fresh eggs are so innocent looking, but the knowledge of geometrics they display is disarmingly sophisticated. How many triangles are involved with these eggs? Count them. Look at those varied negative shapes . . . 1, 2, 3, 4 . . . such good, simple fare.

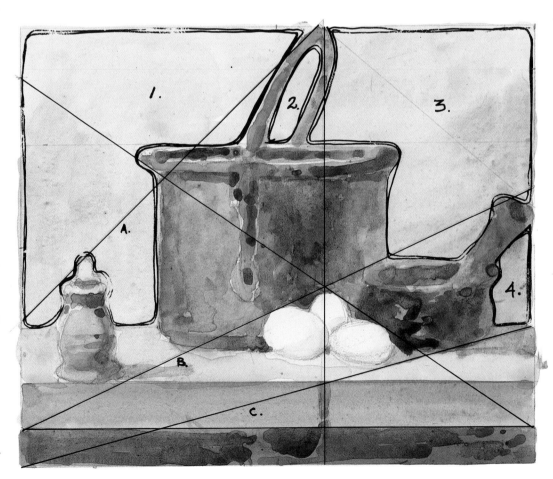

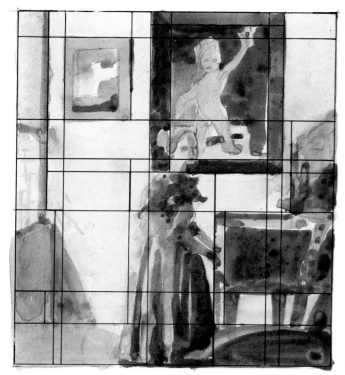

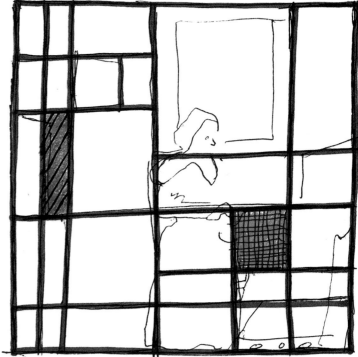

Relating Objects in Space and Light.

Vermeer's *Lady Standing at the Virginals* is a masterpiece of arranging a figure with objects in space. Vermeer was wonderfully gifted at painting light. He painted about twenty-eight pieces and each one is a priceless lesson in capturing the quality and patterns of light. Rather than use a set of structure for measurement, such as rabatment, Vermeer was engrossed in how one item related to the next in space and light. Design, value, and color . . . in that order.

Do you think from this overlay of rectangles that Mondrian was deciphering Vermeer's arrangements? Try some similar overlays of your own in this style of squares and rectangles and then set them aside and color some segments of your own creation.

Using Measurement to Place Figures.

Gauguin's *Whence Come We?* is structured on the use of a rabatment, where he has taken the height of the short side as his measurement and from the left across the top, spaces first to R¹A, again to R¹B, dividing this latter unit in half to arrive at the placement of the tallest figure.

Now from the bottom right he used the same rabatment of the short side in two measurements, R²A and R²B, to arrive at the positioning of the idol. See then how he has drawn diagonals to these points and arranged his figures to suit these directionals.

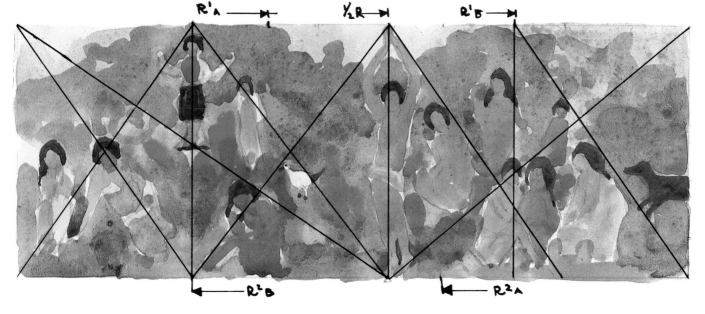

Positioning Subjects in Your Paintings.

Hunter's Moon shows how I applied Pythagorian theories to my own work. It all began when I once juried a show where a very fine painting was shot down because the artist had, I think, arbitrarily placed a full moon in his painting and the jury didn't like its position. The idea that there was a "correct" position was news to me, and so I decided to explore the problem . . . hence, *Hunter's Moon*.

In this particular painting, I decided to put the moon on the rabatment of the rectangle in this painting. That is, I formed a square using the left side of the painting as a basis for measurement to points along the top and base of the painting and ran an imaginary vertical line at this point to form a square. With this spot in mind, I began the seascape. Then I placed the moon where the sloping rooftop and swooping clouds converge with an imaginary line drawn from the top of the mast line, that is, along the rabatment of the rectangle (see diagram). I've led the eye to the moon by running puffy little cloud dots to it from the roof peak.

I laid in a basic wash of cerulean blue and light red over all but the white areas. The deep cloud tones are burnt umber and mauve. The buildings are cobalt violet, raw umber, and cerulean blue. I floated cendre blue and cerulean blue into the deep cloud areas to wake up those spots that lacked life. You can see these blues especially between the top edge of the boat roof and the furthest building center left. To float your colors, add them wet-in-wet: They float to the top as they dry and add a concentrated but vibrant statement of color where it's needed. (Full sheet: 22″ x 30″ (56 x 76 cm), 300 lb. cold-pressed Arches paper)

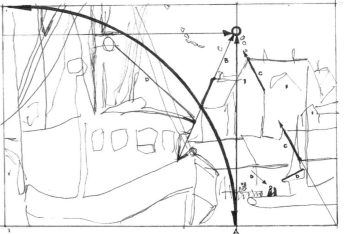

USING THE SKETCHBOOK AS A TOOL

Choosing a Good Sketchbook.
The Super Aquabee sketchbook has surfaced as my favorite after many years and after trying many different kinds of paper. The weight of the paper in the Super Aquabee has a good heavy quality which doesn't buckle, bulge, or ripple when I apply big juicy washes. Look at the ripples in the painting on page 44, and you'll see why I changed from the lightweight Aquabee sketchbook with the yellow cover to the heavy Super Aquabee with the burgundy cover.

Your sketchbook sizes can vary. Sixty sheets can give you lots of room to work. I usually use a 9″ x 12″ (23 x 30 cm) size, but the illustrations on page 39 were done on an 11″ x 14″ (28 x 35.5 cm) sheet, and you can see the benefit of the extra space and how I jammed it with mini-sketches which served the purpose of that particular day and place.

Use only a sketchbook with a spiral binding since it puts each sheet back into its exact same position when the book is closed.

People Watching at the Beach.
You plan to spend the entire day at this tropical beach watching beach parties . . . groups of figures. Keep your sketches small. Try for tiny gems of color, bits and fragments of humanity. Start at the top and work your way down comfortably. Don't hurry. Look for patterns . . . shapes . . . designs. When the design occurs, nail it in your memory . . . and then sketch it. Think of the frescoes of the old Italian masters.

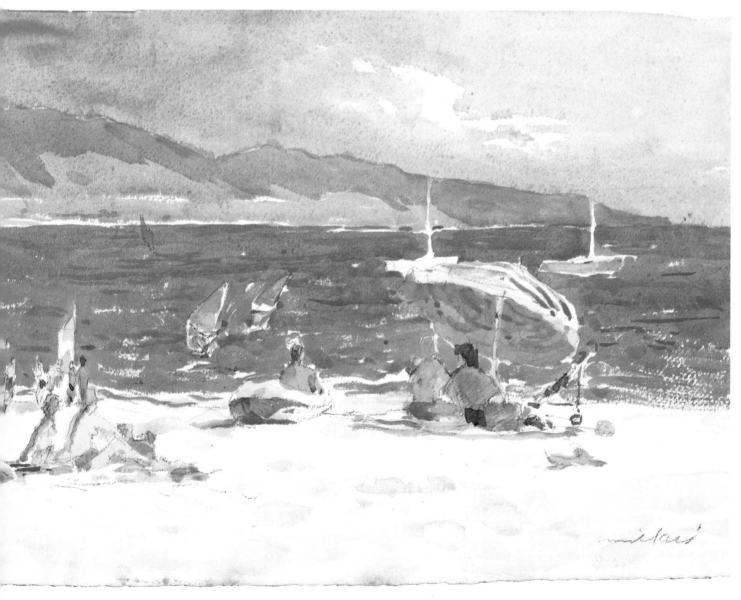

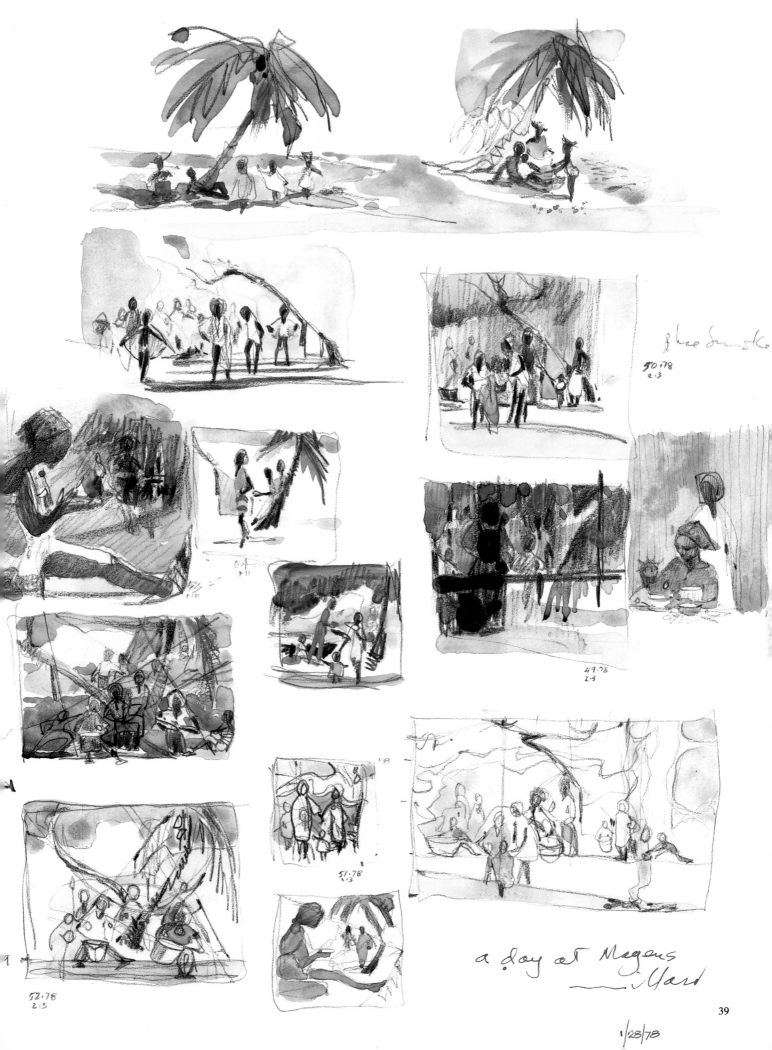

Blue Smoke
50.78
2.3

49.78
2.3

51.78
2.3

52.78
2.3

a Day at Megens
Mort

39

1/28/78

Designing the Page

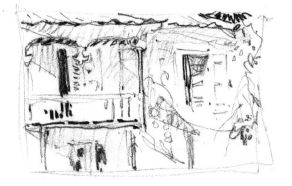

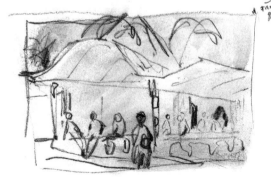

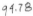

94.78

Working Out Ideas.
You see a market coming into view . . . looks interesting. Sketch it quickly, but leave room on your sketchbook page for another sketch. Squint your eyes (always keep squinting your eyes before you sketch). See how this pattern of light is made up of the roofs as well as the sky . . . now see how all the dark mass is pulled into one major tonal shape where all the street figures and the various buildings fall into a single unit. Paint it this way! Sketch like a painter thinks!

As you move in on your subject, make a note of that odd and interesting "gull wing" roof and catch those figures quickly . . . you've got just a few seconds or they'll notice you and disappear. Don't try to sketch at close range. It's an invasion of privacy and will likely be resented. Instead, train your mind and draw from memory.

Working in Your
Sketchbook. (Opposite)
You'll be gathering material for an hour or two on this jaunt, so start at top left and, leaving room each time, work down the left side: A. There are bottles of native juices and local vegetables . . . unusual . . . beautiful. Commit color to memory or make a few color notes later that day. B. The archway is done with a modern approach to color. C. Some attractive handwoven hats make an intriguing design. D. Catch that interesting detail on some balconies as you meander. It might come in handy someday, and you're a long way from home. Now down from the top right: E. There's a couple in a doorway . . . catch that. F. Stop for coffee and sketch while you sip. Add your color later from memory. G. and H. Fill out your page with odds and ends. You select the material . . . you'll be the one doing the painting.

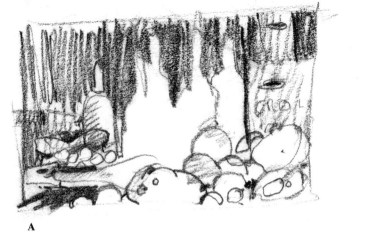

A

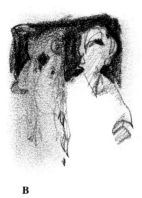

B

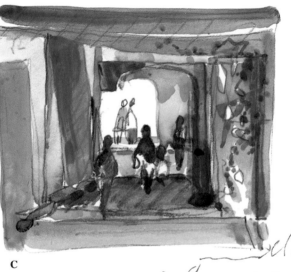

C

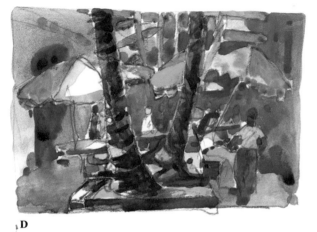

D

St. Thomas, V.I.

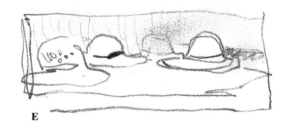

E

F

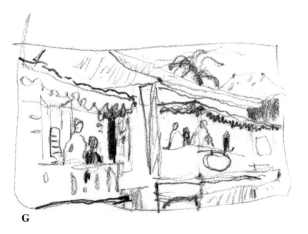

G

H

WORKING FROM MEMORY AT THE MARKETPLACE

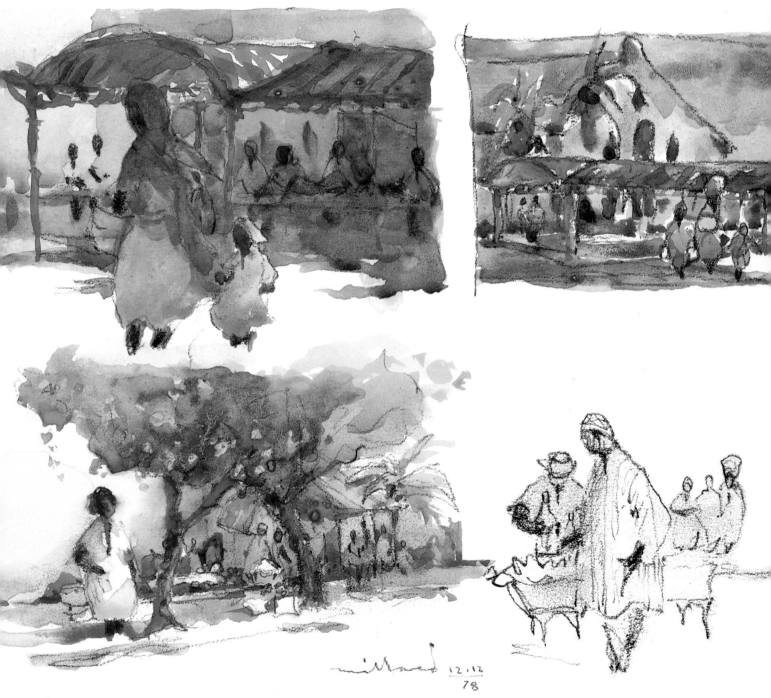

Get Loose with Sketches.
You're spending the morning researching material for paintings. Start all of these market scene studies by allowing each a quarter of a page on a single horizontal sketchbook sheet. This could be Trinidad or Brooklyn or New Orleans . . . or your own local market, no matter where you live.

The top two sketches were done from memory. They're a bit stiff, but they got me started. Then I sketched the bottom two from a block away, and these two hit pay dirt, as far as I'm concerned! I was loose by then and even though I was looking at my subjects, I was still working from memory.

This is how it works. Sketch in the surroundings . . . the "stage set" . . . the trees or tables or huts. Then watch for the best "character" and select the best "stage position" for this figure . . . then zap it in.

Watch for the next figure . . . then the next . . . and draw them in place. Color the sketches later, from memory, in your studio.

TURN YOUR SKETCHES INTO PAINTINGS

Fill Your Painting with Well-Designed Pieces. These white roofs and houses give this sketch a tropical feeling. Yet in reality the roofs were rather rusty and the houses mostly brown. (You might like to try the real-life colors in a second sketch — just to see what I mean.)

Again I worked from memory — and from my sketch (right). The balcony railings were dark green and the pink and blue garden were invented colors. The palm trees were moved from elsewhere but drawn from life. They create a well-designed backdrop for the houses and say "tropics." (Full sheet 22″ x 30″ — 56 x 76 cm — cold-pressed Millbourne handmade paper, 140-lb.)

TREAT FIGURES AND SUBJECT AS ONE SHAPE

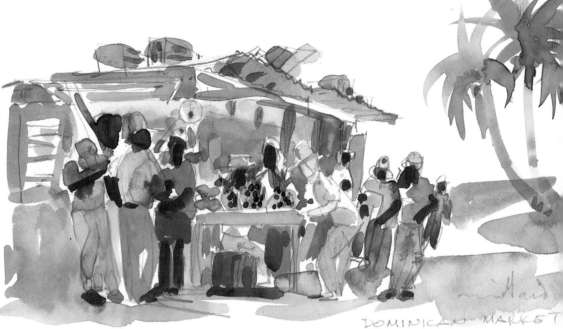

Use Contrasts Creatively.
The prominence of the figures in this sketch is gained primarily from the dark spotting of the heads, arms, and feet. This is one of the joys of painting the handsome rich chocolate flesh of black people in contrast to the rich brilliant orange-pinks, limes, and citron yellow flowers and fruits, turquoise waters, and cobalt skies. Try this as a second painting using white people instead. It's different — the color is weak!

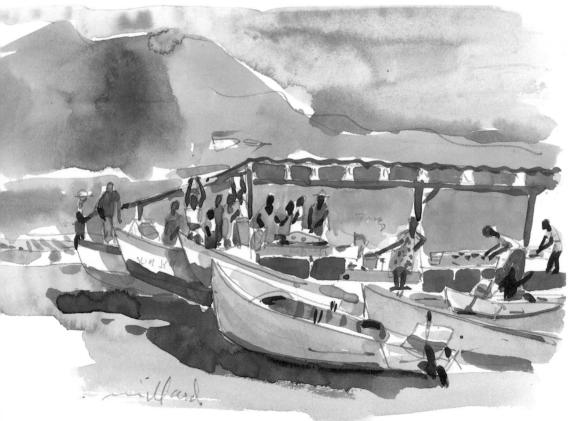

Separate Your Figures from the Market.
These figures are silhouetted in color and value against the structure of the fish house. Block out the foreground boats (close one eye and hold a finger) and see how important a prop they are. They tell you where you are. You can convey a great sense of scale with the small customers waiting for their fish. Note how these early sketches buckled with the amount of watercolor applied on too thin a sketchbook page. This is why you must use the heavyweight super Aquabee sketchbook.

LET FIGURES AND SUBJECT REPEAT A PATTERN

Look for Patterns in Your Paintings.
The triangular shapes of these roofs intuitively suggest that you try to locate your figures the same way. To test this, try a second painting using a square block instead of this angled form behind the two central figures, and see how your composition falls apart. (The angle reinforces the thrust of the roofs.) Also, leave out the telephone pole. I like it in, but it's your choice. This African store presented a good set of shapes and colors — to me, these colors are the sound of Debussy's music being played.

. . .And Rhythms.
There is a staccato rhythm in the repetition of the awnings and, more particularly, the windows. I felt that the figures should also be spaced on a single horizontal level rather than levels like those in the top painting. Let your figures help you compose your paintings.

ACOLOR SYMPHONY: THE 40-COLOR PALETTE

My 40-color palette has grown over the years. I originally had a palette of 24 colors, but I kept adding a color here . . . experimenting with another color there . . . keeping colors I'd used before . . . adding new brands and colors I found I just couldn't live without.

As you know by now, I also find classical music to be an important part of my life—as important as color! In fact, to me they're related. I started thinking this way years ago when my instructor at the Art Student's League in New York City, Bernard Lamotte, taught me to think of color in terms of musical instruments: trumpet—

red, piano — green, clarinet — orange, piccolo — light yellow, etc. There really wasn't a particular instrument for each color, but I caught the feeling of what he meant, and I've had colors in my blood ever since. Color is what painting is all about . . . for me, anyway. Now, how can I get you to become more excited about the use of color?

When I listen to a Beethoven or Brahms symphony I can feel the great breadth and range of their "color" . . . running all the way from a piccolo to the deep tympani. And when I paint, I feel all of my 40 colors sitting out there in the orchestra

waiting for me to point the baton at them — and when I do, they perform for me! Colors (like instruments) never all play at the same time. Thus, painting a large, important studio work gives me a chance to compose a symphony . . . and I feel this when I'm painting. I call on a particular "arrangement" or group of colors to perform for me. I feel the viewer, too, is listening.

I want you to think of composing music when you are *first* struck by a subject. Before you start to paint it, stop and listen for the music. Then decide how you're going to arrange the color . . . where your accents

will be placed and what color combinations you'll use. Ask yourself if you'll start with a tone poem or two first, before you strike into a full-blown symphony. The point is to think about music and color before you get carried away by the excitement of painting a nice watercolor.

Think out your plan of composing. Don't be overwhelmed by the reality of the subject before you.

An Advanced Palette.
Looking at the photo of my palette, you can see that I'm presently experimenting with 9 half pans of Rowney and one of

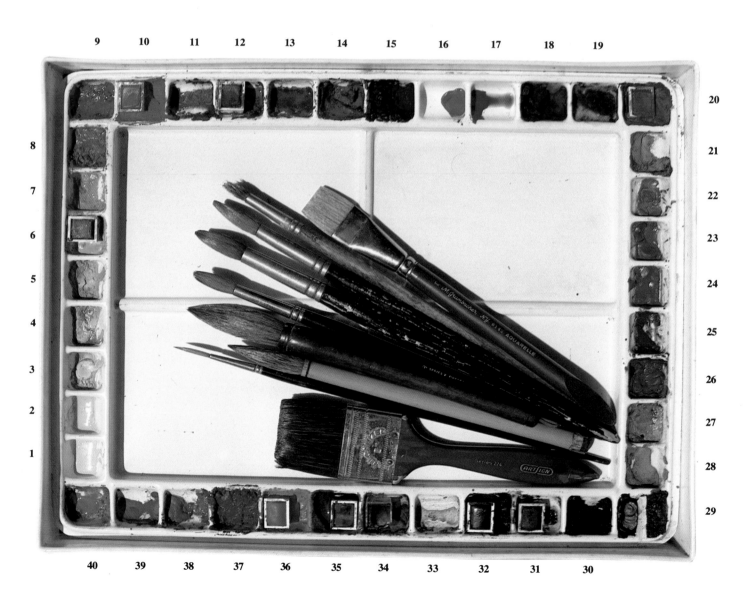

The Colors

1. **NAPLES YELLOW** *creamy, warm, opaque, unusual mixer, dulls raw colors*
2. **WINSOR YELLOW** *cool, clear, brilliant mixer*
3. **CADMIUM YELLOW LIGHT** *warm, high key, easy mixer with blues and reds*
4. **NEW GAMBOGE** *cool, clean, "cobalt yellow," good basic mixer*
5. **CADMIUM YELLOW DEEP** *warm, hearty, semi-opaque, great strength*
6. **INDIAN YELLOW** *very warm, clear, unusual color combinations*
 (R) ½ pan *warm, less toward orange (being tested)*
7. **CADMIUM ORANGE** *a handsome, brilliant, opaque color, floats wet in wet*
8. **CHINESE ORANGE (FB)** *richly blended unusual tones, unique*
9. **CADMIUM SCARLET** *the brightest and highest key of the cadmium reds*
10. **CADMIUM RED** *opaque, deepest cadmium red, try it in pale tints*
 (R) ½ pan *opaque, brilliant high key, brightest cadmium red*
11. **LIGHT RED** *opaque, great gray with cerulean blue, dulls raw colors*
12. **ROSE DORÉ** *clear, delicate pink, special with Davy's gray*
 (R) ½ pan *this is rose doré alizarin, slightly browner, delicate (being tested)*
13. **ROSE MADDER** *clear, delicate, for that ringing Renoir pink*
14. **PERMANENT ROSE** *clear, hot pink, important high-key color, unique*
15. **ALIZARIN CRIMSON** *clear, excellent mixer, carries good strength*
16. **COBALT VIOLET (FB)** *rather opaque, surprisingly powerful, very unusual*
17. **COBALT VIOLET** *clear, very granular in special mixes, Bonnard's "pet"*
18. **MAUVE** *semi-clear, reddish purple, unusual*
19. **WINSOR VIOLET** *clear, bluish, gives me a purple in a single color*
20. **VENETIAN RED** *very opaque, very overpowering, classical quality*
 (R) ½ pan *Indian red, very opaque, rich mixer (being tested)*
21. **YELLOW OCHRE** *rather clear, has its own special qualities as a mixer*
22. **RAW SIENNA** *strong, but clean, can be added heavily into mixes, warm*
23. **RAW UMBER** *surprisingly clear for an earth color, cool, (my most used color— I constantly use this for "graying off" other colors)*
24. **BURNT SIENNA** *hot, clear, medium granular, a good mixer*
25. **BURNT UMBER** *cool, deep, heavy granular deposits; can get your colors muddy*
26. **BROWN ALIZARIN** *clear, ultra rich, very unusual, don't overuse*
27. **EMERALD GREEN** *cool, can be an opaque spotting color, unique*
28. **COBALT GREEN** *semi-clear, rare beauty, delicate, pale mixer*
29. **OLIVE GREEN** *can be surprisingly clear, neutral cool/warm mixer*
 ½ well *Hooker's green deep, a special deep green (being tested— I've made a divider out of Styrofoam to separate the greens.)*
30. **SAP GREEN** *very clear, warm, stains nicely (in my florals especially)*
31. **VIRIDIAN** *cool, brilliant, mixes well, stays clean*
 (R) ½ pan *a bit cooler and "more unusual," unique (being tested)*
32. **IVORY BLACK** *the cooler black, differs in some mixes, clear*
 (R) ½ pan *the warmer black – I'm puzzling these two out (being tested)*
33. **DAVY'S GRAY** *a rich, slightly warm yet neutral; I prefer it over Payne's gray*
34. **PHTHALO BLUE** *cool, clear, very strong – hang out the red flag, but use it*
 (M) ½ pan *Maimeri ultramarine blue is the most granular brand I've used (being tested)*
35. **ULTRAMARINE BLUE** *very warm blue, very granular, mix it with other granular colors*
 (R) ½ pan *used alone, this Rowney ultramarine blue handles the way I'd like cobalt blue to behave for me (being tested)*
36. **CERULEAN BLUE (G)** *very cool, an opaque floater when used wet-in-wet, good spotter, milky color, a pet of mine for florals. I use Grumbacher's light-fast Academy grade*
 (R) ½ pan *cool, clear, a surprising mixer (being tested – and likely to stay in my pallette)*
37. **COBALT BLUE** *good for summer skies, makes a key gray when mixed with raw umber*
38. **CERULEAN BLUE** *cool, rather opaque, floats well wet into deep colors*
39. **MANGANESE BLUE** *very cool, very granular, unusual mixer, lively*
40. **CENDRE BLUE (FB)** *very cool, milky, unique color mixes, a special color*

a Maimeri brand color. I've been accumulating Rowney paints for two years and I added the Maimeri color after seeing it in a lush watercolor issue of *American Artist*, February 1983. Each of these new colors will be discussed.

Set up your palette exactly as you see illustrated and listed: These colors are arranged like a piano keyboard. Paint this way, and you'll get so that these color locations are second nature to you. Just like Serkin knows where to hit his keys.

Note: All colors are Winsor & Newton except those indicated by the following code

R = Rowney (English)

FB = Le Franc & Bourgeois (French)

G = Grumbacher Academy (USA)

M = Maimeri (Italian)

Depending on your temperament for experimenting, your stage of capability, your access to the various colors noted, and the size of your purse, I would like to carry the ball a few yards further and mention some additional hues.

Le Franc & Bourgeois makes an exceptional ultramarine blue that is available in *clair* (light) and *foncé* (deep). I have tested these colors and given them a permanent place in my carryall brush box. I also carry their hortensia blue (for Mediterranean and Aegean areas) and Aubusson green (for floral work). And I keep the following colors handy in my studio:

Grumbacher Academy manganese blue

Permanent Pigments (now Liquitex) manganese blue and also their ultramarine blue

Utrecht permanent violet and also cadmium orange (both powerful)

Winsor & Newton Payne's gray (sometimes good for stormy skies) and also their No. 011 Chinese white (if I want to lay a preliminary white wash on a hot-pressed or plate finish paper for a "liftout" technique).

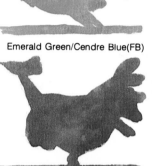

Get Acquainted with Your Colors.
Making colored chickens is a more practical way of blending two colors than the usual "grid" system, where each color is painted horizontally, followed by the same colors painted across the first set vertically . . . noting opaque and transparent features. The chickens give you a larger mixed area in the belly section than the grid system.

Mix your chickens to see which colors are more aggressive, opaque, transparent, or granular. Then set up a system of color combinations that will help you in painting landscapes, seascapes, portraits, and still lifes. For instance, make up several sheets of warm colors. Mix all the reds with all the yellows, solids or tints, and make your mixtures a variety of oranges and pinks. Mix all your blues and reds together to make different kinds of purples and violets. Do a series of brown-pink or purple-brown mixtures — and you can certainly mix the blues with the earths to create an important record of basic grays . . . they are the keystone in getting more brilliance out of your palette.

I have read many times that cobalt violet and emerald green are poisonous. It likely depends on the pigment used, but I caution you: Never put your brush in your mouth!

You'll be using 40 colors, plus a few in the test stages. That's a handful. Using them should give you a challenge and great satisfaction over the years ahead. It should also get you into the "symphonic color" we're talking about . . . and thus into an endless variety of creativity. Dust off your wings, pal, and go! These chickens are put together in sets to show you a method of organizing color mixtures according to how they relate to each other. Make your colored chickens larger than the ones shown here — about 3″ x 5″ (7½ x 12.7 cm).

Cobalt Green/Cobalt Violet

Cobalt Green/Permanent Rose

Viridian/Alizarin Crimson

Hooker's Green/Manganese Blue

Emerald Green/Cendre Blue(FB)

Sap Green/Manganese Blue

Viridian(H)/Cobalt Violet

Sap Green and Burnt Sienna (mixed)/
Dropped-in Burnt Sienna

Sap Green/Burnt Sienna

Here you are pre-testing mixtures for stems and leaves with red flowers. You'll gain an additional benefit when you discover some new grays made with a few of these combinations.

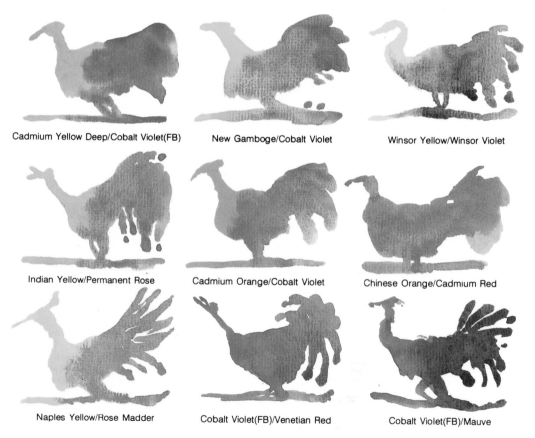

Cadmium Yellow Deep/Cobalt Violet(FB)

New Gamboge/Cobalt Violet

Winsor Yellow/Winsor Violet

Indian Yellow/Permanent Rose

Cadmium Orange/Cobalt Violet

Chinese Orange/Cadmium Red

Naples Yellow/Rose Madder

Cobalt Violet(FB)/Venetian Red

Cobalt Violet(FB)/Mauve

This "set" of chickens organizes some reds with yellows . . . florals and foliage, and on the same page, reds with red-violets . . . florals and landscapes, and violet and yellow, for a different gray mix.

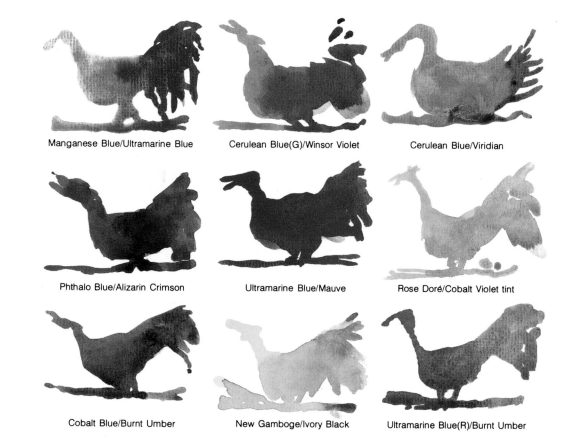

Manganese Blue/Ultramarine Blue Cerulean Blue(G)/Winsor Violet Cerulean Blue/Viridian

Phthalo Blue/Alizarin Crimson Ultramarine Blue/Mauve Rose Doré/Cobalt Violet tint

Cobalt Blue/Burnt Umber New Gamboge/Ivory Black Ultramarine Blue(R)/Burnt Umber

Here is a set of very deep color mixtures. (Keep your paper slanted at all times so that you get clean washes.) I put a few brilliant hues next to these deep colors to show how you might use these same combinations in a painting.

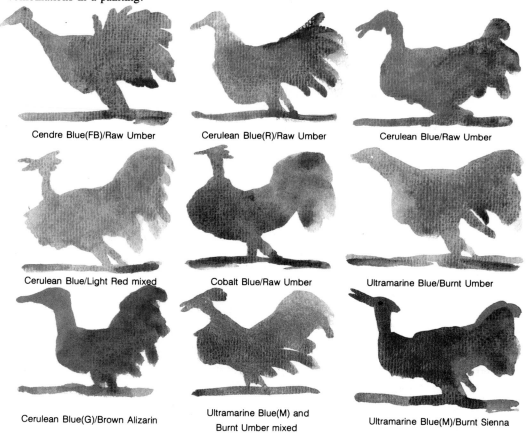

Cendre Blue(FB)/Raw Umber Cerulean Blue(R)/Raw Umber Cerulean Blue/Raw Umber

Cerulean Blue/Light Red mixed Cobalt Blue/Raw Umber Ultramarine Blue/Burnt Umber

Cerulean Blue(G)/Brown Alizarin Ultramarine Blue(M) and Burnt Umber mixed Ultramarine Blue(M)/Burnt Sienna

Organize several "sets" of grays . . . these were made by combining blues with earth colors. Using the right gray in a painting can make it *sing*.

Try what you think will be beautiful, and with these new colors in the "40" that you've never seen before, try what you think will be exciting. Throw your hat in the air . . . let go . . . invent. Try several pages putting color together the way Grieg or Tchaikovsky or Debussy put their souls on paper for the first time. Nobody held *their* hand. Nobody showed *them* the way. Cut *your own* swath . . . grow your own wings. Think poetry and music! Fly, baby, fly!

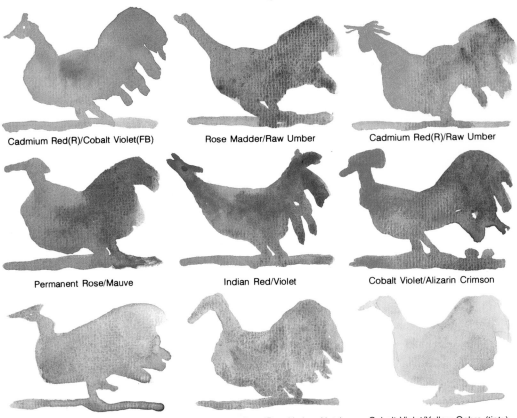

Cadmium Red(R)/Cobalt Violet(FB) Rose Madder/Raw Umber Cadmium Red(R)/Raw Umber

Permanent Rose/Mauve Indian Red/Violet Cobalt Violet/Alizarin Crimson

Rose Doré Alizarin(R)/Davy's Gray Permanent Rose/Raw Umber (tints) Cobalt Violet/Yellow Ochre (tints)

Take all of your reds and study how they relate to a host of other colors. Make yourself familiar with the color red by creating pink shades, then make pink-brown and pink-lavender mixtures. After that, start in on your blues . . . then yellows . . . in fact, do all 40.

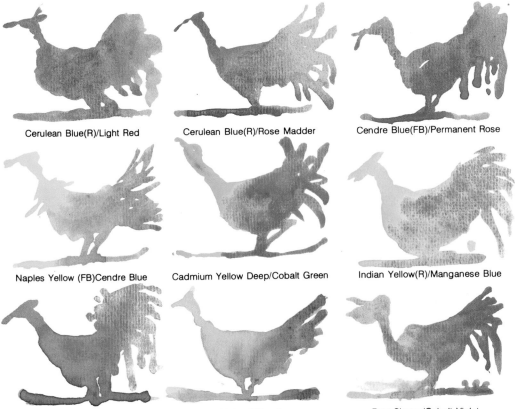

Cerulean Blue(R)/Light Red Cerulean Blue(R)/Rose Madder Cendre Blue(FB)/Permanent Rose

Naples Yellow (FB)Cendre Blue Cadmium Yellow Deep/Cobalt Green Indian Yellow(R)/Manganese Blue

Hooker's Green/Manganese Blue Naples Yellow/Olive Green Raw Sienna/Cobalt Violet

Here is an exercise designed to encourage you to mix colors in combinations that are new to you from the 40-color palette. To get your feet wet, duplicate these nine combinations reproduced here. Now start to take off on your own. Think color.

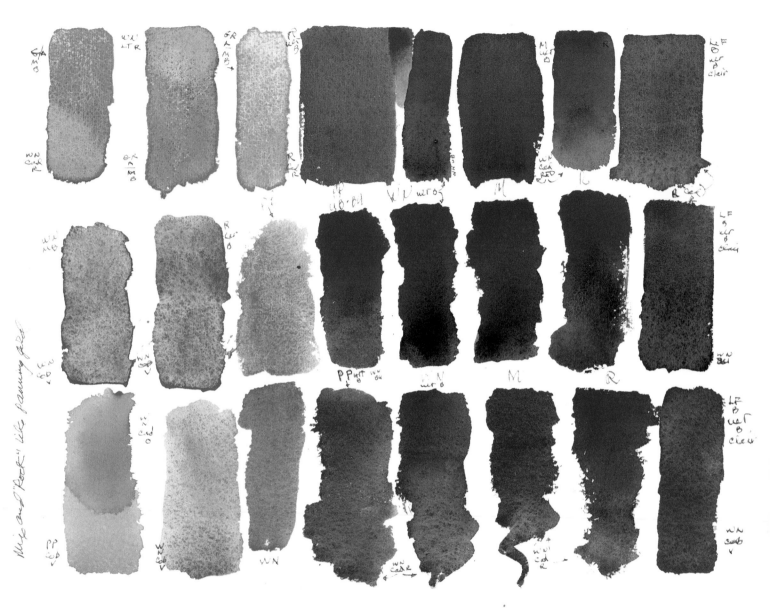

Making Granular Washes.
If you like granular washes I have a tidbit that came from London gallery owner George Coogan, that Sir William Russel Flint (the reknowned British watercolorist) used egg white in his watercolor washes. And nobody in my humble opinion could lay a grainy sweetheart of a wash like Flint! I've used Robert Massey's recipe* for the ancient illuminating mixture glair (which means "clear"): Whip an egg white on a platter with a fork until the froth is dry. Pour the liquid into a clean jar. I mix it with four tablespoons of distilled water and decant it after eight hours. After using this mixture, wash your brushes with soap and water. And use only an inexpensive Japanese brush since this glair can ruin a good brush. The Japanese brushes are good, but since they're inexpensive you won't mind ruining them! You can find Massey's mixture in his book, *Formulas for Painters* (Watson-Guptill).

Furthermore, if you let a small accumulation of the previous day's mixtures remain in your palette for use in the next watercolor, you'll benefit from a surprising granulation as you "gray off" some of your new, freshly concocted color combinations for any new watercolor you want to experiment with.

Testing for Granulation in Color Mixtures.
I usually test the granulation or sediment of a color right on a large 22″x 30″ (56 x 76 cm) watercolor as I paint it, but you can test your colors as shown. Here is an illustration of twenty-four color combinations, two to a test, that are put down in a rectangle, a bar at a time. To do your own test, brush a bar of clear water on dry paper. Lay one color at one end, and into this water wash, with a different brush, lay the second color into the opposite end of the bar. Hold the paper flat for a few moments and then rock it back and forth — like panning gold — until the granular wash sets. Try cold-pressed, hotpressed, and rough watercolor papers. Dry it flat! Here's a sample page with my notations.

COLOR PERMANENCY TESTS

Testing for Color Fastness. This shows the results of my test for color fastness. I washed a set of colors onto good paper with each color strip 8″ (20 cm) long and kept separate (I goofed in one spot). The paper is taped to a south window in direct sunlight and left there for two months *in summer only*. If you look carefully you can see where I taped an opaque "belly band" across the entire mid-section, tightly! Test all of your colors like this . . . always!

These colors failed the test. Of course, none of these are among our 40 colors!

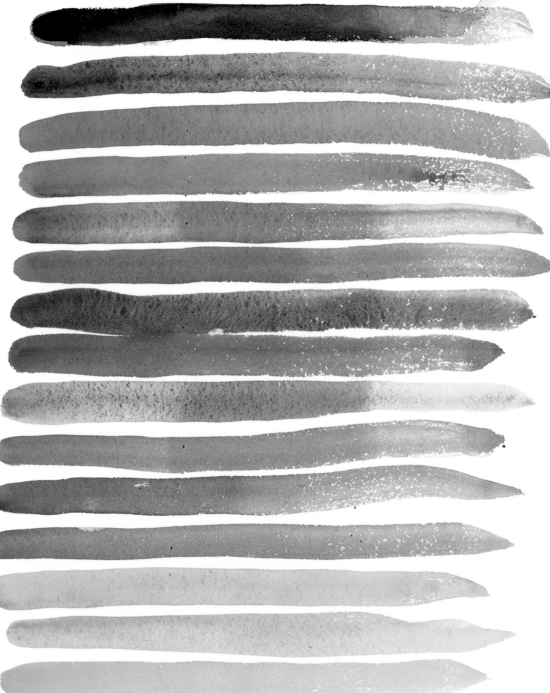

WATERCOLOR PAPERS AND HOW TO STRETCH THEM

Watercolor Paper Textures.
Papers come in smooth, hot-pressed, plate textures; in cold-pressed, medium texture; and in rough texture, which catches the granular washes better than the other papers. (Hot-pressed papers play neat tricks with your washes.)

Common Weights in Watercolor Paper.
The lightest and least expensive watercolor papers are the 70-lb and 90-lb papers, due to their weight. They produce the most brilliant effects when it comes to accepting your color washes because your colors sit on top of the surface instead of sinking into the pulp, as they do on 300-lb paper. The 90-lb paper is less delicate than 70-lb, but both papers still must be stretched.

Stretching Lightweight Papers.
Soak the 70-lb paper 5 to 10 minutes and the 90-lb paper for ½ hour in an enameled photographer's tray and stretch either weight over wooden canvas stretcher strips (see diagram at right). Limit the 70-lb paper to 12″ x 16″ (30 x 40.5 cm) finished size and wrap the paper over the sides just as you would staple a canvas, using stainless steel staples, of course. Sand the wooden corners so they

don't puncture your paper. Limit the 90-lb paper to 16″ x 20″ (40.5 x 51 cm). You can work a bit larger after you've been at it for a few years. A resilient drum head is the response you'll get when you slap your spirited washes onto this dry, taut 70-lb or 90-lb stretched surface. You will respond with great excitement to this "pure" form of painting.

The 140-lb paper can also be stretched in the above manner, but you won't get the purity and brilliance of the 70-lb and 90-lb paper. You can stretch up to a full sheet (22″ x 30″ — 56 x 76 cm) but it's more comfortable (fewer tears and spoiled sheets) if you work up to only 20″ x 24″ (51 x 61 cm) sizes.

I never stretch 200-lb and 300-lb paper, but I do use this weight frequently for studio paintings that will be going to galleries and exhibits where I may be doing a fast one-hour painting. Or I use it for a subject I'll be working on (and reworking and punishing) for an extended period of time.

Stretching Heavy Paper.
When I don't stretch the paper, I usually just put two clips at the top of 140-lb, 200-lb, and 300-lb paper on a piece of Masonite which has had two coats of five parts shellac to one part alcohol. Watercolor papers are sized (starched). I usually wash off the size from these papers, though occasionally I'll leave the size on and increase my pigment content instead and use the added size to help produce a granulation. If you want to remove the sizing, you can soak these heavy papers in a clean tub of distilled water for at least an hour for full sheets. Always be sure your tub is clean of soap — in all operations for all

weights of paper and for your painting water. Use only distilled water at all times!

Speaking of water, in the eastern United States and Canada, you can be sure of rainwater like vinegar. It's killing the fish and lake life and it'll do a job on your watercolors, too! And if you live in a city or town, you'll find that chlorine is added to water — and chlorine is a *bleach*! Yeah! In *your* painting water! When I travel, I use Perrier or carbonated soda water . . . *sealed*. I'm fussy, but then I don't want any unhappy customers coming back to me later. Buy spring water by the gallon — but get it laboratory tested for purity.

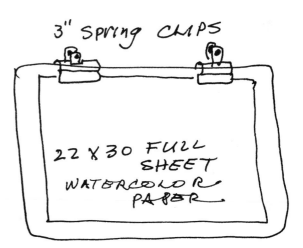

3″ SPRING CLIPS

22 X 30 FULL SHEET WATERCOLOR PAPER

Stretching and Mounting Wet Paper on Panels

Mount a dozen 70-lb or 90-lb inexpensive, hand-made water-color papers on 20″ × 24″ × ¼″ pieces of Masonite, untempered, on the smooth side. Sand lightly, dust off, and apply white shellac on both sides, thinned down 1 to 1 with de-natured alcohol, over your India ink guidelines, which have been drawn to locate the centered position for your ¼ sheet (11″ × 15″) paper (see diagram 1). Bleed your guidelines off the edges to leave plenty of "sight" room, outside your tapes.

Soak your paper in a white porcelain photo tray in distilled water for 5 to 15 minutes (try different time segments for what you like best for your style washes).

Lift your soaked paper out of the tray at an angle to drain off the water and place on your shellacked Masonite panel, within the guidelines, touching the paper in a U shape in the center, laying the sides out flat. Rub the edge of your palms toward the corners to squeeze out any air bubbles.

Diagram 3 indicates side tapes of 3″ or 2″ in width. Use a damp cellulose sponge to wipe excess water off the perimeter edges, 1″ for 3″ tape and ½″ for 2″ tape. (Try out to see your preference.) Mark in 3B pencil guidelines on the tapes to indicate where your long horizontal tapes will overlap the watercolor paper by the amount desired.

Diagram 4 indicates where you place your long tapes. Rub all tapes from the centers out to get out air bubbles, and crease along the watercolor paper with your thumbnail to seal for better bonding of the glue.

Dry overnight and pack in the morning. Slip-sheet each mounted panel between news stock to travel well, in a dust-proof, rainproof box, and dream about the great, brilliant water-colors you will do on your trip!

The great advantage to this method is that your papers won't buckle. Another plus is that you can take great advantage of the less expensive papers, get more brilliance, and better hold the subtle nuances of color than with 140-lb papers.

For traveling, you may find it more convenient to mount your paper on lightweight panels with an oval hold for carrying (shown below).

Summary: The 70-lb and 90-lb papers give you the most brilliance and are the least expensive, but the most difficult to handle. The 140-lb paper has the best average weight (accounts for more than 50 percent of my work) and best average color reception, and the 300-lb paper is the least brilliant and most costly, but its unequalled for toughness . . . a real work-horse!

Machine-made or Mold-made Papers.

These are the stock-in-trade of the good, competent watercolor-ist. Many companies — Arches, Fabriano, Whatman — have excellent papers. They are equally popular and well represented in art stores in major cities. These are the papers with international reputations. There are also many fine American-made papers, but they are too numerous to mention here. I occasionally use Strathmore, which, for example, makes a four-ply kid (cold-pressed) and plate (smooth) paper.

Handmade Papers.

They're expensive, but I feel that handmade papers are outstanding for professional use. No other paper can approach their special quality because they're made exclusively of linen fibers — the same fine linen of men's shirts and ker-chiefs. With the advent of synthetic fibers, these handmade papers became a watercolorist's treasure. I have painted on nothing but handmade papers since 1975 with few exceptions. As I said, they're expensive, but they can be found. First a

few names: Crissbrook, J. Green, Hayle Mills, Mill-bourne, Whatman, Fabriano. My papers date back to 1951 — the older the better. All hand-made papers are watermarked "Hand Made" — this is your guarantee! Ask your local art supply store. Look in your local museum or art school in the art supply shops. When you travel, or if you have friends or relatives in distant cities, ask them to inquire. *American Artist* regularly runs ads listing companies in the United States that carry handmade papers, but be sure they're watermarked "Hand Made." Buy a sample sheet first to be sure.

Look for ads for Japanese papers. I like Masa the best for all-around use, and Troya for soupy washes on this very white paper. Hosho is excellent for moody and poetic effects.

The book with the most complete and extensive technical information on watercolor papers that I've read, is *Wash and Gouache Watercolor Materials* published by the Harvard Fogg Museum in Cambridge Mass. 1977 — an absolute *must* for the top pro only! A great, great book with a fabulous bibliography!

Fabriano used to make a student-grade paper called "Capri." It was the absolute greatest. It had a laid grain tooth that formed a series of lines in the paper. These lines gave an atmospheric quality to drawings and took watercolor really well. If everyone wrote to Fabriano begging, maybe they would reinstate the discontinued, inexpensive "Capri." Ask your art dealer.

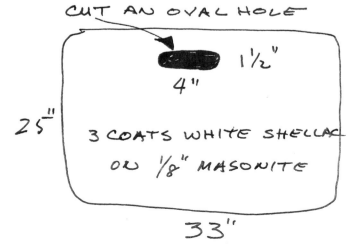

CUT AN OVAL HOLE

1½″

4″

25″

33″

3 COATS WHITE SHELLAC ON ⅛″ MASONITE

BRUSHES AND ASSORTED EXTRAS

Round Brushes.
Winsor & Newton's series no. 7 red sables. I think these are the best brushes anywhere, but they're expensive. They last very well though. I'm still using the no. 14 I bought in London during my 1962 world trip (cost — $40.00 *then*). Try no. 5 and 9 to start . . . add others as you need to. I recommend the following brushes as substitutes for the series no. 7 round, in case you're not ready to make a costly investment!

White nylon rounds . . . by many manufacturers. Check out *American Artist* regularly for their many brush advertisers with descriptive testimonials of various artists.

Bamboo brushes. You'll have to check out various Oriental brands (they have various brand symbols). Buy the ones with a small silk loop you can hang them on to dry. The better brands keep a sharp point for years and are inexpensive! Use a tiny screw eye in brushes without the cord, but hang all bamboo brushes after each use.

Flat Brushes.
I recommend Grumbacher's, Aquarelle, Delta, and other brands of sable flats. I use ½-inch (1.3 cm) and 1-inch (2.54 cm) sizes. I also use a 2-inch (5 cm) no. 224 ArtSign. I painted all my outdoor full sheets for six years with nothing but this 2-inch (5 cm) brush in order to discipline myself! Strathmore makes a good 2-inch (5 cm) brush, and many companies now make white bristle nylon flats. You can also use any good oxhair varnish brush from a paint store.

The Japanese hake brush comes in amazing widths. (See Frederick Wong's *Oriental Watercolor Techniques* (Watson-Guptill) for details.) For flooding great background washes and puddles, I now prefer using a huge 1-inch (2.54 cm) diameter x 4-inch (10 cm) long horsehair Japanese brush. It holds a half cup

of watercolor wash and comes to a single hair point. I also have a ½-inch (3 cm) version in horsehair. (You can get wolf, cat, pony, sheep, or rabbit hair etc., brushes, and each has a personality of its own, from the Unique Co., 444 Grant St., San Francisco.)

Easels.
I like a Fench easel made of Beechwood. I place my palette on the pullout tray and hang my water bucket on a side fitting. Be sure all your fittings are *bronze*. Caveat Emptor.

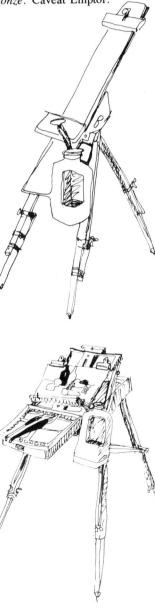

I also use the Franco #30 watercolor easel, available from the Ansco Company. The flat board slides up and down from its center mount and tips forward or backward 180 degrees. The legs are adjustable and I like the heavy steel points at its base. If I'm using the easel in an indoor demonstration, I put it on a small carpet, but I like this easel best when I'm on the rocks painting a seascape.

Masking Fluid.
I never use any masking-out techniques, but that's a quirk of mine. If you need a good masking fluid, I recommend Winsor & Newton's *washable*, yellow color.

Water Jug.
Every fall I cut a new watercolor jug from a quart plastic cider container (after drinking the cider!). I cut 5″ (12.5 cm) out of the front and two sides, leaving 3″ (7.5 cm) at the bottom, and leave the screw cap and handle intact. Use a loop cord to hang it.

Palette.
In *Joy of Watercolor* I described my 24-color palette, which I used for many years and still use when I travel. In this book, we're dealing exclusively with my 40-color palette. I use a 12″ x 6″ (30.5 x 40.5 cm) plastic palette with 40 wells and four mixing wells. That's a huge mixing area and I urge you to take advantage of its size to mix washes much larger than you think you'll ever need. I use the bottom left pan to mix blues and blue-grays, the bottom right pan for mixing greens and green-browns, the top left pan for oranges, pinks, and pink-browns, and the top right pan for purples and purple-browns.

I keep this palette in a plastic box manufactured by Palette Seal. The base is a heavy white unbreakable plastic and it has a flexible snap-on blue top which

holds a small round flat sponge for keeping colors moist. Do not use this wet sponge in the tropics . . . it'll cause mildew! In tropical climates I advise you to expose your colors to sunlight for a full hour every three or four days to avoid mildew damage to several colors, particularly: cadmium yellow deep, cadmium orange, light red, rose madder, alizarin crimson, cobalt violet, mauve, and raw umber.

Equipment to Travel With.
I've gone abroad with my 40 colors, 80 ¼ sheets of handmade paper; four new 3B carbon pencils; three Winsor & Newton series 7 brushes, nos. 5, 9, and 12, plus both ¼″ and ½″ Japanese bamboo brushes, and a no. 3 Rigger ArtSign 831; my Super Aquabee 9″ x 12″ (23 x 30.5 cm) 60-page sketchbook; and a ¼-bottle of Winsor & Newton brown shellac ink, and my old "wooden" pen which is actually bamboo. I took no eraser, no Maskoid, no easel or stool. All my gear was tucked carefully at the bottom of a canvas sports bag. I also took Cutter's insect repellant, vitamins, film (25 ASA, 36 exposure, 35mm), my Olympus OM-1 35mm SLR camera, and 35mm and 75-205 zoom lenses. All this gear went along with drip-dry clothing and a windbreaker. I sealed my palette shut so the paints would be dry to travel with and taped paper masking tape over all the wells to prevent dry particles from intermixing with the paints while in transit.

In '62 I went around the world with fifteen pounds of luggage in a small "throwaway" suitcase. (I travel Spartan!) I drank only sealed bottled water, beer, and wine, so I wouldn't lose any painting days to sickness. (I didn't eat salads, either.) What do you paint when you travel? The same things you'd paint in your own backyard!

PAINTING PEOPLE AND LIGHT

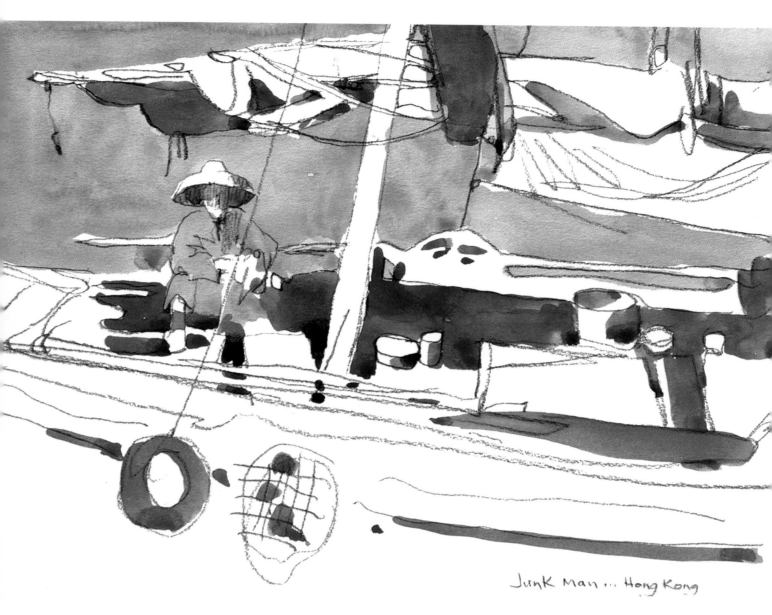

Junk Man ... Hong Kong

Begin with a Monochrome Wash.
Through the ages, artists have been concerned about these two major aspects of painting, people and light — solving how light strikes a group of figures and, particularly in watercolor, how to capture the elusive, luminous quality of light in a painting. In order to pursue these two solutions on a narrow track, let's start with limited color and only gradually in-

crease it so we're more mindful of how light is handled in each of the paintings ahead.

The Junkman is your starting point. Your monochromatic color is a mixture of mauve, ultramarine blue, and lamp black. Use this mixture in three values . . . according to how much water you add to the base color. Begin by abandoning the dark brown junk (boat).

Let design command every watercolor you paint. Place your mast first, then seat your

center of interest and work from this figure outward . . . along the gunwhale, the sails, the cook stove. You're applying color in patterns, but you're really designing that most unusual white shape . . . your light. This is very simple in color, and it is luminous. There is an unmistakable feeling of light! And you're using light on your figure to emphasize his unusual hat and posture. Note that capricious red sock!

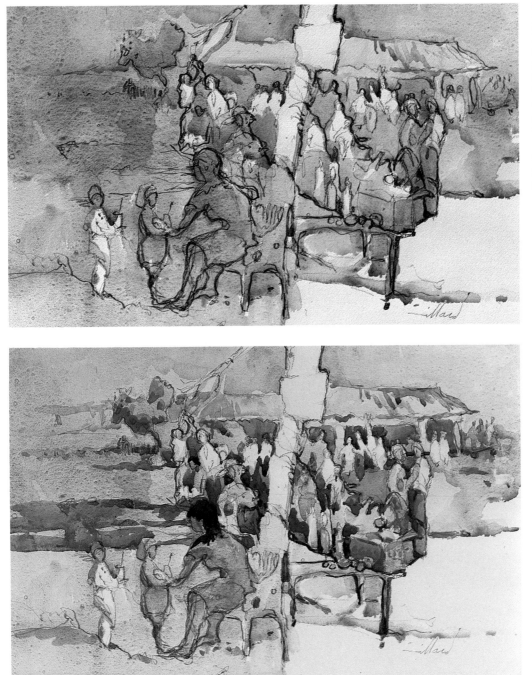

Look for the Pattern of Light.

In this case you're using the figures themselves as the major pattern of light, plus two very interestingly shaped pieces of white on the tree/sign and that chunk of design, at the lower right-hand corner. There is an odd quality to the light here . . . cup your hand, making a spyglass, close one eye and peek at this painting. *It's luminous.* It's also clean and clear in your washes . . . put it down once and leave it alone! You have added a touch of raw umber, and a touch of rose madder, and a bit more of mauve, combined with base color, as separate washes.

Intensify Your Colors.

Give yourself a little more punch and concentrate your interest in the middle distance. Join some of your figures together in white so that two or three figures become one shape. Unifying them like this seems to lose the edges between them and definitely adds to the feeling of luminosity. Do the spyglass cupping of your hand again . . . it eliminates peripheral distraction. Your colors remain the same, with the addition of a bit of yellow ochre. This increased intensity has not destroyed the shimmer.

57

WORK GRADUALLY INTO COLOR

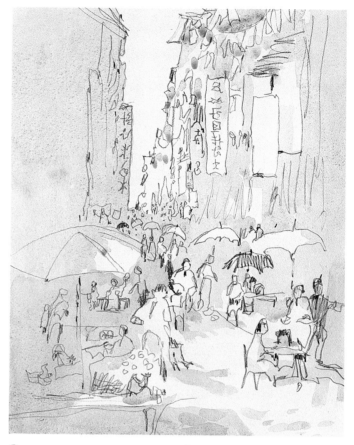

Guide the Viewer's Eye.
Begin to decide where you want
your viewer's eye to travel into
the picture. Do an unweighted
contour, freehand drawing.
Now, just touch in the darks,
intuitively, to guide the eye.
Leave out figures in the bottom
of the street so the eye has an
alley of entry.

Study Your Values.
There is so much pattern and
jumble here, you decide to stay
monochromatic and just lay in
subtle value washes. In your
first wash, look for some sem-
blance of form and selection of
white pattern as you grow out
of your flat drawing.

**Increase Your Buildup
of Tone.** (Opposite)
Lay second and third color
washes. The cool side is
mauve, raw umber, and cobalt
blue; the warm side, mauve,
burnt sienna, and cobalt blue.
Don't use bright colors . . .
stay with monochrome. Now,
feel your way into the few dark
spots (ultramarine blue and
ivory black). Add just a touch
of bright color, cobalt green,
yellow ochre, cadmium orange,
and Chinese orange.

Involve the Viewer. (Detail)
Cropping like this brings the
viewer right into the crowd ac-
tion. You, as the artist, the
composer, decide on the format
. . . where and if to crop. De-
ciding if you should crop is
creative emotion from the right
side of the brain, but knowing
where to crop is logic (left
side). Learn to separate your
thoughts and be able to shift
sides!

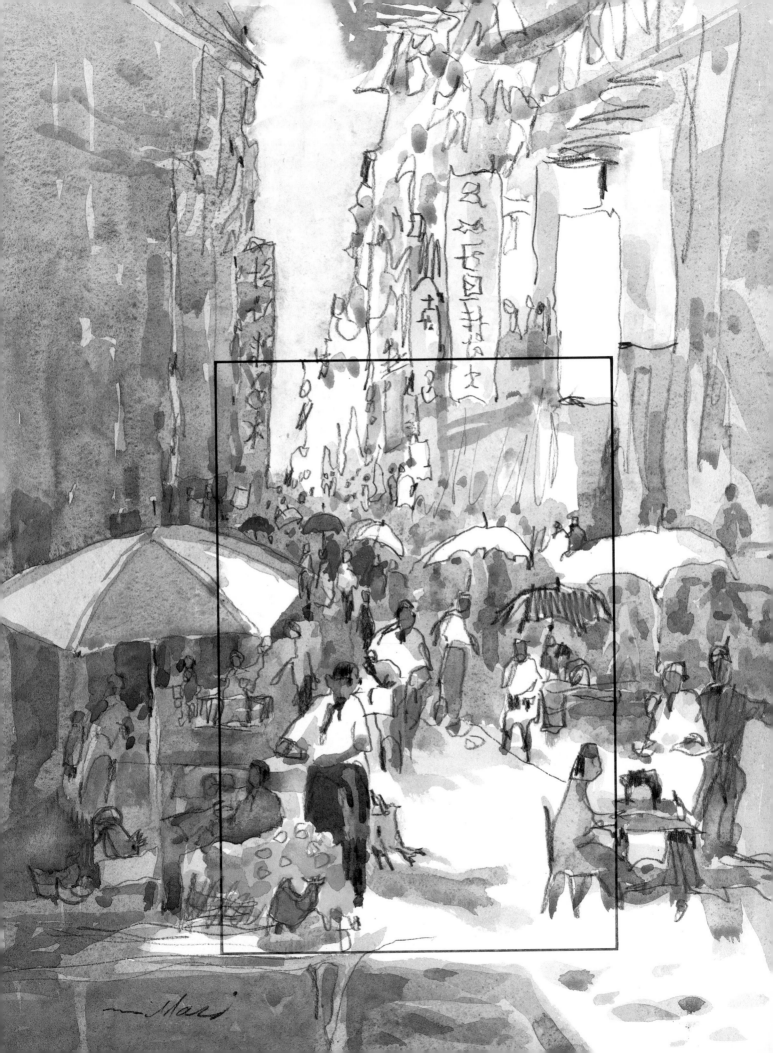

SINGLE OUT MAJOR SHAPES

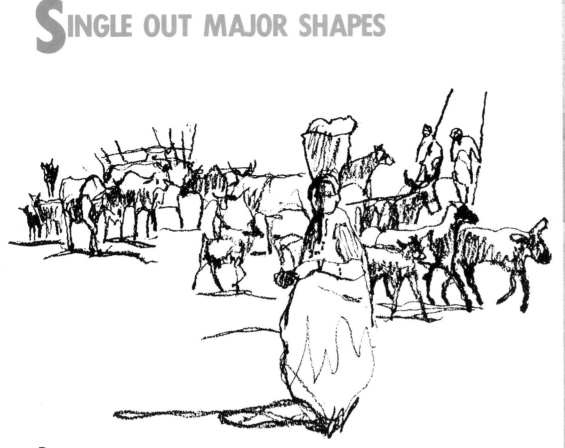

People and Light . . . a Color Lesson.
The title of this sketch is *On the Road to Agra*. Choose a woman out of the passing throngs . . . select a spot and place her. Draw from this figure outward in all directions a bit at a time. You're excited about every piece you add . . . each animal or figure has to be a good shape related to it's neighbor. Look for the patterns of heads and between heads. Look for the pattern in the legs and feet and the negatives they create.

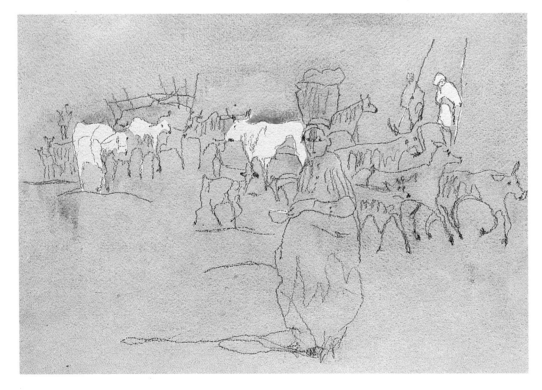

Know Your Setting . . . and Paint It!
This is India . . . 120°F hot . . . animal dust is blowing in the wind. That's your setting . . . paint a "dusty" wash around your selected white shapes. Your positioning of the white animals and shepherd seems to move them back into space . . . away from the woman. Move very slowly toward reality. At this stage your color is raw umber with touches of cobalt violet and burnt umber. You could almost stop at this point if you added a black or two.

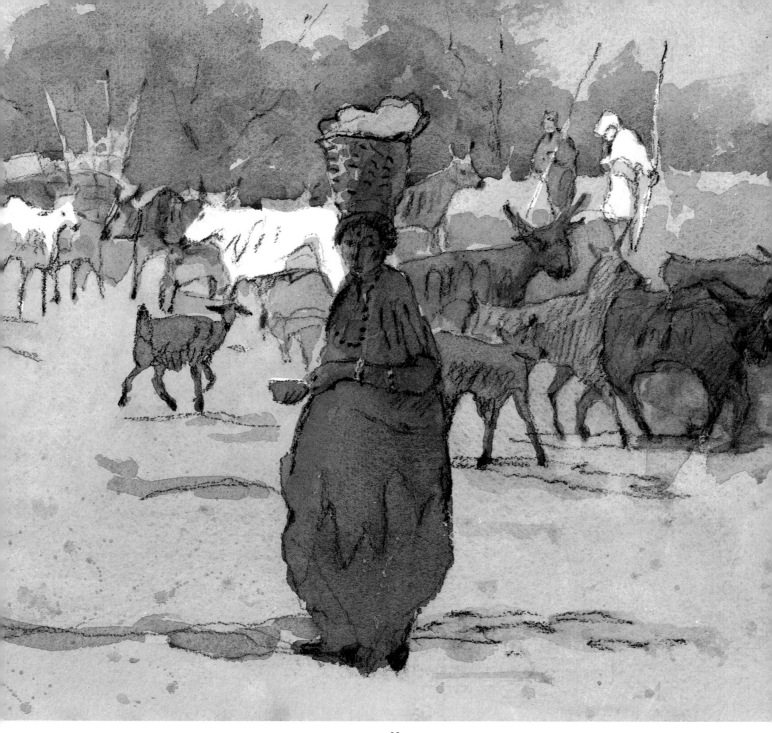

Use Many Edges
to Get a Shimmer.
Here you're painting the shape
of a crowd of animals and peo-
ple. Make the trees shimmer by
using many edges, not just one
hard line. Lay in two washes of
raw umber and Davy's gray on
the trees. Add to the second
wash, a touch of mauve and
burnt umber.

To bring your central figure
forward, use mauve and burnt
sienna. You could stop your
painting here if you want. Or,
apply Venetian red. Your paint-
ing now has added dimension
and focus. Color the goats the
same as the figure, mauve and
burnt sienna, but forget the Ve-
netian red.

Now, give the shepherd a
coat of few colors, just cobalt
blue and lamp black. Cup your
hand and peek . . . the edges
and those lavender shadows
help the luminosity here.

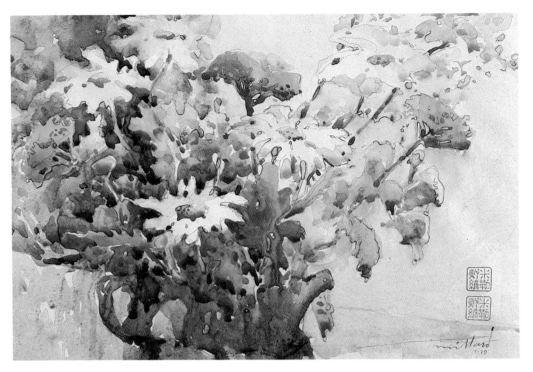

A Soft, Wet Wash.
Study this sequence of washes carefully: Rinse a 90-lb stretched and taped sheet of paper with clear water. Apply the first washes in pale tones of color just after the paper has lost its wet sheen, so you have a bit of control. Put on the second wash while the paper is still damp. (Look at the upper right-hand side to see how you can form blossoms out of the first wash . . . using your imagination.) Concentrate your color in the center, creating a columnar shape. Continue adding deeper colors on the flowers and stems and let it dry. Add a pale final wash, and as you run it over the dry flowers, softly nudge a little color from them to dislodge the pigment. (I used 90-lb paper to gain about 20 percent more brillance. The smooth, hot-pressed surface aids in wiping out highlights on the stems, rim of the vase, and flowers. This painting has the unusual brilliance of a piano concerto by Franz Liszt.)

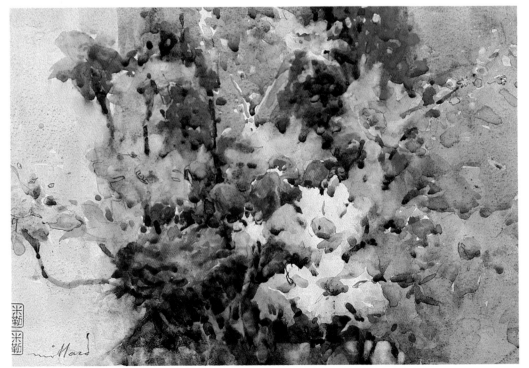

Drop Color into a Colored Wash.
Again, study the order in which light-to-dark tones are applied. Rinse a 90-lb sheet of Milbourne handmade paper, taped and stretched. Apply pale tones, cutting around your whites. Concentrate your colors, as they grow deeper, along a diagonal light purple river of color, dropping in browns and winding up at the earthen pitcher with deep burnt sienna and purple blues. Drop rose doré into the wash at the pitcher handle and put Indian yellow into the yellow flower at the upper right . . . and let both colors bleed.

Cut
Your
Own
Bamboo
Pens

Shellac
Ink

Use Shiny Brown Ink for Calligraphy.

These wildflowers were wild and wooly enough without a patterned background! Lay in a pale pink-lavender-ochre wash around and between them, except for the white edges and the bowl and tablecloth, which greatly enhances the pink tones. Gradually build your washes deeper and deeper, dropping in color and letting it bleed. The deep purple is mauve and burnt sienna, with brown shellac ink dropped into the wash and a bit of cendre blue floated in. Later in the studio I dipped a Japanese wooden pen into the brown shellac ink and loosely inscribed some exciting bits of brown calligraphy. This ink has a shiny, rich quality. Here it's applied freely, but designed carefully. Try Winsor & Newton's shellac ink. This leaves a shiny residue in any deeply pooler line or brush mark. Or try Pelikan Tusche Drawing Ink which dries flat or matte. The Shellac ink doesn't make a wash shiny, but it *will* shine if you let it pool.

USE COLOR AND LIGHT IN YOUR WET WASHES

"Push" the Light with Receding Darks.
Build a platform for your still life models . . . or set up a special table or shelf, big and roomy . . . or a wide board fastened to a windowsill. Then play with light. Try natural light or spotlighted effects within a colored box on a table. This is like a stage setting for Tchaikovsky's *Swan Lake* . . . crisp, elegant, bright! Think the colors of music. Here the dark "stage wing" (mauve and brown) accepts the purple iris into its shadow . . . pushing hard on that edge of the white, swanlike flower, like a spotlight. You can create moods by the way light and paint your watercolor florals. Look at the versatility of Bonnard's shadows of color.

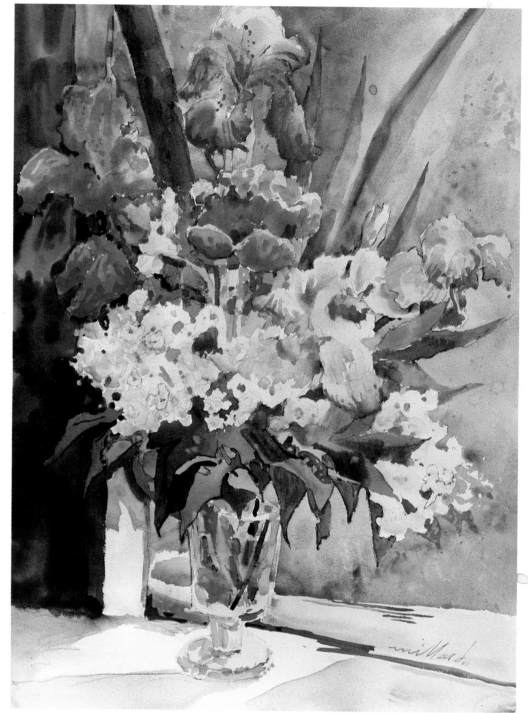

Make Your Colors Brilliant.
Set off your colors with a soft
background of cool gray against
the warm flowers and warm
gray under the cool leaves.
Keep the background pale. Use
a multiplicity of colors within
each set: from yellow-oranges
to burnt sienna; from mauve
and permanent rose to the palest
pink, etc. Arrange the cool col-
ors around the warms, and the
contrasting colors around the
whites.

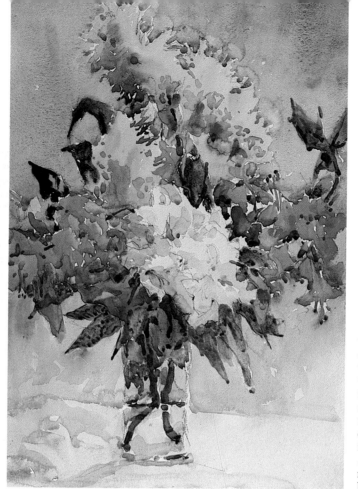

**Pack Color
Around the Whites.**
Can you see the soft edge on
the left-hand side, and the hard
edge on the right? Note that
there's no detail where the
white is brightest. Now look at
the green leaves. Green leaves
are not all green as you might
think at first. How many greens
can you see here? Blues, mov-
ing into purples . . . to ochres
. . . to olive. Think color, think
music . . . think Rimsky-
Korsakov's *Scheherazade*.

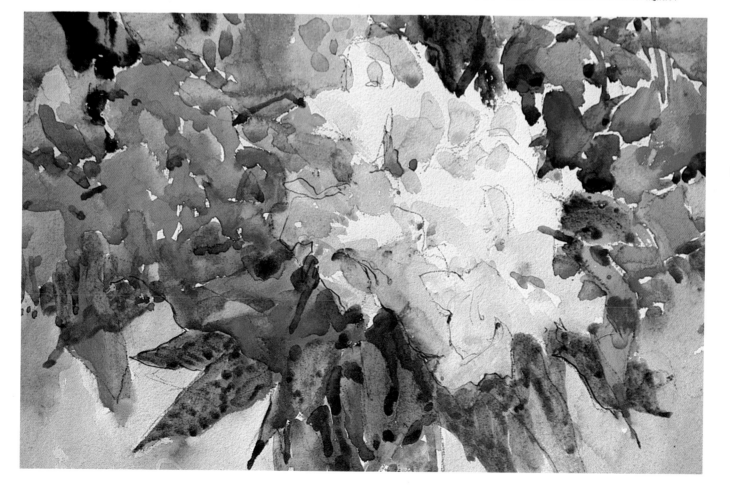

65

CREATE YOUR OWN QUALITY OF LIGHT

Painting Luminosity.

Your carbon pencil just barely forms the shapes of the watering can, fruit, flowers, and blue dish here . . . leaving much to the viewer's imagination. Next, wet your paper front and back, and apply color wet-in-wet on the glistening paper.

Now, rock the paper back and forth, left and right, and also top and bottom, until the color is set. Stop rocking momentarily at the "loss-of-glisten" stage just long enough to dash in the deepest ultramarine blue (M) with a touch of ivory black as well as deep cobalt green . . . quick, man!

Run a second overall wash of palest raw umber and cobalt blue broadly over all but the pink-lavender, yellow, and orange areas.

When the painting is dry, sprinkle clear water over the foreground fruit. Then dip your hand into the water and scrub the base of the fruits to dislodge some pigment there, and allow it to trickle down into the foreground . . . let it dry. Now, touch in reflection marks and add deeper color to the can and fruits . . . again adding water to

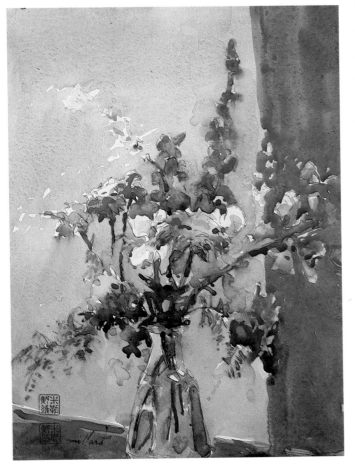

coax pigment subtly down into the area just under the fruits . . . blending as you go.

Use Soft Edges for a Luminous Glow.

This *Bouquet in a Crystal Vase* was an appealing challenge. It was painted in a series of washes . . . one glazed over a dried prior application. A preliminary background mixture was a cool cobalt blue and light red . . . painted up to the flowers. This was allowed to dry. Then the flowers and stems were done in a straightaway manner . . . and left to dry. This resulted in a bright, hard-edged painting. The question became . . . how to make it different? A big puddle was mixed with manganese blue added to the two previous colors.

Starting at the top, this mixture was washed with a large brush right across the entire watercolor, except for the white areas, which were painted around. This was done on 140-lb hot-pressed paper so the granular deposits would be quite pronounced. As this last wash was applied, it was scrubbed lightly in several places to dislodge the previously painted pigment, so it would run down into the new background in a very soft-edged manner. It had a nice glow! . . . I had captured the luminosity!

Then I painted that panel of deep purple, mauve, alizarin crimson, and a bit of burnt umber to see how I might improve the painting.

Instead, the panel, with it's deep-toned hard edge, destroyed the nice glow I had created. The painting lost it's luminosity. The lesson? . . . *When you get a good thing . . . stop!*

Regain the Luminosity by Cropping. (Detail)

Take out that hard-edged panel and let the soft, runny edges have a chance.

You can see in this detail how the second background wash dislodged color from the pigment of the flowers . . . letting it run down into the wet application created a neat effect which salvaged the ruined panel job.

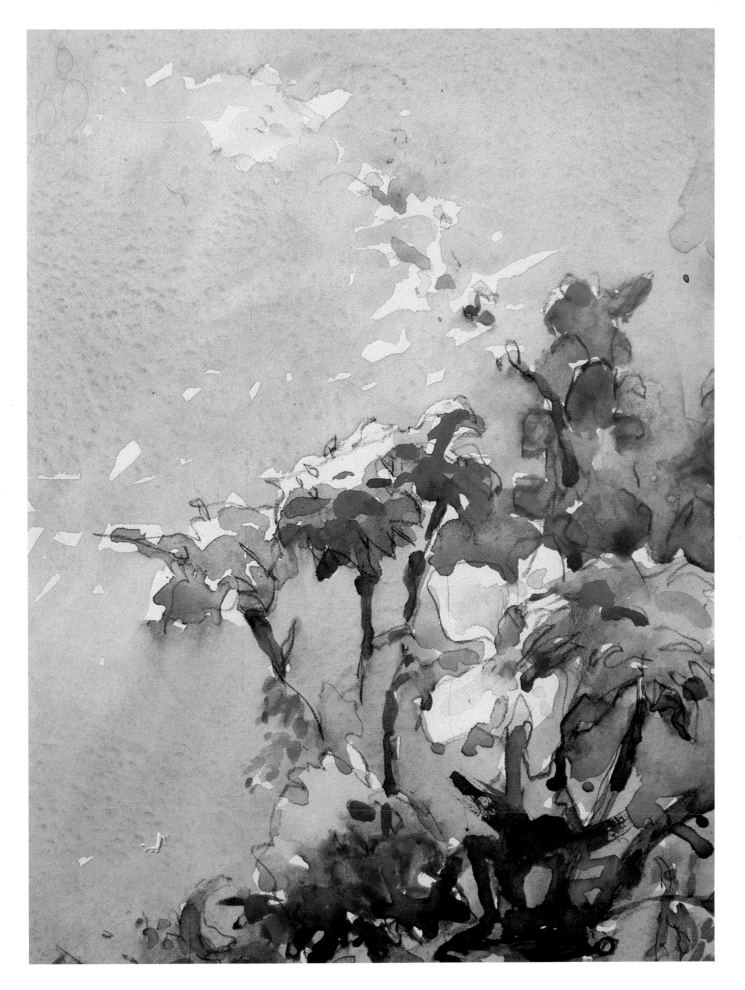

GET THE BEST ANGLE ON A STILL LIFE

Search for Patterns.

Look for design in your still life paintings . . . just as you would street scenes or landscapes. Walk around the motif and draw several compositions first. Then paint watercolors on ¼ sheet of good watercolor paper of your best compositions.

Make each new angle work as a painting. Invent, experiment, be daring! Look at the positions of the cutting board here to orient yourself to each of these seven different points of view. After you've done seven sketches like these, try painting each one in a different technique . . . wet over dry washes, wet-in-wet, etc. each with a different combination of colors. That's a tough assignment, but try it. It's the best way to learn the effects of various techniques.

Lay in the Background First. Then start your move from two dimensions to three by painting the shadow side of the objects only. Note the subtle changes where color has been dropped into the monotone wash. Note, also, how the intensity or relative brightness of the color affects its apparent position within the depth of the picture plane . . . that is, the brighter the color, the closer it appears.

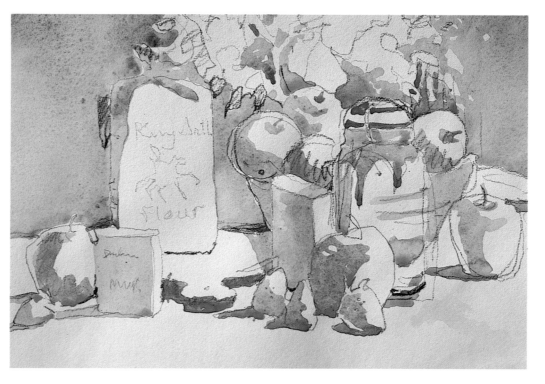

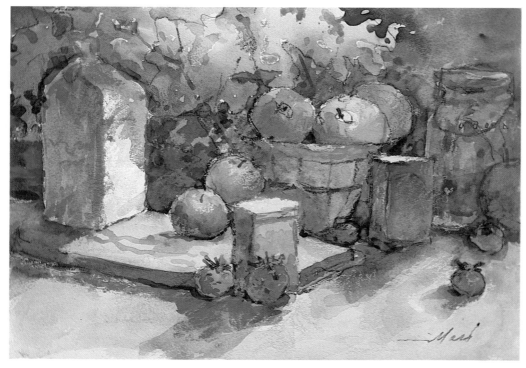

Start with Very Loose Washes. Then enhance the form's with touches of pastel after the painting is bone dry for the sheer brilliance of pure pigment. Add just enough pastel to cause a color vibration, a shimmer, where pure color hits more subdued tone, but let your previous color show through. Study Degas' pastels . . . the way he strokes his pastel *across* the form!

REPAINT THE SCENE... AND VARY ONE ELEMENT

Get into Your Subject with Sketches.
Probe the scene for a painting. Take time to make several studies of the birches, stone shapes, waterfalls, figures, negative shapes, diagonal thrusts, rhythms, accents. Search for a good composition . . . try to improve on nature.

Do You Want a Cool Painting or a Warm One?
Try one of each to see. Or you can start cool . . . then paint warm colors over it. Put rich, deep color into your negative shapes, but don't get too close to the realism. Keep it loose and poetic.

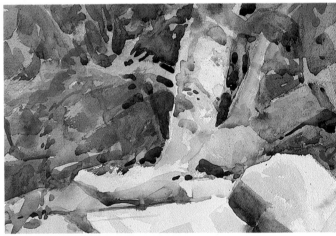

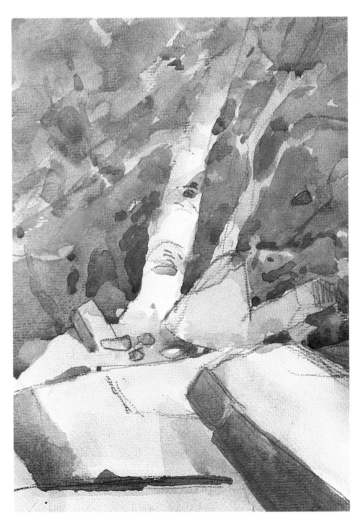

Try a Vertical Composition.
It yields a very different emotion from a horizontal one. A taller format gives the birches a chance to reach up and become more majestic. The horizontal format gives the great granite monoliths more authority . . . a chance to look more blocky and powerful. Experiment with different formats before you make a final decision on a painting.

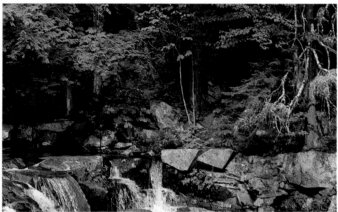

Compare the Scene with the Painting.
Having three different waterfalls was distracting . . . I painted one. The shadows were too deep . . . I lightened them. The diagonal tree limb was too far to the right . . . I moved it to the center. The forest seemed lonely . . . so I added two fig-ures. And I let the angular shapes of the stones by the waterfall inspire a repetition of similar positive and negative shapes in the forest. Note the decision to bring a green, mossy quiet look into this last study . . . you have several choices for your final painting.

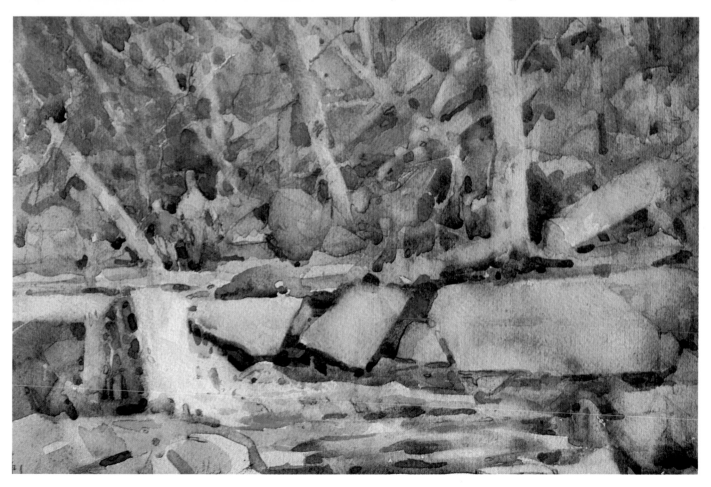

EXPERIMENT WITH HARBORS

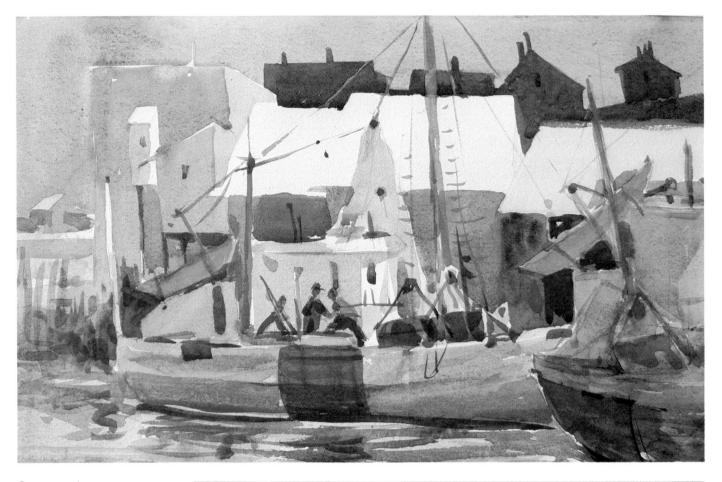

Shift Elements and Accents Within the Same Scene.
Try changing the emphasis, the focus. Shift the houses around . . . change their colors. Alter the shapes of the white roofs. Try a different trawler in a different position. Vary the shape of the fish house on the left . . . and shift it around to another angle.

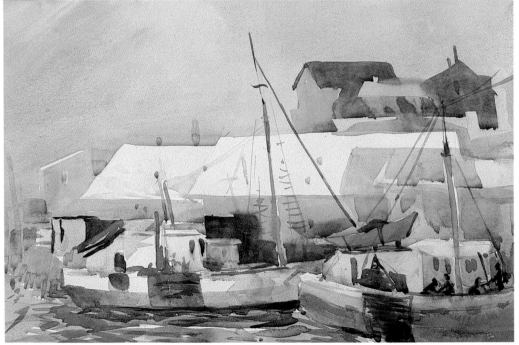

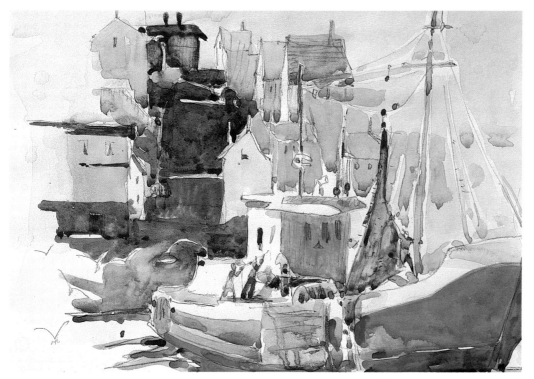

Build Your Painting from the Center Out.
Then work your sketch into a full-sheet painting. Make your whites sing by surrounding them with darks . . . the gulls, the sides of the houses in the low slanting sunlight. Balance the painting with the accent of that black rooftop on the right.

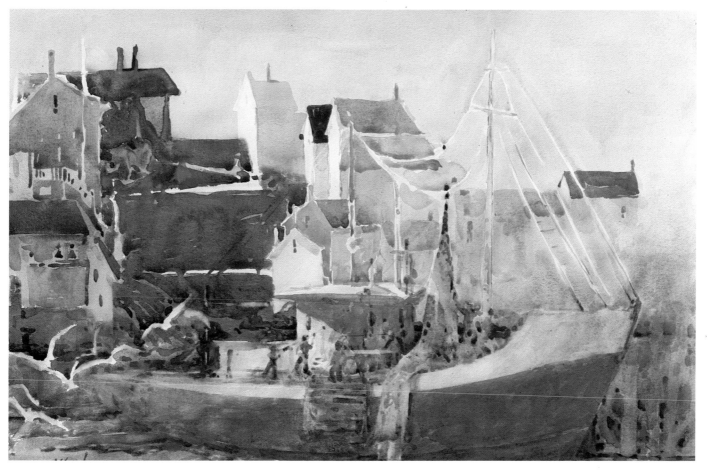

Invent Your Own color.
The houses are white . . . paint them a color. Cluster black accents together . . . the tree, gate, doorway. Shift the houses to the right to get in more trees . . . and paint some trees burgundy, some blue. Then mix both colors together for the shadow of the house on the left. Arch the line of the street and raise or lower the horizon line. Reserve a light area on the ground floor of the purple-brown house for a good design shape.

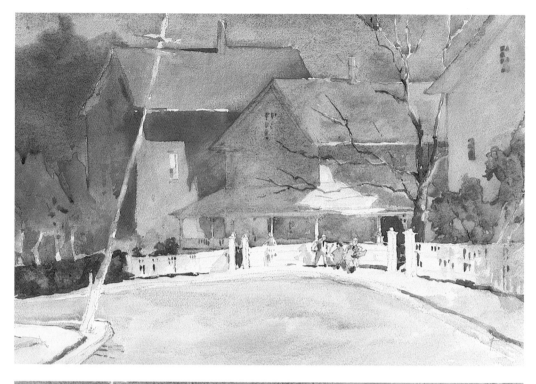

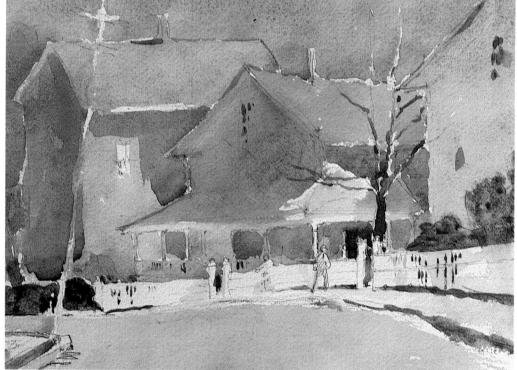

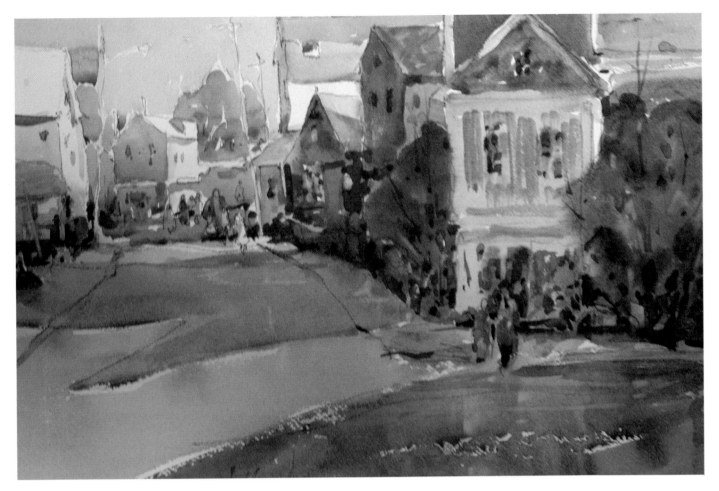

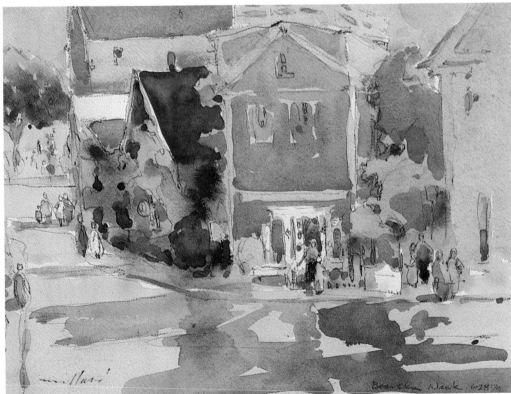

Move the Eye Across the Picture Plane . . . or into the Distance.

Shift the composition to the right and move the eye down the street . . . by using perspective . . . by adding figures . . . by shining a ray of sunlight on the distant buildings. Create interest in the puddles and their reflections, but subdue the colors there and simplify them . . . the interest lies elsewhere. Let the foreground puddle pull you into the picture, and let the middle ground puddle pull you to the left and into the distance.

Lessons in a Trip to Chinatown

Sketching in San Francisco's Chinatown

is an artist's dream! Who else has dragons on their lampposts? You won't believe the tasteful ornateness of the character of the streets' . . . and the signage . . . and the friendly people. Wherever you go, think design! The lessons are the same — you needn't be somewhere exotic to apply them. Select each pattern as it appeals to you and don't be shy about rearranging objects, colors, light patterns, *everything,* to better *every* composition. You don't hesitate to move an apple in a still life, why not here as well? (That's my chop, Millard in Chinese, in the lower right-hand corner.)

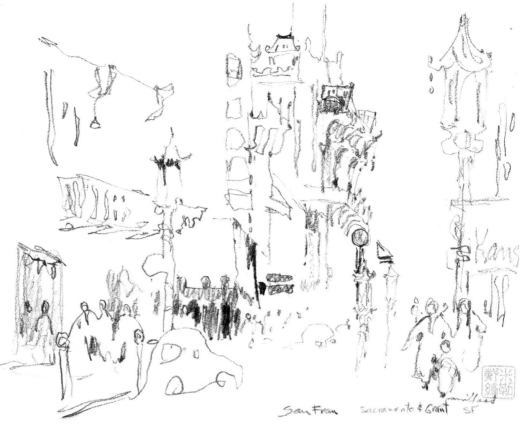

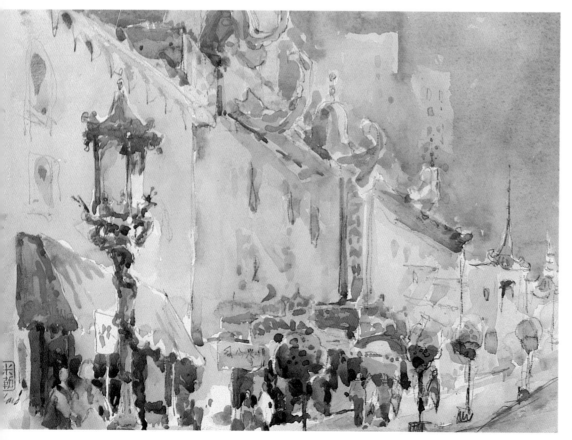

Concentrate Your Darks Along the Bottom.

Use a light and dark pattern with the dark tones behind your figures. Notice that there is a variation in figure tones . . . some are "lost" in shadow and there are just a few further out on the sidewalk catching that spot of sunlight. Also note that the greens are cool up front. The warmer greens recede against the "rule" toward the background. I've included just a hint of skyscrapers. The air is usually moist here, to the watercolorist's delight. Colors seem to respond beautifully on this 90-lb handmade hot-pressed paper. See how the negative darks are used as descriptive design . . . not just dabbed in? As you paint, think constantly of design and keep your paper on a slant!

LET YOUR EMOTIONS HELP YOU CREATE

Use What the Camera "Sees" as Information Only.
You still must create your own interpretation in your painting. Here, the light and the pattern of this building stopped me. Take a photo to record the detail . . . then make your sketch.

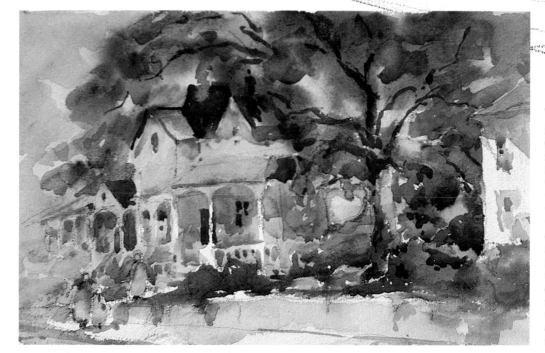

Sketchbook to the Rescue.
Begin a freehand/contour drawing in your sketchbook, and as you start to work, keep thinking of how you can make it *different*. Outline your structure and by now your mind is saying "let's tone off" the background. Next enrich the tree . . . smudge it with your finger or a tortillon to lose that last house into the smudge. Don't overdo your shading and get dirty. Your sketchbook has already moved you away from what the camera gave you. You are starting to feel some emotion. It's time to stop!

Transfer Your Emotions into Your Color.
Once your sketch conveys mood and some poetry, dive into your watercolors, working wet-in-wet with exciting first washes . . . dropping in color wherever you want design and value, but daring to alter the color from what you're looking at. Remember, you are designing with an artist's eye. Note the figures . . . size, position, color, edges . . . they all help to create *mood*. Your vertical whites and clean, rich, darks concentrate on and give structure to your center of interest.

EXPLORE COLOR IN YOUR PAINTINGS

Interpret the Subject in Your Sketchbook.
There is a venerable collection of crumbling structures in Monterey, California, called Cannery Row. I call my series of studies and watercolors and oils *Steinbeck's Bones* in honor of the author who immortalized this place. Think of possible titles as you work. It will help clarify your main ideas. Begin by searching for an interpretation of the subject in your sketchbook. As you work, your excitement will mount . . . you're looking for design, sorting out those many facets, feeling a lot of power in these old buildings jutting into the sea. Working intuitively, begin a second course of attack . . . *abstract the subject!*

Backlight the structures to pull the forms together in a silhouette. Do your carbon drawing in a repetition of heavy vertical strokes . . . then switch to horizontal in the distant group. Don't use the smudging technique since it brings a softness not in character for this study.

Record the Details.
I didn't want to be influenced by a photograph, but I knew I'd be overstaying my welcome at my lunch-time vantage point. I wanted to capture the details before I left so I'd have a record of all the solid forms and angles that inspired me.

Let Your Sketches Inspire You.
As your sketches multiply you gain an intimacy with your subject. Now pieces of white are being emphasized . . . negative and positive design pieces in the understructures . . . rhythms in the curves of the waves and the sagging roof, arched shadow forms. An idea is coming! You are beginning to see the subject as a wedge between the sky and sea . . . material for paintings.

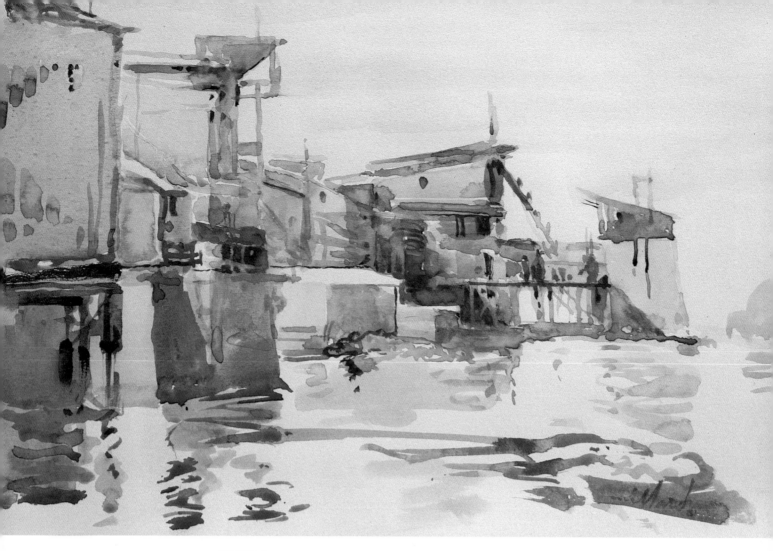

Think About Color Combinations Now.

When you have a subject that has great appeal, such as this unusual collection of shapes, consider creative color variations from the *beginning*. Don't let the colors you see before you (see photo) throw you off stride. Your sketches of shapes and patterns have lifted you to a level of exciting creativity! Dream up an unusual color combination. Here the roof is raw sienna, burnt sienna, and manganese blue. The building is Davy's gray brushed lightly with raw sienna. The lower piers of the three buildings are a mixture of cendre blue, ultramarine blue, and Davy's gray. That same mixture is in the water where the piers reflect into it. Remember, you've got 40 colors to work with! Notice how the colors diminish as they approach the fog at sea.

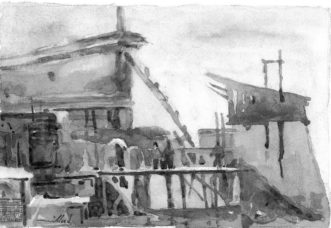

Crop . . . and Create a New Painting

This is a "come to life" stage setting. This cropped version of the painting has become a complete new painting in its own right. Degas frequently added strips of paper to his pastels . . . I'll bet he also cropped them! This painting reveals a tiny touch of sap green and burnt sienna in the negative shapes. That same mixture was dropped here and there into the wet Davy's gray and raw sienna brushstroke.

CREATE IMPACT WITH COLOR

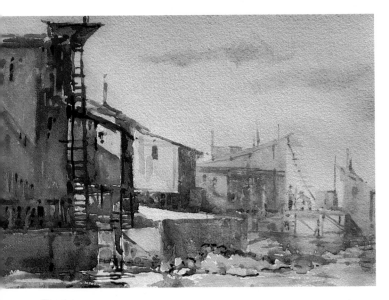

Put Impact in Your Design with Color.

Use mauve and burnt sienna to create deep colors on the buildings . . . right up in the foreground. Touches of ultramarine blue are in those strong, clean shadows. Cendre blue, ultramarine blue, and a touch of mauve goes into the blue side shadows. Get brown madder alizarin into these mixtures toward the base areas and second building. For the building in the background, lay in a wet wash of mostly Davy's gray, with some raw umber and phthalocyanine blue, and let it get weaker as it recedes. Include a figure . . . a hot spot of cadmium scarlet . . . let it bleed into the wet wash on the building. Increase the power of your colors by contrasting the Davy's gray with touches of permanent rose and cendre blue in your sky patches . . . and the sensitive, pale colors — raw umber and Davy's gray — in your rocks and water. There are touches of viridian in the deepest values of the middle building and in the pier base and water reflections. Feel free using your colors, within the framework of this strong pattern, but relate each color carefully to its neighbor, just as musical tones are related to achieve harmony.

Use Color Creatively.

Your ability with color increases as you become more intimate with your subject. This is your third variation on this theme, so throw your hat in the air and shift into high gear! Think of this challenge as a symphony . . . think of all the colors as the various instruments . . . you are the composer and conductor. This is Khachaturian's *Firebird Suite* . . . an emotional, vibrating sequence of color bursting at the seams. Select all of your colors with affection! Choose colors because of the way you feel about what one color does when it's mixed with another. For instance, if I feel that a color is too raw, I'll tone it down with raw umber. I also use raw umber to cause a vibration, or shimmer, in a purer hue when it's beside a brighter hue. For instance, there are touches of raw umber in the sky of Davy's gray and yellow ochre to set off those delicate clouds of cendre blue and permanent rose. The building on the left has raw umber with a mixture of mauve and burnt sienna that enhances the combination of four or five yellows in the curved roof . . . making that pocket of yellows more brilliant.

The water at the bottom left of the painting starts off as a wash of viridian green and manganese blue which then gets a touch of watered raw umber . . . then bleed some olive green . . . then a bit of raw sienna mixed with the slightest bit of emerald green . . . add raw umber with touches of Indian yellow in that odd little patch of water. When this first wash is dry, lay a second wash to create the green wave marks, using emerald green and viridian green. Make this second wash brighter by going over the first wash which contains thin, glowing raw sienna. Here, transparent over transparent can get brighter . . . not duller! Slant your paper always, to keep your colors clear! Keep it on the same slant as it dries.

As you move down the piers the buildings are the white (that's the paper) shed and pier surface . . . a setting for those small figures, your center of attention. The small roof is cadmium orange bordered by burnt sienna. The next building is the same lavender as the cloud — permanent rose and cendre blue. Under it is a fish cart of Venetian red, cadmium red, and alizarin crimson, near the figures.

Pieces of permanent rose and alizarin crimson are over the Winsor violet and burnt umber shadow side. The sheds are burnt sienna and raw umber with cadmium orange dropped in wet . . . a touch trickles into the water. At the far right end of this version of Cannery Row, use pale cendre blue and emerald green, with raw umber, burnt sienna, and cadmium orange.

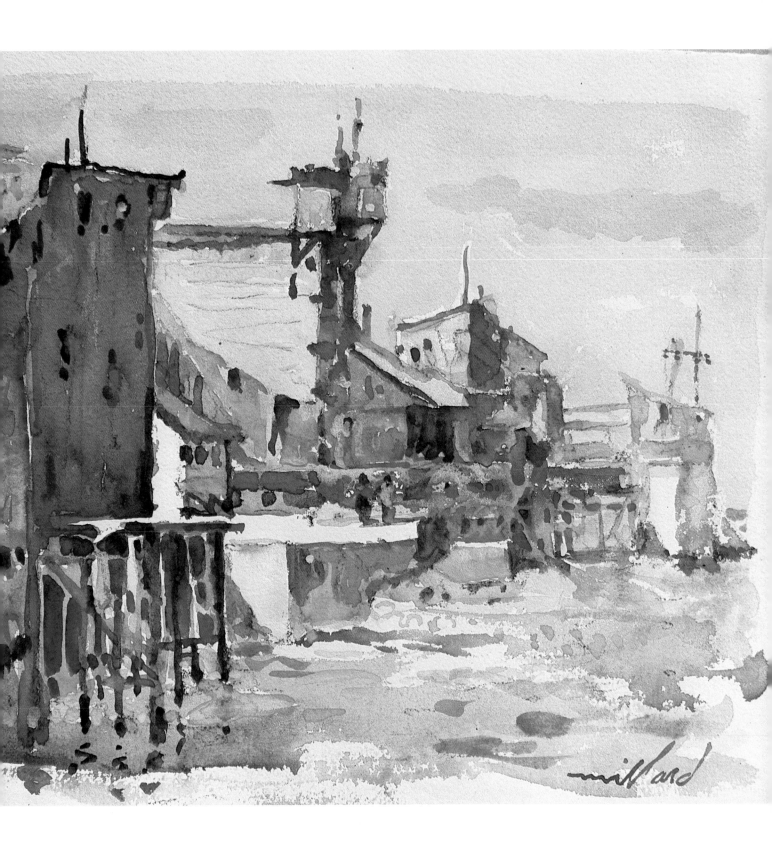

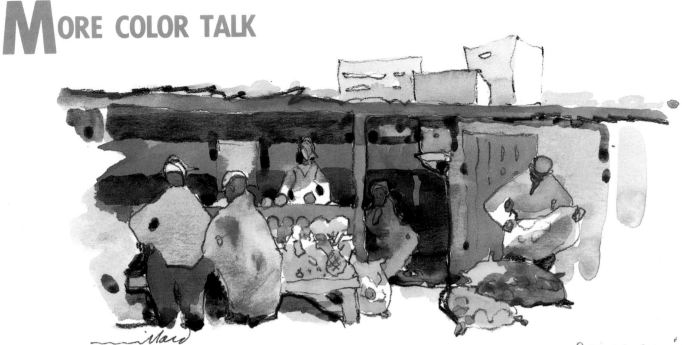

Ramsaran's
Market

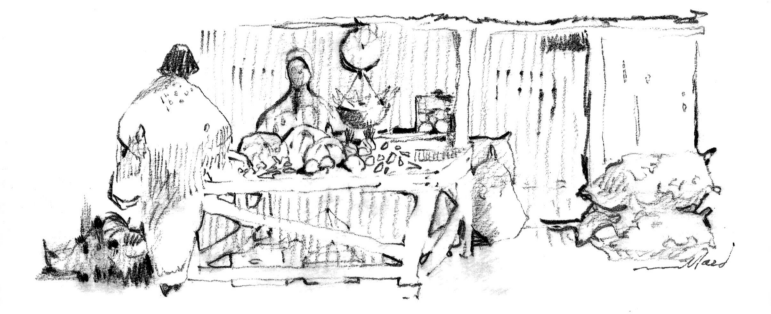

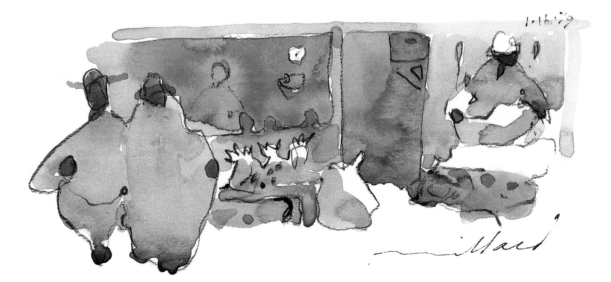

A Page from the Sketchbook.
Invent your own color combinations and your light and dark patterns (a photograph of this scene would have shown a dark maroon structure).

To paint the fascia board roof use, from the left, lavender (a mixture of violet and Davy's gray), then pink rose doré tint, cadmium scarlet, cadmium red(R), alizarin crimson, and end with cobalt violet at the right. Apply these colors wet-in-wet to keep them soft.

The post in the sunlight is cadmium orange bleeding into cadmium scarlet.

The panel around the door and the figure are cobalt violet and Davy's gray (paint it over the door area as well).

Make the door rose doré alizarin and permanent rose tint. Apply it over the previous wash that you've allowed to dry. Use this mixture for the counter front too.

Make the dress of the figure in the doorway progressively bright in color: Go from burnt umber to burnt sienna to Chinese orange to cadmium orange.

Color the sack in the sun a bright Indian yellow, then make the sack above it a warm burnt sienna.

The Carbon Sketch
(middle) provides detailed information for a future painting.

The Bottom Sketch
is meant to be just a simple tone poem. For the inside of the booth, use Davy's gray with tints of Winsor violet . . . apply a touch of raw umber on the wood box in the upper right-hand corner, wet-in-wet.

Color the market front and fat lady with tints of Davy's gray and rose doré.

Then make her companion Davy's gray with rose doré bleeding into a wet wash on his shoulders and down his left side.

The other colors here are raw umber, burnt umber, and burnt sienna, with touches of cadmium orange and Chinese orange. *Use* those 40 colors!

(Do you recognize these sketches? They were on the cover of *Joy of Watercolor*.)

Making the Painting.
Your primary decision here is to make the dominoes player on the left your hero in the painting. Silhouette him against an almost white sky piece composed of palest Naples yellow and emerald green. Use scarlet tints bleeding into a mixture of rose madder and lavender to create the setting for the other players. Color the heads from burnt umber to burnt sienna. Use the arms of your figures to direct the eye toward the fruit stand.

Make the market interior a mixture of Winsor violet, Davy's gray, and Naples yellow. Let your permanent rose wood trim bleed into this interior, then let it dry. Add deep accents of burnt umber . . . wipe it wet to create soft edges.

Let the market exterior wood trim vary from permanent rose to mauve-violets.

Play games with all your figures . . . make hard edges and soft edges . . . make some figures very clear and lose some into your background wash.

The arm of the man on the left guides the eye down the slanted table brace toward the dominoes players. Those deep negative accents under the table are a counterpoint to the players' heads.

Change your sky colors from cool manganese and cendre blue to warmer ultramarine blue, violet, and raw umber, left to right.

Work fast (this was painted from memory) to get emotion in your watercolor, but keep the creative side of your mind cooking all the time. Use what you've learned from art history that's stored in your third mind for easy recall!

There will be many vantage points along a street from which to make a painting. Follow your intuition as to what appeals to you, then put the three essential pieces together . . . design (pattern), value, and color . . . and create a painting. The combination of these three elements, listed in order of importance, is what helps you decide how to paint . . . whether your subject is a street scene, still life, landscape . . . whatever.

Think First . . . Then Simplify What You See.
See your figures in your mind's eye . . . your artist's eye . . . before you sketch. "See" the negative darks behind these figures . . . in your mind. Capture the local charm of the iron balcony and underbraces. Create the effect of distance . . . force your viewer to believe what you want. Remember, you're the conductor of this piece of music. Give your painting a geometric structure. This one is based on triangles. Notice how the cendre blue on the third building carries the viewer's eye back. Try closing one eye and covering the blue building with your finger tip. You'll see how, without that cendre blue, the viewer's eye just wouldn't go as far back. I use this "finger test" in just about every painting I do, and I constantly teach this.

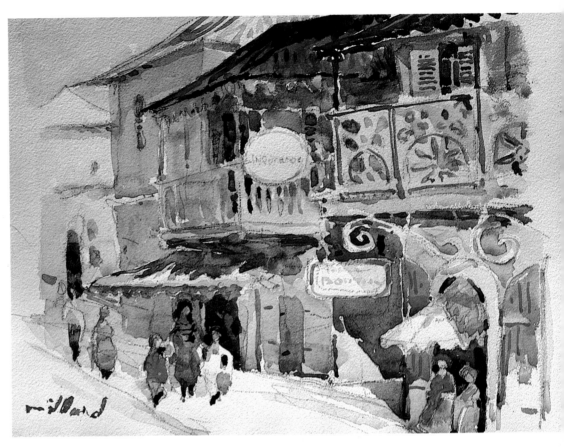

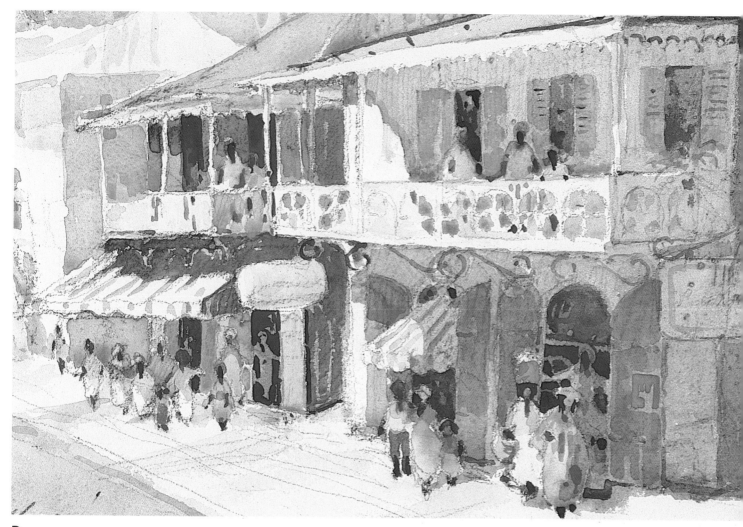

Design Is the First Element of Creating a Painting.

The design here is four strips of white accents and two strips of black accents. Make diagrams of the accent structure — one for the black, one for the white. See this geometric alignment of accents before you start your sketch . . . or work this out first in your sketchbook . . . then into your painting! Design your figure groupings. Start with the larger figures in front. Although green is a deeper value . . . orange-pink is a more exciting color! Design a color sequence using the inventiveness . . . of the right side of your brain. Go from orange to pink to rose in the first building . . . then from lavender to blue to green in the second building. Make your road a mixture of orange and cobalt violet. Make another finger test by first covering the pink building . . . then the green. Do this to see the different effects back and forth like a pendulum.

MAKING YOUR CHOICES WORK

Create Your Own Composition.

Choose the best angle from which to paint your subject . . . this is part of thinking design. For this painting, I was far from the Frenchtown Cathedral. For the painting opposite, I was close up. Poke around your theme . . . don't settle for the easy way out, taking a photograph and copying it in watercolor. No dice! Simplify what you see. Choose the ships from along the dock that *you* want to paint. The light is coming from the left . . . do you want to keep it that way? Look at all the devices I've used to take the eye back to the cathedral. How many can you count? Colors . . . perspective . . . angle . . . values . . . and don't forget those plunging brushmarks in the sky.

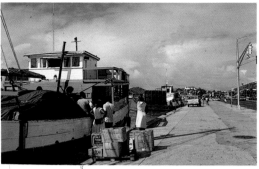

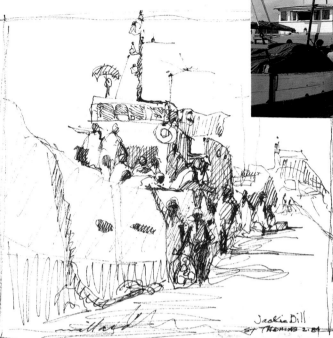

Use pigment-rich washes in your sketchbook where it's easy. When you try the painting full sheet, you''ll be accustomed to working with washes loaded with pigment. See the importance of that little hill on the right? Give it the finger test. It keeps your viewer's eye from wandering out of the right-hand side of the picture.

I made separate sketches of ships along the waterfront, and put them in position one at a time. You can't do that with a photo!

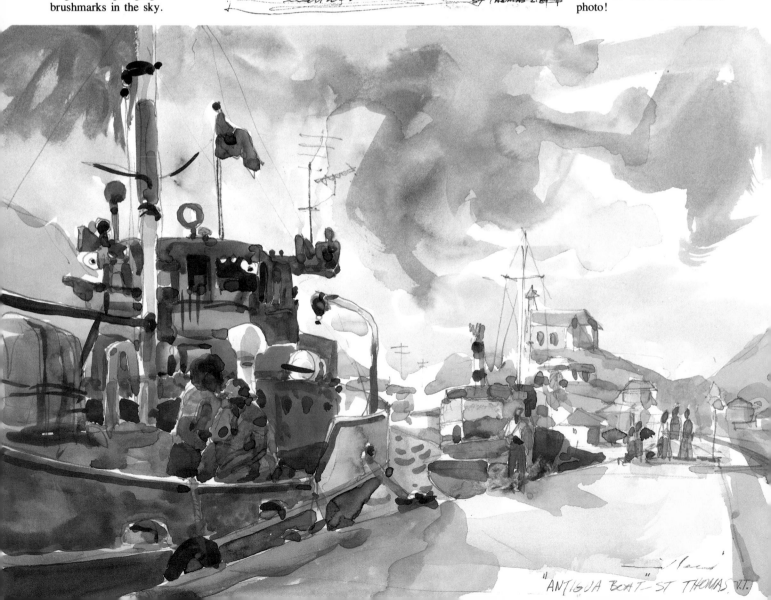

"ANTIGUA BOAT" ST THOMAS, V.I.

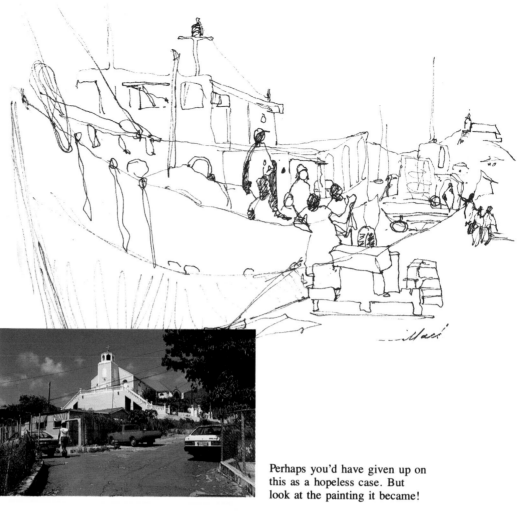

. . . To Enhance Your Subject and Design.

I couldn't see the cathedral from the street, but from the Normandy balcony I had a wonderful view! (Ask permission to sketch . . . and tip the waiter!) All these buildings were different colors . . . turquoise, green, tan, yellow . . . but select colors that complement your design. Change that bright red cathedral roof to a gentle rose madder to create a sense of aerial perspective, and apply it against the edge of the sky wet-in-wet to keep it soft. Lift the cathedral up and elongate the stairs to get the majestic effect seen here. Think light! Look at how the changing values and colors in the sky enhance the quality of light moving across from left to right, lighter to darker.

Perhaps you'd have given up on this as a hopeless case. But look at the painting it became!

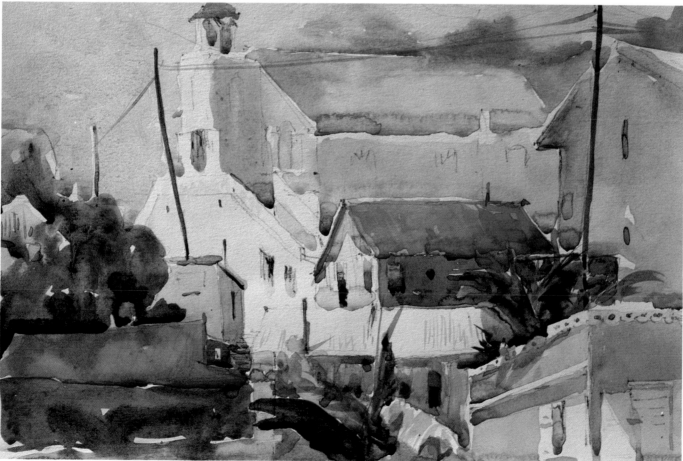

Harmonize the Elements in Your Paintings.
Let's compare five paintings on the treatment of three different elements: figures, trees, and whites. The point is, any new element can work if you arrange your painting to harmonize with it.

Figures. In motion . . . coming toward the viewer.

Tree. Repeats the shape of the roofs with foliage; the telephone pole creates distance, as does the distant roof mimicking the shape of the mountain.

White. The major design element, making the painting majestic.

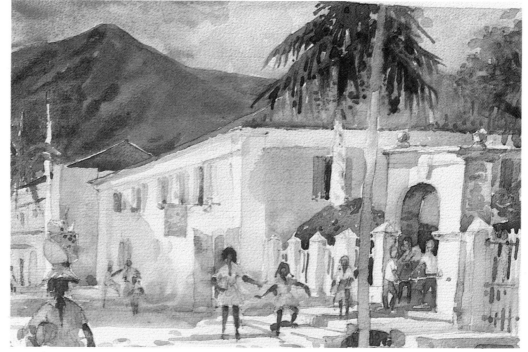

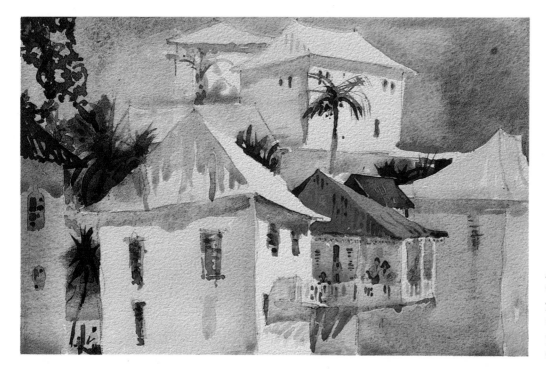

Figures. Quiet, subdued center of interest.

Trees. Pendant and decorative at left . . . decorative at top.

White. Creates brilliant patterns of sunlight.

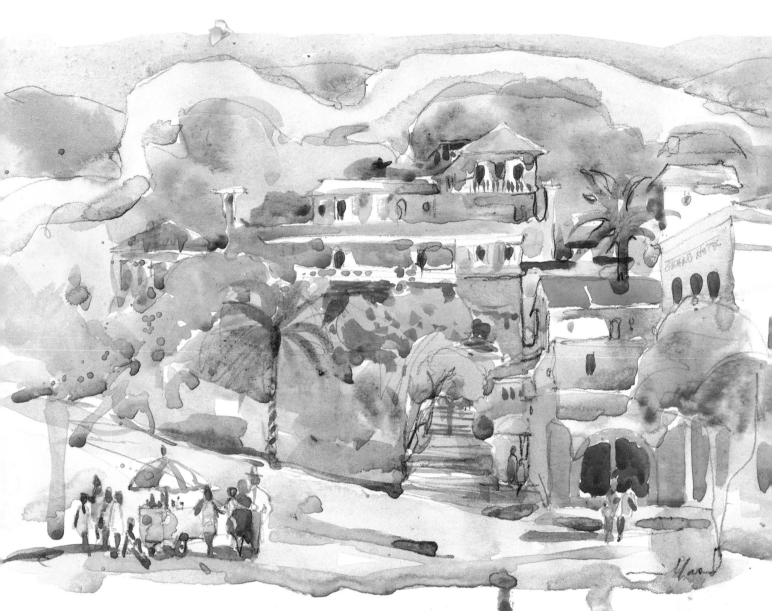

Figures. Push-pull . . . left group versus right couple; left group contrasts with the foliage and buildings, yet belongs. Do the finger test on this group.

Trees. Tapestry setting around pink, white, and red buildings.

White. Carefully positioned for visual motion.

Figures. They reach forever back along the beach.

Trees. Of major importance . . . the dominant palm tree actually frames the picture. A loose palm in the upper right-hand corner keeps the eye from wandering out of the picture.

White. The edge of the palm tree repeats the curve of the surf — both are lined in white.

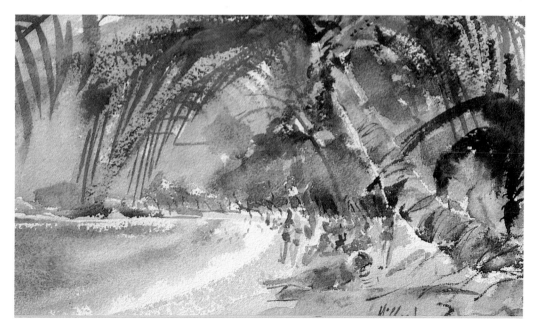

TRY DIFFERENT VIEWPOINTS OF A SCENE

Paint One Version.
Use the building's local blue color, but invent the figures and purple roof. Don't fall for all those green palm trees. Make your own poetry! The light is coming in from directly overhead . . . bounce ground light reflections up to accentuate the stairs and pilings. This is a distant frontal view of the custom house on St. John.

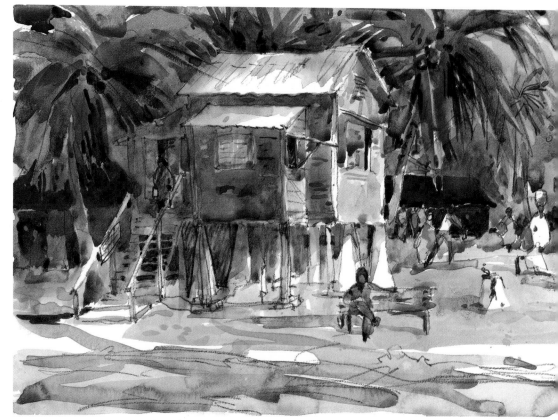

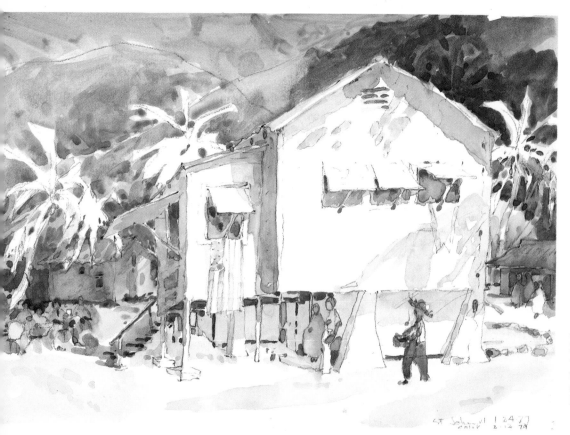

Then Change the Viewpoint and Color.
Start your "standard" watercolor, but this time keep the color off the building and palm trees. Just do the mountains and shadows first . . . improvise colors . . . not what you're looking at! Leave the trees white if the design demands it, then stop painting before you add color. This scene is front lit.

WORKING IN A SERIES: PAINTING BOTTLESCAPES

An Aid to Technique.
Painting bottlescapes is a valuable way to practice capturing form and light in a transparent and sparkling manner. Painting a bottlescape offers:

1. A chance to study those color mixtures that portray tone nuances of translucency where you are looking through a bottle or bottles to background light or color changes.

2. Where highlights should be placed on vitreous objects to denote form . . . exactly, where the turning point occurs. This is similar to locating the highlight on an eyeball in portraiture.

3. A chance to practice painting how and where light passes through transparent materials from light source to background . . . and from background to the viewer.

4. The knowledge of how to add a bottle of wine to a still life so the sparkle and transparency of glass adds a pleasant contrast to perk up the more solid qualities of the bread and apples routine. Studying bottlescapes will definitely improve the quality of light in your still lifes.

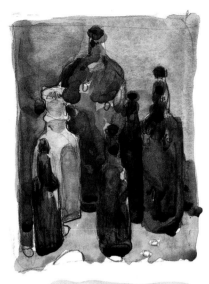

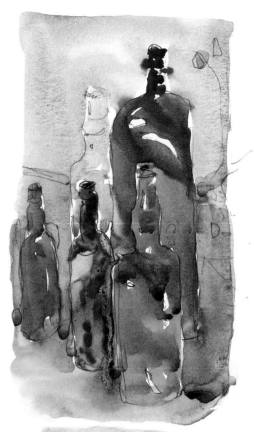

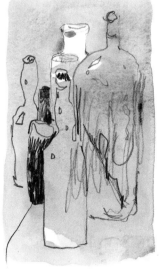

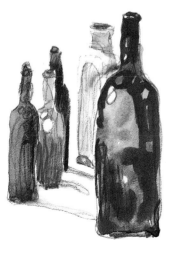

Work Intuitively.
This is a quiet, intuitive search . . . a looking . . . a probing . . . into seven old sea bottles from the harbor bottom at St. Thomas. I made these sketchbook studies as a bad weather "captive" during a three day visit on the island. These are preliminary sketches for future paintings.

PAINT BOTTLESCAPES TO STUDY FORM AND COLOR

More Bottlescapes . . . Design, Value, and Color.
To achieve transparency, let your background wash run right through your bottles. Keep your highlights as the white paper by painting around them and any other special light-struck planes and edges. Don't use masking fluid. It introduces an artificial attitude to your work and besides, it's non-painterly! Study these factors:

Backgrounds. See how they differ in the use of wash techniques and design elements.

Bottles. Play with the endless variety of form arrangements. Build up your sequence of washes, wet over dry . . . wet over dry. Design your negative areas . . . create patterns with the shapes.

Lighting. Use only stage lighting techniques . . . spot, side, back, and silhouette. If you use front flood lighting you won't get any good shadows . . . it's deadsville. Don't use it!

Color. Work to get mystique, poetry, power, and subtlety into your sketch . . . and into your painting. Now, include this still life form in your repertoire. Study Morandi. He spent his lifetime painting bottle arrangements, and was a master of negative shapes and exquisite color.

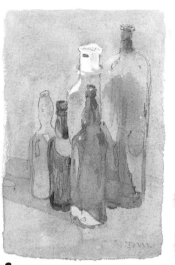

Sea Bottles 1. (Above)
Lay in the background wash . . . cerulean blue and light red with a touch of cobalt violet added as you move to the right, and let it dry. Paint each of the bottles here differently. The largest bottle is ultramarine blue with cobalt violet added wet-into-damp-wet in the center. Note the two spots of cobalt violet (FB). In the dark bottle, leave a provocative pattern of light. Use cobalt green, sap green, raw umber, and some manganese blue at the base. The second bottle from left is cobalt violet. Let it pick up some of the carbon from your drawing. The bottle at left is manganese blue with a slight touch of cobalt green.

Sea Bottles 2. (Below)
Lay a pale tone of raw umber and Davy's gray over all but the white areas. Lay in a second wash using the background mixture from the previous bottlescape. Again, avoid the white spaces. Drop in at top left a mixture of cobalt violet, cobalt blue, and ivory black into the wet background and coax this mixture down onto the shoulder of the largest bottle. Add color to the background at right with touches of manganese blue, cerulean blue (G), and raw umber. Run this mixture in patterns onto the base of the square bottle. Paint the darkest bottle sap green and burnt sienna. The bottle at far left is Winsor violet and ultramarine blue. Use this mixture to create your deepest accents overall.

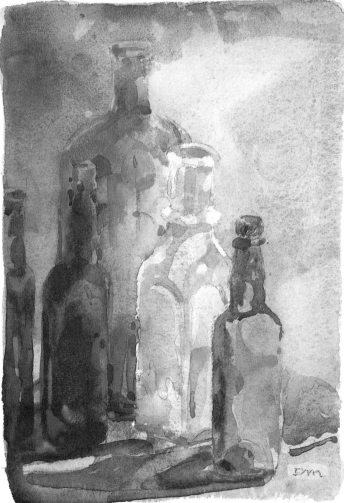

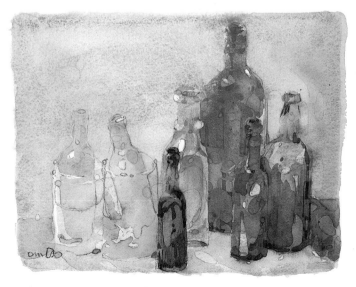

Sea Bottles 3. (Left)
Your *background wash* here is cerulean blue and light red with emerald green tint added wet-in-wet on the third left . . . the tint is stronger in the second and third bottles. The background tint on the extreme right side is sap green and burnt sienna. Deeper glazes of this mixture are on bottles 3, 6, and 7. *Bottle No. 5* is based on ul-tramarine blue with touches of mauve, lamp black, and cerulean blue. There's some pure cerulean blue and a spot or two of (FB) cobalt violet, too. *Bottles 3, 6, 7* and the side shadow at right are cobalt green and raw umber in cool dark grayish patterns of glass. *Don't overwork* your washes. Let each wash dry before glazing another.

Sea Bottles 4.

Mix a big puddle of Naples yellow, Davy's gray, sap green, and burnt sienna. Add a spoonful of this mixture to a large clear puddle of water to make your background wash. Wash this over everything but your white areas. Let it get dry as a bone. Make a second mixture of manganese blue and cobalt green and lay it over everything except the white rim of bottle 6. Let this wash get bone dry. Next lay in your third wash in very pale tones. Build up your background designs using color from your first mixture. Now lay in a first wash on bottles 1, 2, and 3 using your first mixture. Then begin a series of increasingly deeper glazes, always applied wet onto bone dry color. Apply quickly — once — don't dally or you'll pick up under color! Use sap green, burnt sienna, ivory black, cobalt violet (FB), and Chinese orange. Next, to do the blue bottle, use a careful buildup of shapes and pieces. Cover the entire bottle with a first wash of Davy's gray and cobalt blue. Then take your larger areas of greens and blues, leaving design and openings of previous colors. To finish, make smaller accent colors if you have the patience. Note how touches and dots of bright, warm color opens up the darker tone quality of the painting. These are Indian yellow, new gamboge, and Chinese orange.

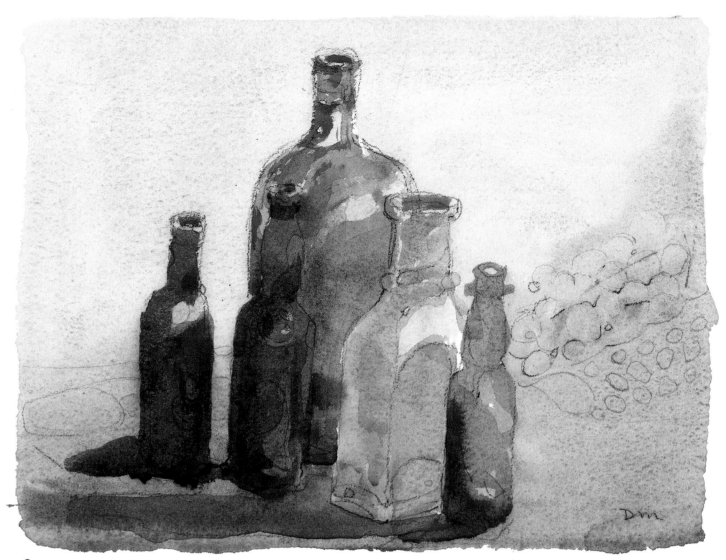

Sea Bottles 5. (Above)
Mix a background wash of
cerulean blue and light red. Lay
in subsequent washes of ultra-
marine blue, cobalt blue, and
cendre blue, using bits of the
first wash, keeping it very very
pale. These same blues go into
the bottles in deeper tones,
toned down further with a touch
of raw umber. The darkest
bottles are sap green, burnt si-
enna, and ivory black. Use the
same combination in the lighter
green bottle. Put two touches of
Antwerp blue (you can use pht-
alo) in the big bottle — one on
the center shoulder, the second
near the base.

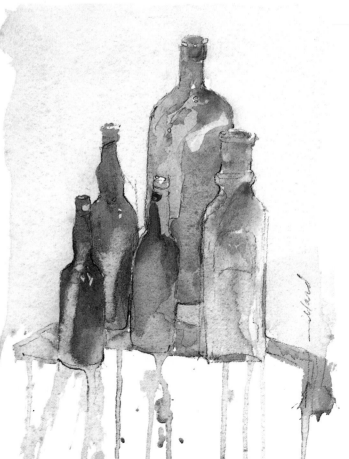

Sea Bottles 6. (Left)
Mix a big puddle of manganese
blue, cobalt violet, permanent
rose, and Davy's gray with a lot
of clear water to make it very,
very pale. *Stir before each use.*
Lay a second wash over all the
bottles except where you want
your first wash, now dry, to
come through to make high-
lights. Make the bottle at left a
deeper toned mixture of mauve,
burnt sienna, and lamp black.
Paint the next two bottles cobalt
blue, raw umber, and cobalt
green. Use this mixture to color
segments of the two bottles at
right, where you will also add
more color on the neck and
shoulders with touches of
mauve and ultramarine blue.
The right-hand bottle gets a
limited wash of ultramarine
blue on its shoulder and a swipe
of manganese blue popped in
wet-in-wet. Let everything run
at a steep angle and don't be
shy about guiding your drips to
make a good pattern look acci-
dental.

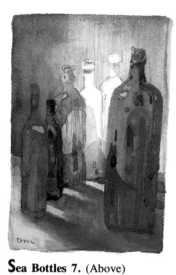

Sea Bottles 7. (Above)

Mix a *background wash* of cerulean blue and light red (mix before each brushful is added). Lay it in on all but your white areas, then quickly add some manganese blue on the extreme right (but not over the big bottle) and ultramarine blue, mauve, and ivory black on the left. Some of this wash goes over parts of bottle No. 3; after your previous washes are dry. Note that the first wash is still evident on parts of bottles 3, 4, and 5.

The *red bottle* is mauve, and permanent rose. Ivory black starts near the bottom . . . cobalt violet is added wet. Use Winsor violet and ultramarine blue to create deeper accents here. Bottle 2 is burnt umber with wet touches of sap green, and mauve. Note touches of yellow ochre in the shadow near this bottle. Bottle 6 is a buildup of cobalt blue, Winsor violet and mauve, with some ultramarine blue, and violet on the left and cobalt violet and rose madder toward the right. Be careful to save highlights between the bottle bases.

Sea Bottles 8. (Below)

Mix a large puddle of cobalt violet and cadmium orange with a touch of Davy's gray. Wash a spoonful of this mixture over all the bottles except the white ones. Go over the entire paper with this mixture except the white shapes, the rear jar, and the highlights on the second bottle. Use mauve and cobalt violet (FB) to paint the tones in the red bottle; use lamp black for the deepest touches. Then, bring burnt sienna washes and touches into play. Finally, use a lavender mixture of Winsor violet and lamp black to overglaze the biggest bottle. Add ultramarine blue for the deeper touches at the base. Use a razor blade to scrape out texture and a broken light pattern.

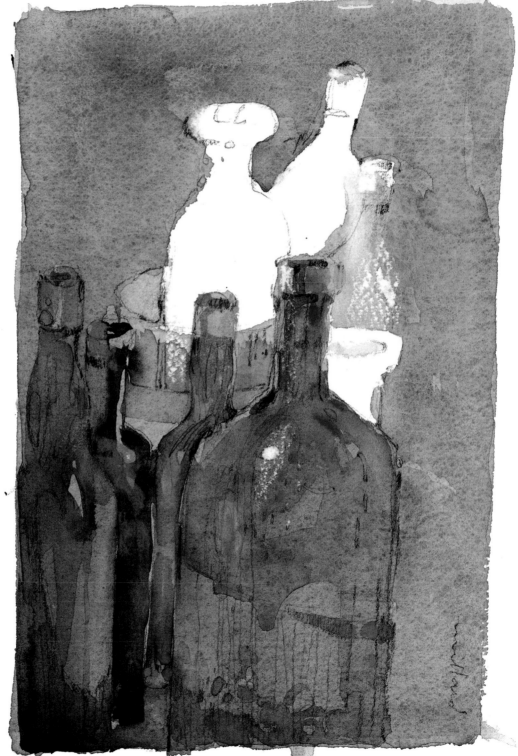

DEVELOPING AN IDEA INTO A PAINTING

Plan with Your Mind's Eye.
You have decided to paint a still life . . . a series of busy, interesting, interrelated shapes cascading out of the left side to contrast against the quiet, simple tones in the right-hand shape. An egg, bread, onions, wine, and apples . . . country fare. You are planning this idea for a painting of humanity . . . everyman's meal. This was inspired by Chardin, an artist who brought honor to humble themes.

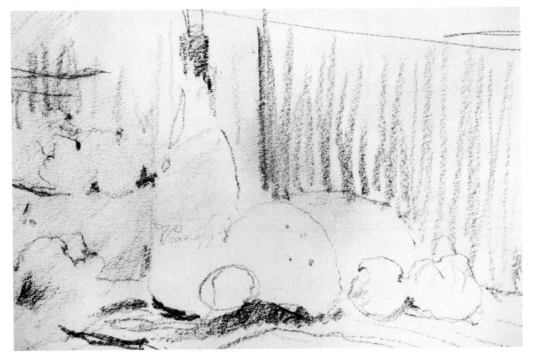

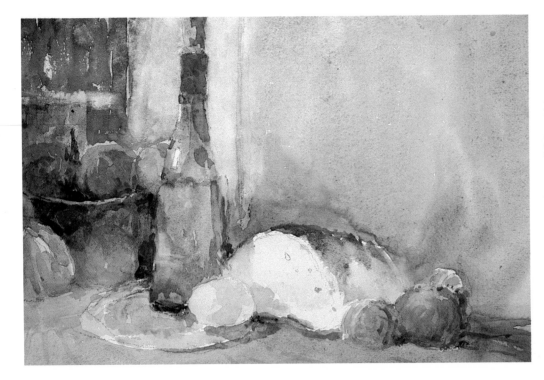

Put Your Bottlescape Practice to Work!
You want the bottle to have a good vitreous quality to bring a snap to the dull finish of the bread, pewter, and onions. Place your bottle on the rabatment to create a square within the rectangle. Let the apples fall off to the left, into the background. Enhance the luminous quality of the bread by contrasting it with the mellow, quiet tones of the background, right. Squint! That egg and bread have become one shape, as the apples and pantry have. Those seeds on the bread crust are worth $40.00 in terms of the interest they bring to the painting.

Try Switching the Media, Too. Let your watercolor inspire you to do an oil painting . . . one about 12″ x 16″ (30.5 x 40.6 cm) will do. Change the bright morning light to a soft afternoon glow. Use your mind's eye again. See it before you paint it! See if you can acquire or borrow a copy of Charles Reid's *Flower Painting in Oil* (Watson-Guptill). It's the greatest book on the transition from watercolor to oil. He makes it easy by mixing a lot of medium in his oil paint. Unfortunately, this book is now out of print, but you may be able to find it in your library.

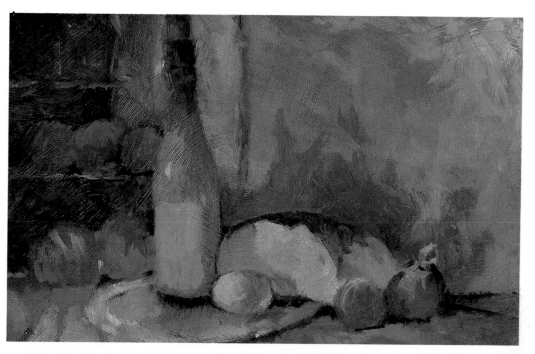

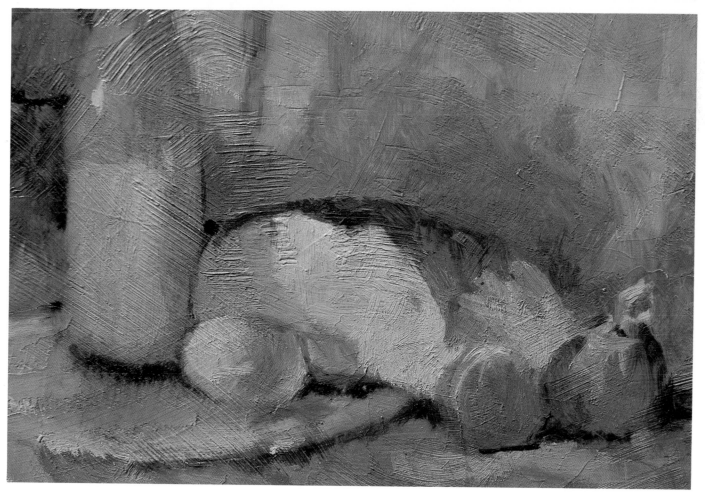

WORKING FROM YOUR MIND'S EYE

Train Your Memory.
In many areas, people resent or prohibit photographing or sketching them. It's an invasion of privacy . . . don't step over the line!

Here's a chance to visualize a painting. You can be inspired by the essence of the scene without being a slave to the reality of your camera. You can make your own poetry from what you see in the first flash just by remembering it. This collection of marbi bottles (marbi is a Caribbean soft drink), fruit, and vegetables, was observed at the St. Thomas marketplace. No sketching allowed here! This series of paintings was done from a black and white memory sketch. They came from my mind, not from objects set up in a still life. Look at what working in a series can do.

Working from Memory.
You're composing as you sketch in carbon pencil away from the scene.

Shapes and Light.
Now use monochrome washes to do a value study of shapes and light from the memory pencil sketch. Mix a large puddle of raw umber, cerulean blue, and Davy's gray. Trail this puddle over and around the white shapes you've delineated in your fast, spirited freehand carbon sketch, but that you saw in your mind first. Drop touches of mauve and burnt sienna into this wash. Work to create an interesting abstract white shape in this monochrome.

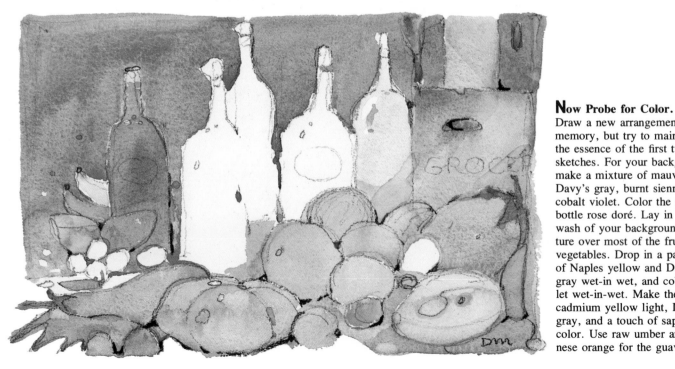

Now Probe for Color.
Draw a new arrangement from memory, but try to maintain the essence of the first two sketches. For your background, make a mixture of mauve, Davy's gray, burnt sienna, and cobalt violet. Color the pink bottle rose doré. Lay in a weak wash of your background mixture over most of the fruit and vegetables. Drop in a pale wash of Naples yellow and Davy's gray wet-in wet, and cobalt violet wet-in-wet. Make the lime cadmium yellow light, Davy's gray, and a touch of sap green color. Use raw umber and Chinese orange for the guavas.

Design with Color.

Explore the second and third dimensions . . . that is, pattern and depth. You're sketching from memory again. Use a single weight line. This image is coming out of your mind . . . you're not copying.

Add water to the mixture left over from your previous bottlescape and use this for your background wash. Make huge puddles — you never know when you'll need them.

Use brown madder alizarin and Davy's gray for the three peppers and the slim stick shape. These colors are also on the base of the far right bottle and a few odd fruits. To the top right side add mauve, burnt sienna, and ultramarine blue over your first wash after it dries. Carry these colors over to your background dark accents, plus the vegetables in the foreground. Use spirited mixtures!

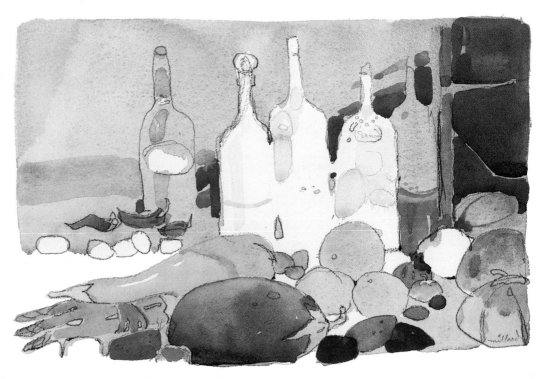

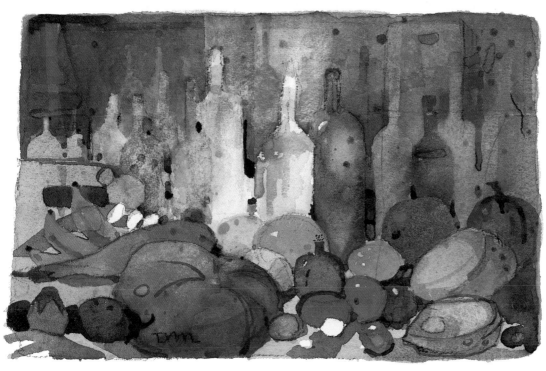

Work Up to a Symphonic Range of Analogous Colors.

Create the spotlight effect of late afternoon sun. Start with imaginary white. Go from white to gray-lemon, then to Indian yellow, yellow ochre, and Chinese orange enriched by burnt sienna on the pumpkin. Then go to burnt sienna-mauve. Add ultramarine blue to your burnt sienna-mauve mixture to make the stem and tiny dark accents around the small fruit on the bottom left, to which you've already added permanent rose.

Color your bananas a diluted bit of the previous mixture of burnt sienna and mauve with some permanent rose for a lighter tone. Move into pinkish violets and reddish purples across the background toward the light . . . intersperse the bottles with diluted touches of pinks, earth tones, then back to pink and blue purples.

PRACTICE COLOR AND DESIGN ON FLORALS

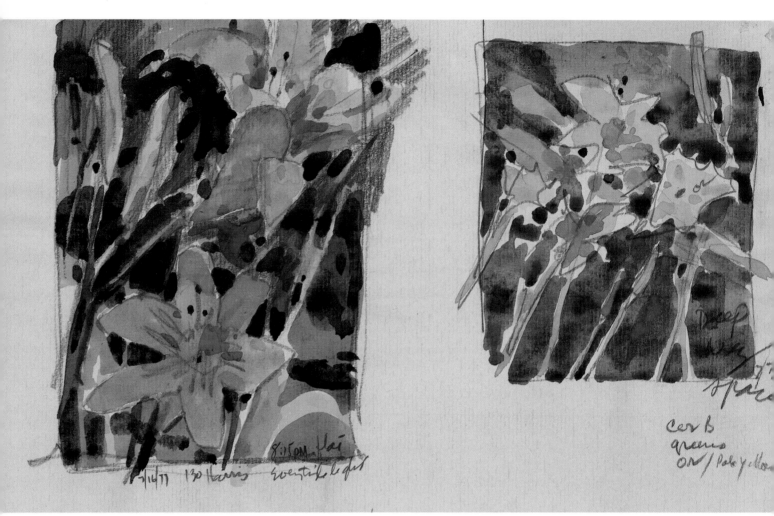

Patterns, Darks, Colors.
What do you have in your backyard? Day lilies are as common a floral subject as you can find, yet there is rich food for thought in a few of these blossoms. Don't neglect the buds . . . they really make the blossoms sit up and talk. Look at:

1. How the negative shapes between the stems create an interesting pattern

2. How the rich clean darks contrast well with the flowers

3. The color combinations . . . try new colors that complement and enhance each other.

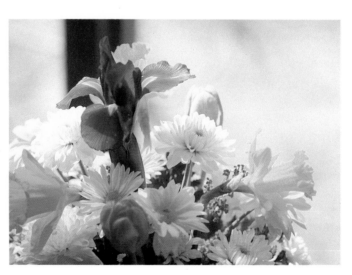

Use Photographs for Inspiration.
This one bouquet inspired the next five illustrations — my spring floral bouquet series. Take from a good photograph, but don't copy!

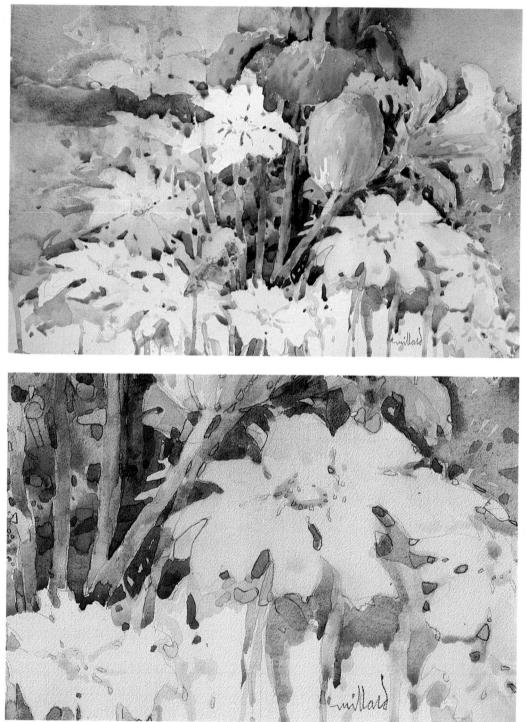

Be Capricious with Color!

Do a contour/freehand drawing. Then study it . . . daydream. Think color. Rearrange those blossoms in the photo. Do this as a "how to see" still-life exercise on 22″ x 30″ (56 x 76 cm) watercolor paper. Start with a touch of green color on the stems. Then add the iris and tulip . . . understate them. (I frequently begin with the stems in green, because I think the academically educated left side of my brain "expects" me to start with the color of the blossoms. I can feel the creative freedom turn on for me when I start with the stems.)

Look at the variety in the grays . . . then mix a big soupy bucketful and lay in a free-flowing background wash on a slant. Come down each side and delineate all the shadows under all the foreground blossoms, but go over some of the uppermost blossoms as you come down with the trailing puddle . . . let runs become stems. Build your values and colors to a crescendo, as in musical poetry. Remember the white palm trees from the painting of the St. John Custom house (page 90). You can do the same with these flowers.

Design! But Stay Free!

(Detail.) Look at the care taken in the design of these flowers and the placement of the darks . . . nothing is haphazard here.

LEARN TO "SEE" WITH FLORALS

Another "How to See" Exercise. (Below)
The same flowers inspired another series of paintings. This time, pattern flow and subdued color are the sources of inspiration. Each time you work out a variety of attempts from the original theme, you learn to see better. Variations of a theme are common in music, so why not in art?

Plan your white patterns! Turn your painting upside down to see it with a fresh eye. This is, again, a 22″ x 30″ (56 x 76 cm) . . . don't be afraid of the big ones . . . just step up to the plate and knock it over the fence!

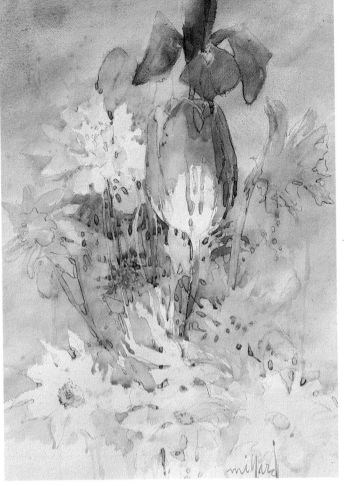

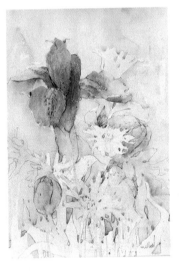

Try Using a Constant Cropping Gesture.
Make cropping a part of your regular painting routine. This painting could well stand on its own stems! Relate your darks and lights. Remember: shapes, values, geometry! Design becomes instinctive . . . if you paint frequently and regularly.

Plan White Shapes First!
Your background color will go over all but these white areas, so you must know where you want them. For your background wash, mix a huge puddle of light red, a touch of raw umber, Davy's gray, and a small amount of cerulean blue. Lay it in heavier wet-in-wet on the upper left, then let it dry.

Paint the iris Winsor violet and Davy's gray. For the dark center petal add ultramarine blue and alizarin crimson. Add a dot of gooey burnt sienna wet-in-wet.

For the tulip, lay in a first wash of rose doré and Davy's gray and let it dry. Paint the center strokes with that same mixture plus some rose madder added. On the right-hand side use cobalt violet and a touch of mauve.

Make the blue flowers with cerulean blue added to your first background wash puddle. Make the stems with touches of viridian. Use raw umber, pale mauve, and Davy's gray to paint the middle flower at right. Add more mauve to this wash for the negative shapes toward the center. Add rose doré to this mixture and use it for your signature!

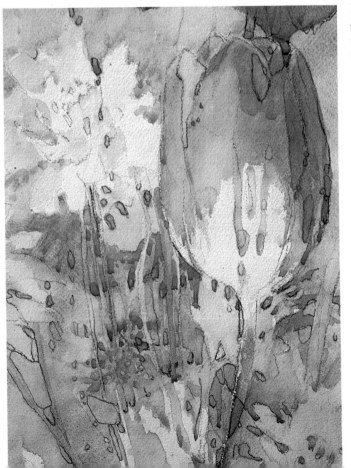

Use Your Whites Creatively.
This painting is a natural outgrowth of the use of white in earlier paintings. It probably wouldn't have happened without the previous sequence. (This is a plug to work in a series!)

Try this very simple, controlled, well-designed way to paint. Use just three colors on a Davy's gray background wash. Save your white paper . . . your "fifth" color . . . think and plan.

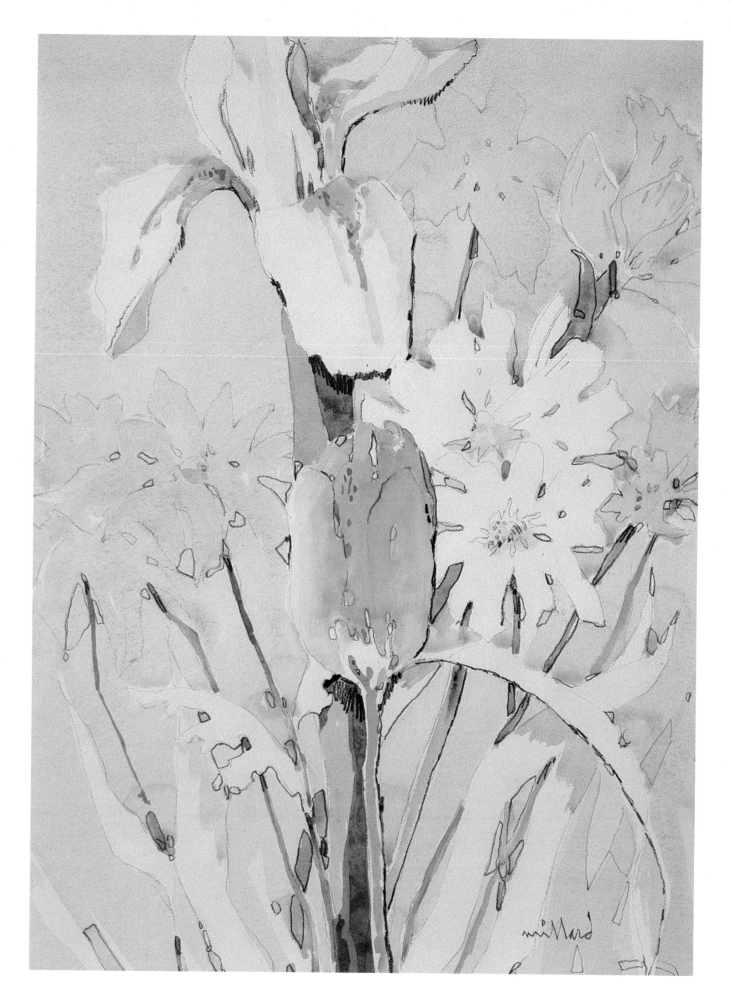

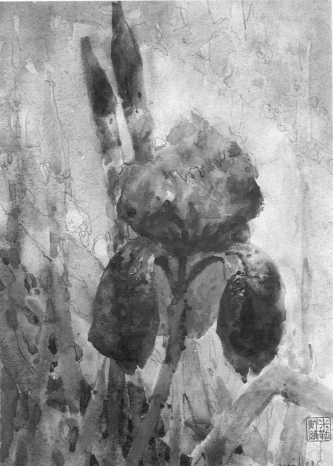

These Colors Come Out of Your Head.
You are looking for a pearly, misty morning light. Brush your entire paper with clear water, using a 2-inch brush. Drop in tints of emerald green, cendre blue, cobalt violet, Naples yellow, and yellow ochre-Davy's gray, wet-into-(damp) wet (you can spot their locations here). Keep your paper flat and get your colors on quickly. Then rock it back and forth several times and dry flat. With few exceptions, a touch of Davy's gray was added to all the colors here. The greens are emerald and sap with a bit of burnt sienna and cobalt. The blues are cendre, cerulean, cobalt, and ultramarine. Make your pinks from rose doré, rose madder, permanent rose, and alizarin crimson. For purples use mauve and Winsor violet. The deeper purple tones are ultramarine blue and alizarin crimson. The back under-petal is Chinese orange and cobalt violet with tiny spots of Venetian red (with (R) cadmium red).

This floral painting was done by layering in very subtle glazes. The undersea bottle series (pgs. 91–94) helped introduce me to this technique. Be gradual in your buildup of the darks . . . *feel your way for balance*.

There is a pair of trapezoids in the understructure here similar to the Rembrandt *Anatomy Lesson* on page 33. Can you spot it?

This painting, *Monet's Iris*, owes a small debt to Monet for his color influence, derived primarily from his multitude of waterlilies and garden color studies. I think it is mainly the relationship of the cobalt greens and cobalt violets and edges.

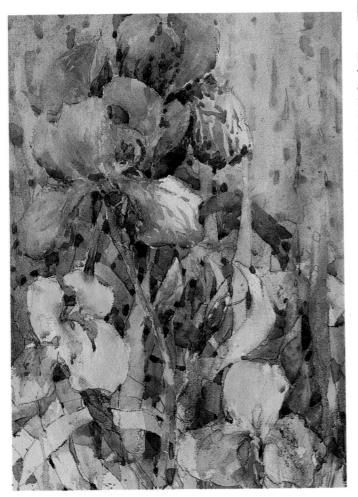

Use Rich, Intertwined Tones.
The background color here is divided: At the top it's cool on the right, warm on the left. Mix a large puddle of cerulean blue and light red and wash over your entire paper except the very few reserved white areas. Re-wet your top left side and lay in a wash of cobalt violet and Davy's gray mixed.

Give all your blossoms a broken wash of a pale mixture of Naples yellow and Davy's gray. Let it dry. Give the upper blossoms additional tones of raw sienna and Davy's gray and let dry. Add touches of Chinese orange, Naples yellow, and burnt sienna. Make the stems Hooker's green dark and cobalt green with a few spots of sap green-burnt sienna. Let your deeper blades carry tones of Davy's gray with Winsor violet and cobalt violet. Put deep tones of phthalo blue-Davy's gray under the ochre blossoms.

Your deepest spots of color here are phthalo blue-Winsor violet. This blade pattern is from the *mind* . . . not from the field. Note the subtle triangle structure.

Don't be afraid to use understated color on some of your more ambitious floral pieces. Its subtly powerful impact makes old ladies faint!

I call this painting *Ochre Iris*. It's in the soft understated light you find in the deep of the forest.

A Carefully Structured Symphony.
This painting is an outgrowth of *Snowflowers* (on page 101). Divide your background here into two unequal parts — make the top warm; the bottom, cool. Keep two of the irises white; color one iris and the grass blades with pale blues and blue-lavenders, changing to lavender pinks above. Start the big iris, your focal point, with overall raw sienna. Let it dry. Use broad touches of Chinese orange, changing to cobalt violet with darker purple accents of alizarin crimson and ultramarine blue. The dots on the petals are Chinese orange, cadmium orange, and Venetian orange.

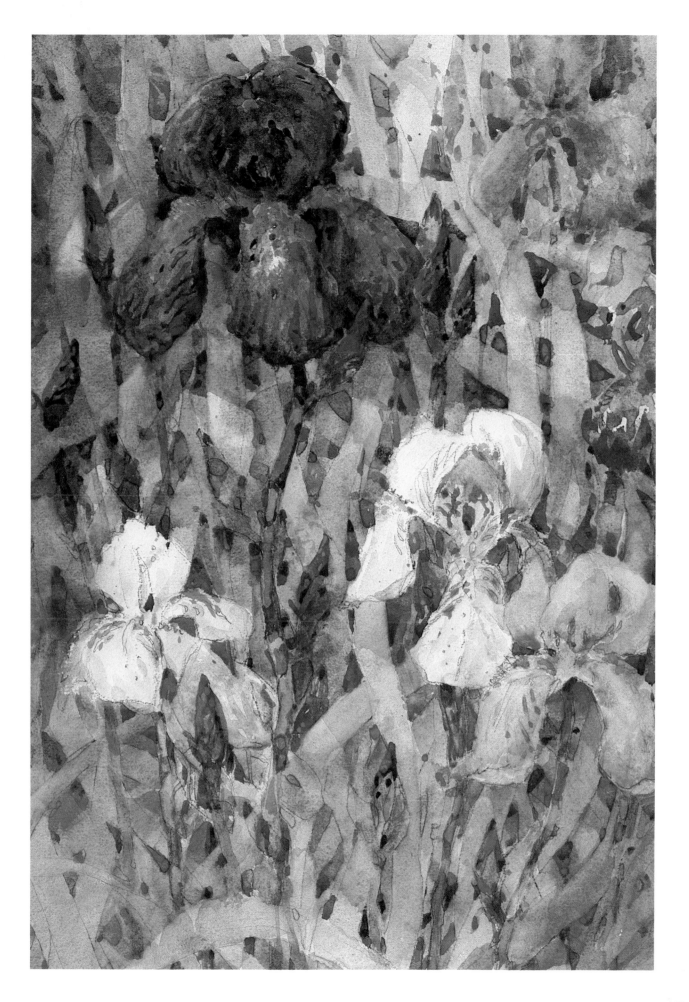

Wet-in-Wet, Lost Edges.

The conch has a glow because of the soft-edge effect. Include just a minimum of hard-edge light for contrast. The rich, deep color in the vine to the right makes the shell seem velvety. Work on a slant and don't try to *fix* anything! If something isn't working, paint another watercolor. Just turn it on the other side.

Using Hard Edges.

The hard edges along the top of this delicately colored conch are striking. The dark negatives in the vines and leaves to the right are extremely diverse in shape and the leaves are quite varied in color.

This is a ''gusty'' Chardin . . . a strong still-life statement. Watercolor can take your breath away when everything clicks . . . but you've got to keep it fresh.

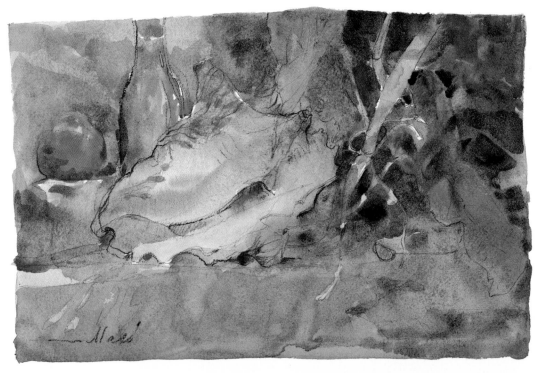

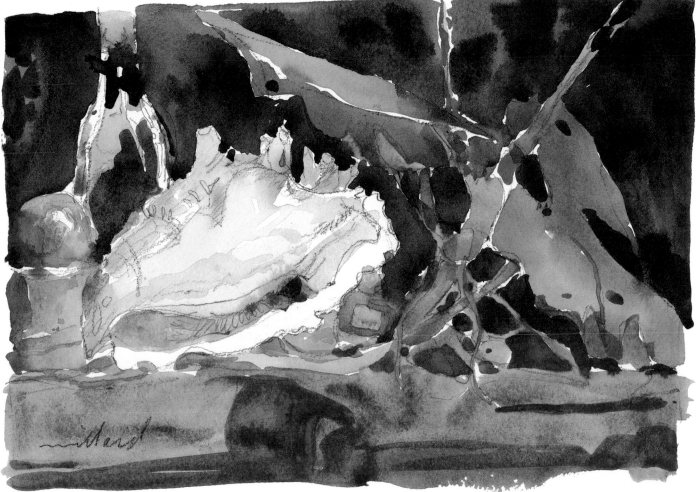

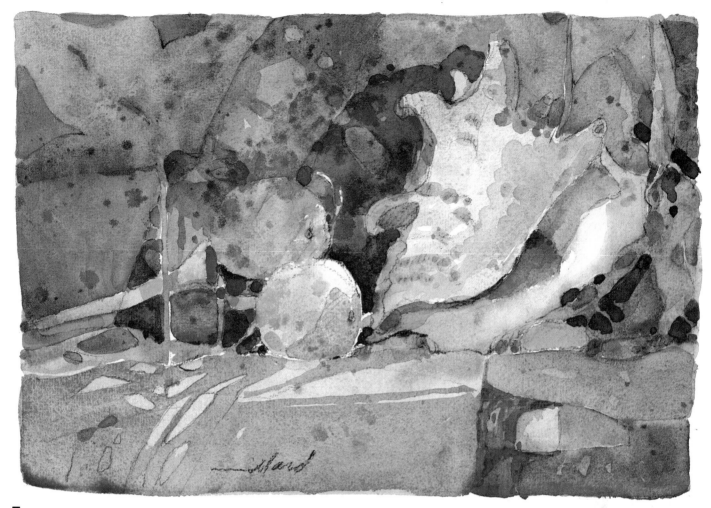

Tone on Top of Tone.

Lay in a carefully designed shadow pattern on top of a completely dry, pale, flatly colored first wash. This abstract light and shadow creates impact even in a small size (11″ x 15″ — 28 x 38 cm).

What if you had quit at the first or the second painting? Don't get locked into doing one watercolor of a subject . . . that's what amateurs do.

Create a Woodblock Effect.

Here's a stylized still life. There's much power in the design, and a definite, almost strident "beat" in the relationship of one object to another. The music has changed . . . from Chopin to Ravel. There's more power in the color, too . . . in the deep dark spots separating the leaf from the fruit and shell. Again, the secondary colors are expressed in the widest range within each context. Select your colors in your mind *before* you tackle color application. As in the pumpkin series (see pages 124-125), the change in planes has tempted a change in color.

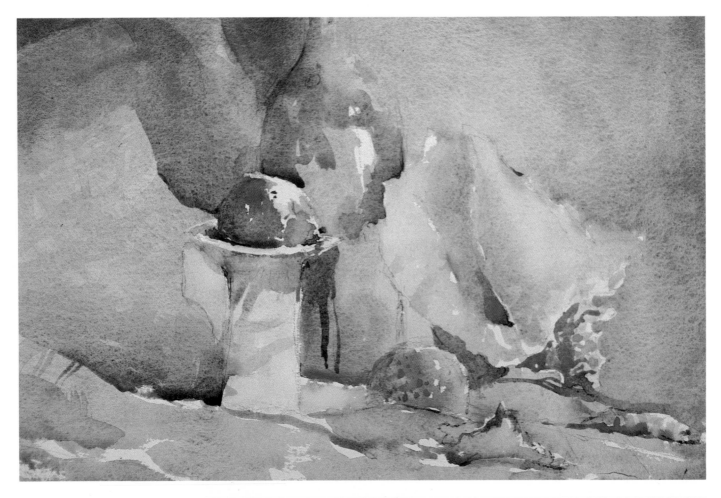

Working Out Painting Problems

Here we are dealing with what's inside your head . . . because the more you paint, the more personal your work gets. When you start a series of paintings in order to solve problems you've discovered in a particular piece, you're beginning to think for yourself. That means you won't have time for the latest "fad" painting. Good! Just stick to your guns and paint what you know and love.

In this series of three compositions from the same painting, you are determining your emotional response to the setup and deciding how you want to emotionally affect the viewer, too. You can do this through cropping . . . and if necessary, repainting your subject.

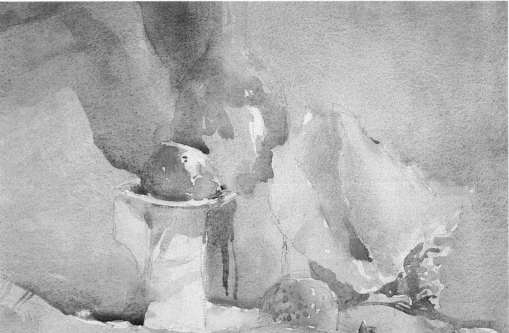

Create a Geometric Understructure. (Left)
This is the actual painting. Triangular structures form the foundation of this composition: there is a triangle within a triangle within a triangle, so to speak, giving a rhythm to this piece of music! This is a classical arrangement . . . moved back from the edge of the table . . . good forms . . . well placed . . . graceful drapery . . . not overworked. It's pleasing . . . you could stop here!

Study Your Finished Paintings. (Left, below)
Would you crop to this format? This composition definitely has a different feeling. Are you in the habit of looking at your paintings and playing around with the format, after you've finished? You should, if you don't already do it.

This bottle is just a breath of a toned wash. Do you feel the need for deep-toned accents? The ones here come from years of drawing the figure . . . I like to "bite-in" under a knee, at the back of a neck, at joints — such as elbows, or cleavage. Do you also? Do you think this "dropped-down" composition creates more excitement?

Getting Close. (Right)
This close to the setup your viewer participates in your painting in a personal way . . . detecting techniques, noting that the background wash goes over everything except the selected whites . . . seeing soft edges . . . hard edges . . . and color dropped in wet-in-wet. Look at the way accents are "biting in" . . . above the orange . . . below the orange . . . beside the vase. Note that there are grainy deposits . . . complementary colors . . . the design is quite evident. Do you like a painting that is this intimate?

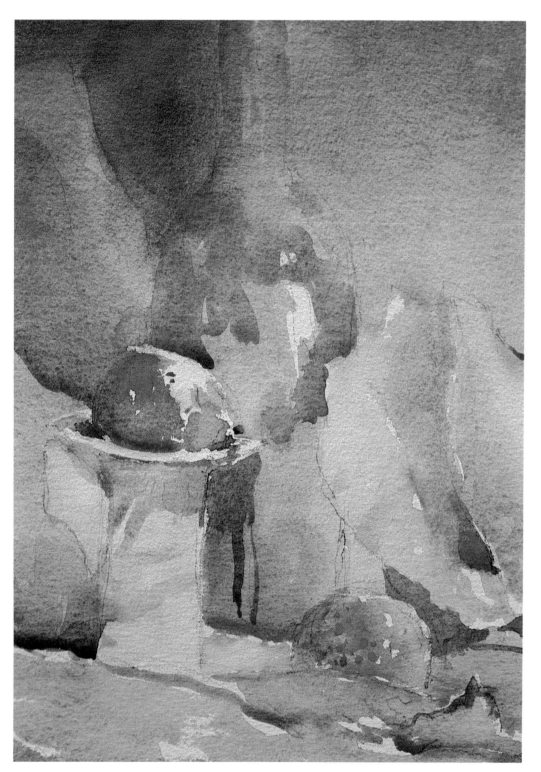

KEEP PROBING FOR A PAINTING

Intensify the Values You See. The drama and impact of using an exciting side light was suggested by this pre-breakfast light pattern that stopped me in my tracks. The closer you get toward noon, the more uninteresting the light patterns, due to the sun's overhead position. The results are similar to front flood stage lighting . . . deadsville!

Catch the first impulses that beckon you. For me, they were:

1. that dark notch between the buildings . . . the negative

2. the dark pattern of the left side (backlighted) and the underpinning.

3. the contrast of the many small building shapes with the large ones. You can generally allow your subject to influence you, but follow your intuition when re-designing these shapes as you work freely in your sketchbook.

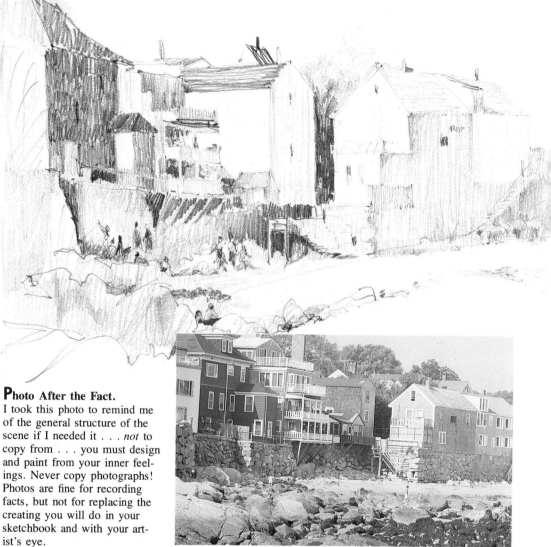

Photo After the Fact. I took this photo to remind me of the general structure of the scene if I needed it . . . *not* to copy from . . . you must design and paint from your inner feelings. Never copy photographs! Photos are fine for recording facts, but not for replacing the creating you will do in your sketchbook and with your artist's eye.

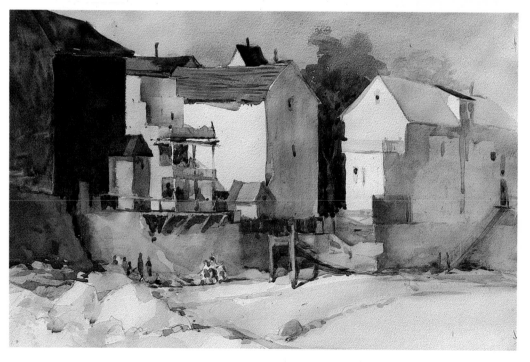

Paint in a Different Location from the Subject. First, set your own stage! The white shapes on the right were actually gray shingle buildings. The second building was brown shingle.

This memory painting was done a week after the pencil sketch, so I was away from the distracting and overabundant detail at the original location. My artist's eye was able to take over and be creatively influenced by my sketch, and I produced this painting with geat dramatic mood and rich sidelighting, and incidentally removed tons of confusing rocks from the beach (see photo).

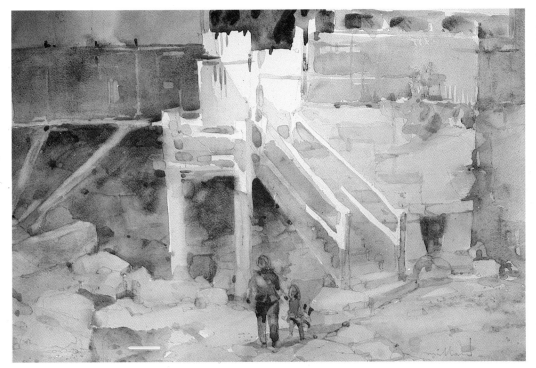

Try Another Angle.

These beach stairs called me back. Why not paint a subject more than just once? Change your point of view and emphasis to this special interest pattern. Probe with your sketch-book for the design structure of the darks . . . record angles and rectangles. Relate the angles of all the supports, for interest . . . against the counter angle of the stairs. Simplify!

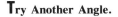

Change Hues and Use Monochromes.

Where values are more important, bite in with the deepest accents. Design with your dark pattern! Crop in closer to get intimate with your subject. There is an odd quality to the light . . . try to capture it. Learn from the marvelous mood lighting of Chardin and Emil Carlsen!

Move further into mood from reality . . . let your carbon sketch lead the way. Change mood by cropping . . . do you see it? Do you "feel" the morning light? Paint around this flow of light . . . don't use masking fluid, come from inside. You are catching the cool morning light on a warm subject (Bumpus Collection, paintings illustrated in *American Artist*, August 1978).

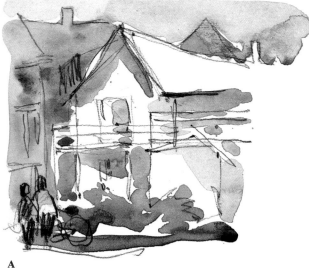

A

B

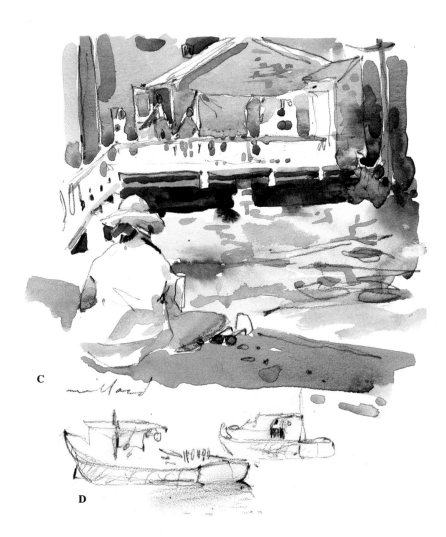

C

D

A Typical Sketchbook Search Party.

Keep an open mind when out hunting subjects to paint.
A. This is just a start.
B. This became a painting (*Joy of Watercolor*, page 53).
C. I liked this low viewpoint from down on a boat ramp of the dark, negative, underpinnings of the porch . . . a worm's eye view . . . a "looking upness."
D. Practice drawing hulls.

A Painting Evolves.

This painting is a natural outgrowth, in my opinion, from *Beach Stairs* (page 111, bottom). I had a gut feeling that this scene presented an unusual opportunity. I changed many of the existing shapes, sizes, and colors to accommodate the geometric rhythm I'd planned.

The lighting emphasized the negative shapes on the angle and counter-angle stemming from the underpinnings and continuing in the down-thrust of the roof perspectives and the up-thrust of the beach boulders. Everything about the scene was right. I could see it as a finished painting . . . and just sat down and painted it. (It became the first painting I ever exhibited at the National Academy.) There is a similarity here to the under-the-porch view in the sketchbook (left). They both have that worm's eye view, and chiaroscuro is common to both.

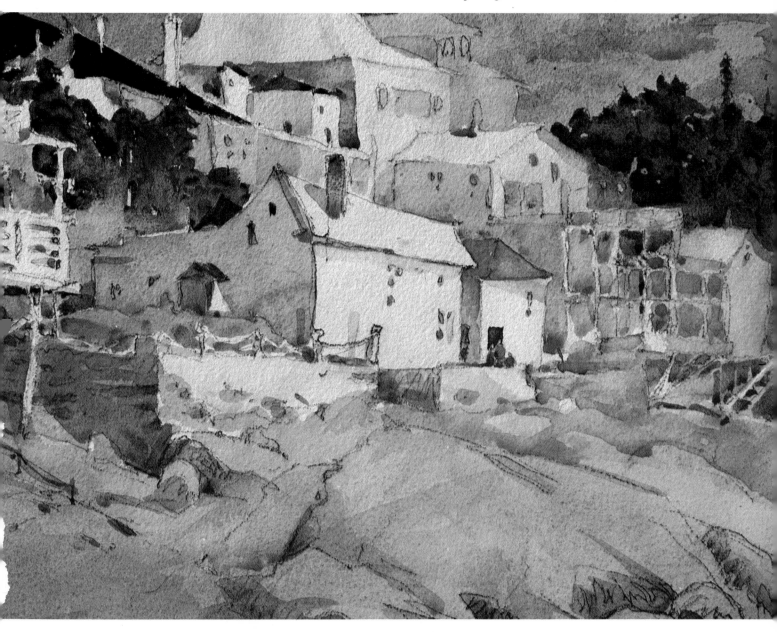

WORK UP TO A SPECIAL PAINTING

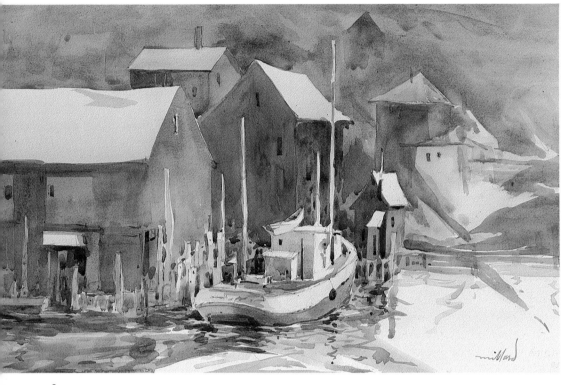

An Intuitive Stroke.
I was painting with a burst of
enthusiasm, trying to capture
this mood before the fog burned
off in the early morning sun.
The fish house roofs were re-
flecting white trapezoids and it
was in aligning two of these
shapes that I intuitively made a
slashing brushstroke diagonally
out into the water.

The unexpected freshness of
this diagonal surprised and
pleased me, so I paralleled the
angle, repeating it further back
in the landscape. Inspired, I
worked out other angles from
the stern of the trawler into the
water in a variety of designed
segments.

Searching Within a Subject.
A month later, on a new loca-
tion, I again tried directional
brushstroke patterns in water.

Paint and study your work.
Let it incubate and grow in
your head. Keep a constant
flow of unfinished works under
scrutiny. I always have twenty
or thirty paintings in various
stages of progress along my stu-
dio walls, and I study them
from my old beat up Eames
swivel chair.

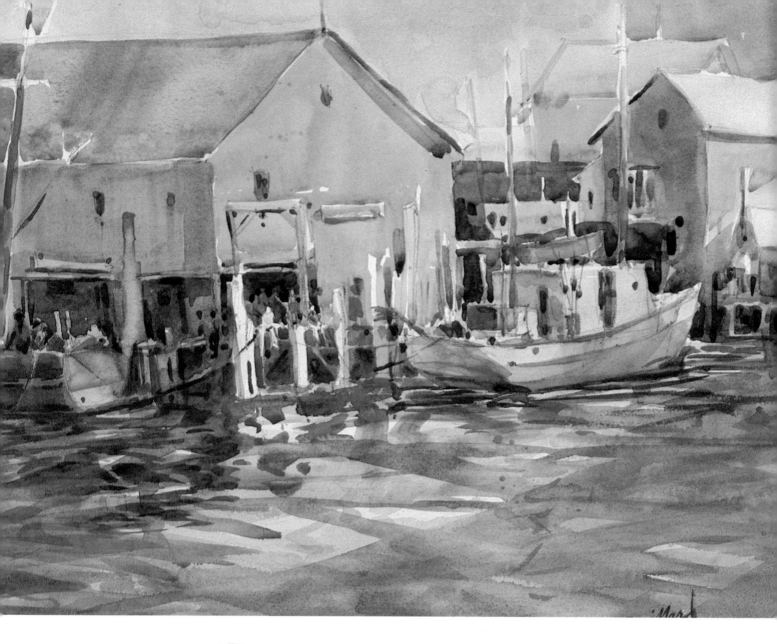

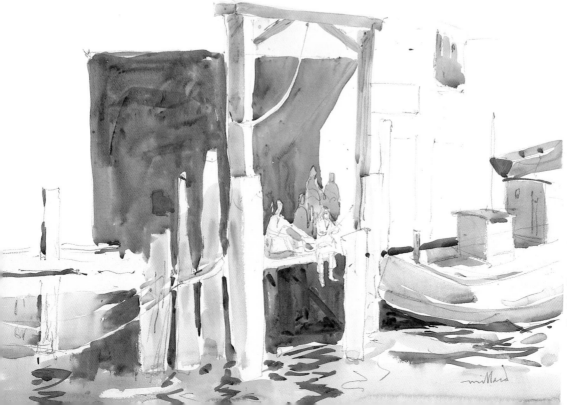

Focus on One Area

This is a full sheet sketch, 22″ x 30″ (56 x 76 cm) started in a burst of enthusiasm. I was concentrating on just the kids fishing here. But I stopped at this stage because I felt the need to get a better rhythm . . . a better geometric structure. This was a false start, but I thought I was on to it!

115

Try Cubist Ideas.

The angles in the preceding sketch started me thinking about Villon, Braque, Duchamp, Picasso. I mentally reviewed their work to see what I could learn from these Cubist painters before starting this carbon study. I decided to reduce the natural (realistic) forms surrounding the fishers to their geometric equivalents. I started in the center with the figures on the platform, where some sense of realism was kept, and worked outward, piece by piece. The idea just grew from there.

Try Cubist Color.

These mauve and earth tones . . . ochres and rusts . . . were influenced by Braque and Duchamp monochromes. Since the early Cubists weren't color enthusiasts, I decided to use muted colors too. I also stayed with the triangles based on parallels (my own idea) and it seemed to work. I was able to keep a very high level of enthusiasm throughout this series. Even the false start, my first sketch, wasn't a loss. It became the impetus, the spark, for my search for a painting.

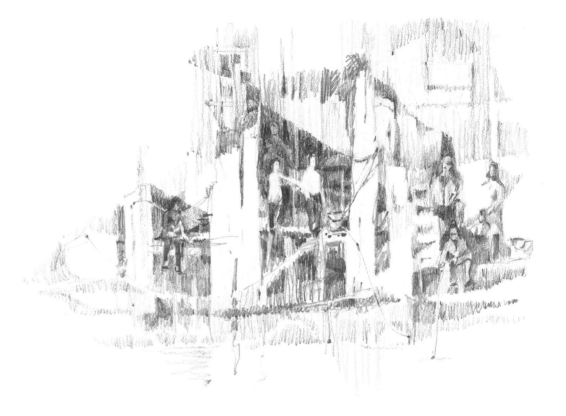

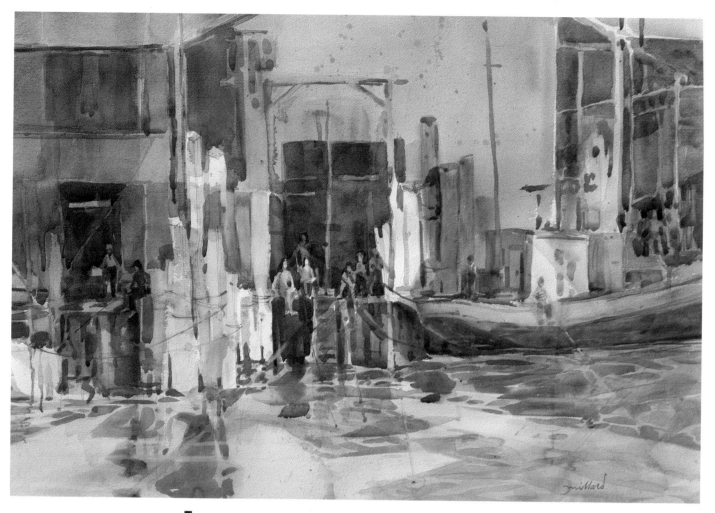

Try a Geometric Structure. This painting is based on an "X" structure . . . and grew out of the original (page 115, top right), which contained my intuitive "X" framework. The supporting role on this marvelous, natural stage set (with the kids fishing) is a program of parallelograms, derived from the roof eaves and repeated in the pilings and water reflections . . . passing through this "X." (Rembrandt used similar structural geometrics; see page 33, *Anatomy Lesson*.)

I felt this series was a creative breakthrough for me. It was tiring, but then again, fa-tigue contributed heavily to the creative efforts of Mme. Curie, Edison, Ford, Pasteur, and countless others. Staying with this creative series of problems paid off. To me, a problem is an opportunity for growth in disguise. (This painting won the Gold Medal, Rockport Art Association, 1976.)

A key point throughout this series, from the painting on page 114 (top) on, is the silhouette effect around the dangling legs and poised heads of the center figures on the dock . . . the intriguing negative shapes . . . and the secondary shadow figures.

Gloucester Fishers was painted in the field with a 2-inch (5 cm) brush in one hour (part of a discipline I maintained for six years, of painting full sheets only with a 2-inch—5 cm—brush within a one-hour time limit). I did the finishing touches in the studio; added deeper toning on the extreme left and right; used a slightly damp sponge to lift and soften edges in the water; and a rigger brush on the cables tied around the white pilings. To me, this watercolor has the mellowness and symphonic range of Brahms.

LET A MUNDANE SUBJECT INSPIRE A GREAT PAINTING

Look for Rhythm Through a Drawing.
Take a simple everyday subject: a hot dog wagon. Try to capture the gestures of the figures if their posture helps your composition. Why this one? What stopped you? What's the appeal? Any subject is fair game! You choose it. Notice how the curves are repeated . . . the umbrella top . . . archway, wheel, heads, curve of the figure leaning . . . all related . . . all similar to a thousand fragments from art history . . . past and present.

Look for Pattern Through Light and Shade.
(Above.) Sketch 100 to 300 feet away from the two old guys who ignore you. Look at the wonderful spots of morning light shining through the trees. It's different from noon . . . much better. Catch the next pattern of the two children with their snacks. (Below.) Now you're warmed up. Try to get the light patterns on the hot dog wagon . . . and add the curved top of the Volkswagen back by the old lady. This was planned as a monotone wash until that gal with the green pants and red hair came along!

Try to Compose a Painting.

Set your stage . . . put your center of interest group under that archway and umbrella. Concentrate on your figures . . . dark accents . . . and side and distant figures. Design your overhead interest as good shapes . . . good pieces . . . good directions. Design your side settings . . . like stage wings. This looks like it's for real, as though the viewer were present.

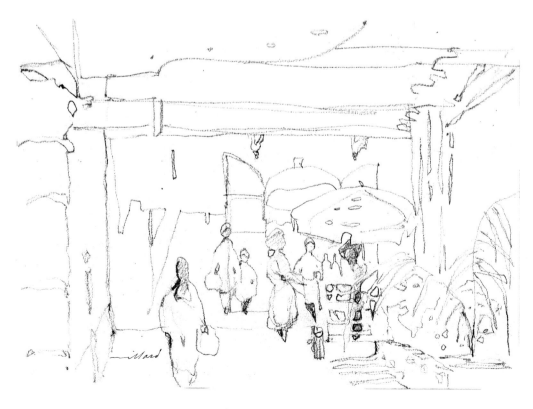

Zoom in to Bring Your Viewer into the Picture.

Start in the center with the hot dog stand and work out to the perimeter. Design your page by placing each item to get good negatives. Make each piece a good positive shape, too . . . especially designed by you. Don't copy the reality!

There's Magic in Color . . .
Give It a Go!
Invent a special color combination to superimpose onto your stage setting. You are the director using colored stage lighting . . . invent . . . create . . . use the magenta filter . . . the orange filter . . . a low white flood from the side.

 New, show biz stage positions and color . . . why not? A *touch* of realism with invented color!

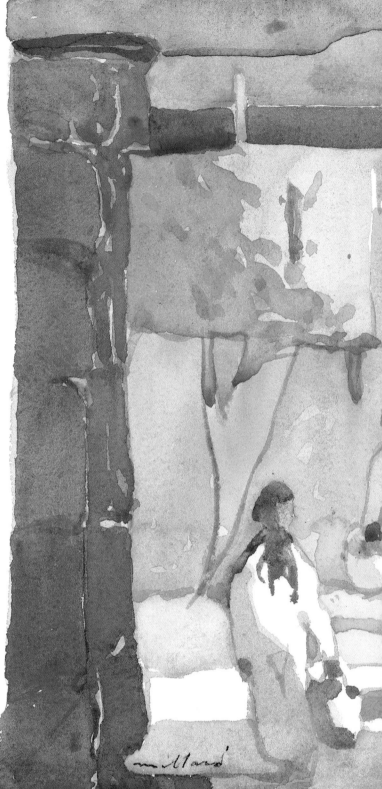

New, Show Biz Stage
Positions and Color.
Why not? A *touch* of realism with invented color! Base it on a cadmium orange and cobalt violet mixture . . . analogous colors running from reddish violet to bluish purples and off-white pale yellow-orange tints, all the way to deep earth orange into mauve-burnt sienna. Keep it clean . . . crisp . . . sparkling. Lay each color *once* and don't poke back into a wash. (Lyrics and Music by Cole Porter).

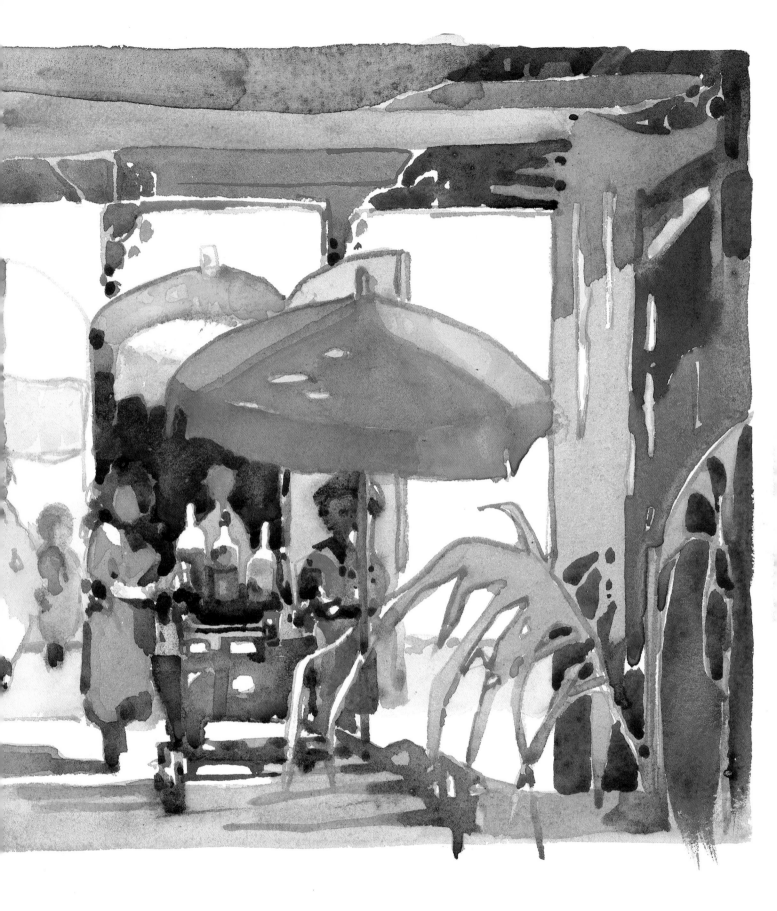

"Spotting" Light Patterns.
A breakthrough in handling
light came one day as I
sketched. I began to encircle
pieces and patterns of sunlight
as it filtered through the trees
. . . falling on the women chat-
ting in the park. I began to
circle the spots of light on their
backs, heads, and umbrellas.

Nothing unusual at the time
. . . but this was the beginning
of a new sequence of painting
material. I applied color to the
sketches in the studio later,
from memory. Had I pulled out
my watercolors and started
painting then, the people would
have fled.

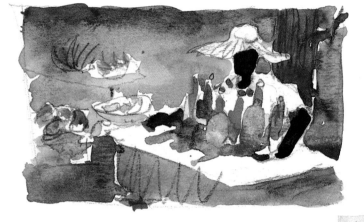

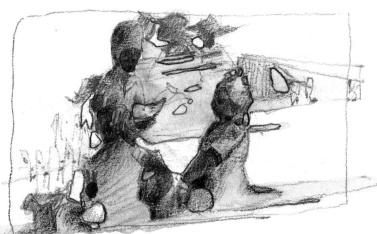

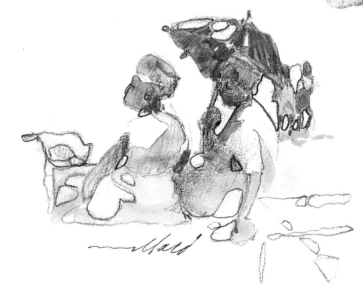

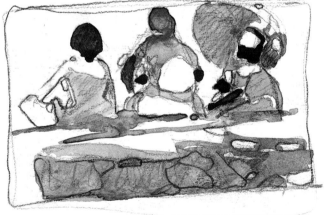

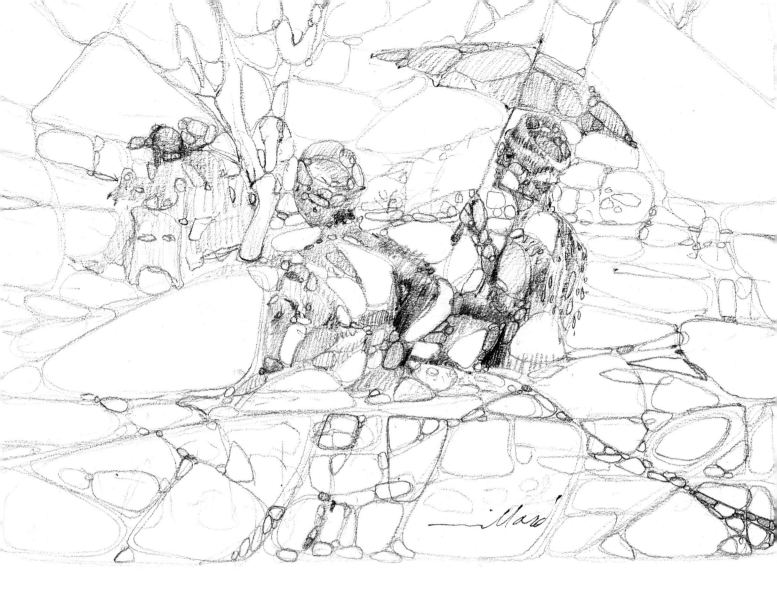

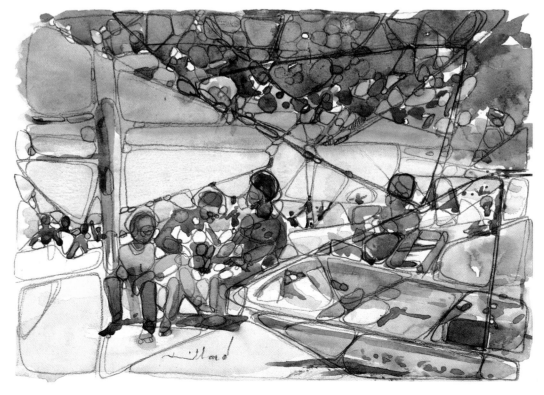

Let Circles Encourage Other Geometric Shapes.

I was seeing the light differently. By the next day in the park, I tried putting geometric shapes over the entire picture . . . figures, trees, stonewall, even in big negative areas. It was exciting! The lesson? Always, be alert to new possibilities, new ideas to try elsewhere.

Let the Circles Influence Your Painting Technique. My sketch, *Morning, Spotted Ladies*, encouraged me to try this labyrinthian technique in a carbon sketch of a piece of pumpkin . . . seeds, flesh, and rind . . . working from the center out in this new design technique.

The Idea Family Keeps Multiplying. (Opposite, top) One idea leads to another . . . it's like measles! Look for design possibilities, even in a placid piece of pumpkin! You never know where your next lead will come from. I hacked this chunk of pumpkin with a hatchet . . . to give me a fresh, unconventional set of shapes and planes to color. The tin pie plate became an unexpected foil for those lavender-pink pigeon peas. Notice how the design controls the rhythm here. Look at the understated color of the secondaries: orange, green, and lavender. Work to keep the harmony (like music) between the colors.

Creativity is Contagious. A planned white pattern was substituted for the pumpkin's orange color . . . which led to a filigree design around the seed area . . . creating an effect of brilliance. Creative techniques and color combinations like this are encouraged whenever you're tempted to exchange reality for beauty and poetry. Think, invent, then paint color. Studying my palette, can you guess what colors I used here?

A Change in Planes Invites New Techniques. Crudely chopping a pumpkin with an old hatchet led to rough facets, creating fragmented, hand-hewn segments, which led to the hand-carved Japanese wood-block effect in this water-color and then to colors simulating the old bygone vegetable and root dyes. This fragmentation was similarly encouraged in the overall picture. You must be alert to any unusual design possibilities. Painting on a rainy day encouraged the use of some Davy's gray in all the paint mixtures. Mix a big puddle of cobalt violet and raw umber (with, as mentioned, Davy's gray). Flood a broad wash over everything except the garlic buds and glass rim of the bowl. When dry, flood a second wash of cendre blue (with Davy's gray) over your shadow patterns and design the background fabric effect. Make your reds using Venetian, Indian, light red, and brown madder alizarin. The earth's blues and greens are similarly made up of multiple combinations.

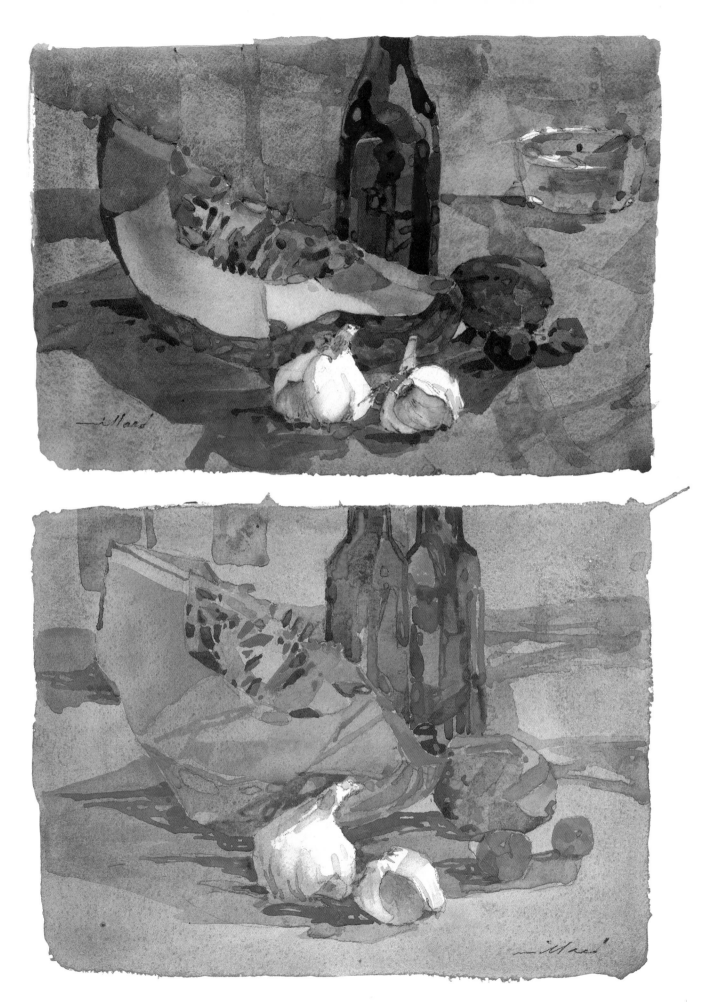

HOW TO THINK AND FEEL LIKE AN ARTIST

Search for a Painting.
You are at a solo piano recital . . . a single figure is playing. You are drawing with speed; freehand, but in single-line contour style. The different postures catch your fancy (I call this sketch *Attitudes at the Piano*), and so you just pile them one on top of the other on a page. You are tuning in . . . looking for negative shapes . . . even between the feet of one and the head of the other.

Search for Shapes.
Now there's a duet . . . a new problem in spacing . . . attitudes with piano and violin. You're looking for the best negative shape between the figures now. Suddenly, the feet take on importance . . . you spot the similarity between the feet of the violinist and the feet of the music stand. (Good for a chuckle.) The verticals of the legs of the piano bench and also the piano legs, prompt you to pick up verticals for the background. Put your hand over these verticals and note the difference they've made. You will see how these verticals assumed prominence in a later sketch.

Back-up Photograph.
This is an excellent example of why you should take a 35mm SLR camera and a zoom lens to concerts. You may need details as to proportions of figure to piano for reference (exposure: 1 second, hand held).

Sketch Intuitively.
These figures are rough, but
this is your first attempt sketch-
ing musicians. This is just a
vignette . . . you're groping for
a good dark pattern on which to
hang it.

Work Out Your Design.
Again you're trying, in the
semi-darkness of the balcony,
to put together a composition.
You're feeling, looking, for in-
tuitive design accents.

How Do You Search with Line and Tone?

Work Quickly with Your Carbon.
Capture the cadence of the strings in your sketch with an emotional outpouring from your carbon pencil. Your fingers are actually sawing the pencil, like a bow emitting sound . . . you are thinking design with your mind's eye and your ears are urging you on. How do you catch the desired position of the violin bows . . . the pattern of the music stands? Place your darks with care and speed. Start your delicate washes of warm and cool . . . playing one against the other . . . feeling out the composition. Keep your 22″ x 30″ (56 x 76 cm) paper slanted as you lay on a soupy wash of yellow ochre and Davy's gray, using a 2-inch (5 cm) brush . . . trailing the puddle around your crucial white shapes. Don't flub this one! Speed is necessary, so you can put in a drop of mixed yellow and a drop of mixed blue for push/pull accents. Make this wash very *subtle* — and lay it only once!

Probing Material. (Above)
Express the sound of music through line. You're breaking through a bit here. You're beginning to catch the emotion of the music you're hearing. You can hear those violin strings in the slanted, sensitive, rhythmic background lines.

Express the Emotion of Music Through a Wash.
(Opposite, top)
You're in the studio, painting from memory. Again, you're fishing for a painting. This is a new experience. There is a feeling that it's like a still life . . . just bits and pieces to put together. The violin bows and the prisms of the subtle washes follow the feeling of the fragmented bottom of the sketch. For the first wash, work around whites for an effect of light and save your attempts to get form for later.

Emotional Sketching "Tunes" Your Mind's Eye. (Right)
There is so much enthusiasm and competence within this quartet that it sweeps into your sketches. The motion of the violin bows is in your background pencil strokes. You're trying to follow Beethoven's rhythm with your carbon pencil. Note the intuitive chiaroscuro, even though the sketch is being done at a furious pace! A parallelogram construction is also intuitively present in the sketch!

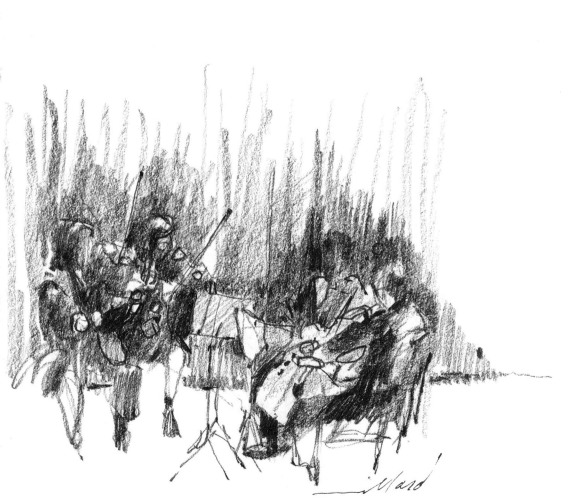

The Angle of the Bow
Establishes the Geometrics
(Overleaf) . . . repeated in the
cellist . . . countered by an op-
posite diagonal. The angles of
the bows, music stand bases,
and the legs of the musicians
and chairs are "felt" right along
with the rhythm of Beethoven.
The figures are not an attempt
at portraiture, but just rapid,
rhythmic gestures. Keep the
color muted so it doesn't up-
stage the exhilarated drawing.
(This painting won the Paton
Prize in 1982 at the Annual Ex-
hibition of the National Acad-
emy, their highest watercolor
award.)

Notice how the abstract white
pieces lead the eye. They are
created by the glitter of the
stage light striking the violin
and the shoulder and hair of the
player. These whites carry the
eye over through the white
sheet music to the cellist. The
cobalt violet stripe is another
one of the splayed accents of
direction, but this is a surprise
color. The unusual white shapes
on the violin seem quite natu-
ral. Paint around them with
great rapidity. Let yourself go!
Paint what you feel!

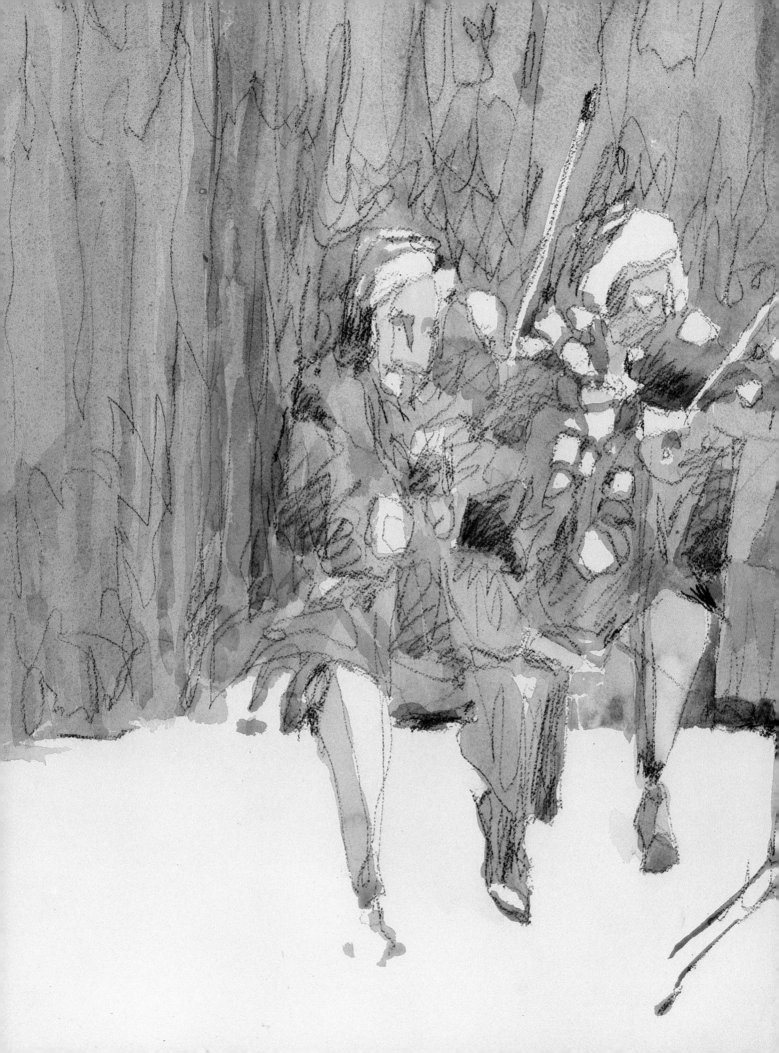

Summary of Basic Painting and Drawing Lessons

Get into the Habit of Art.

Sketch every day, even if for only fifteen minutes. If you will get into the habit you will find yourself becoming self-motivated, and your sketches will become food for your creative mind.

Accumulate these sketches. Fill your sketchbooks with material you'll be yearning to get onto watercolor paper. Do lots of starts. It will give you a chance to daydream about how you might finish them. Problem-solving is a creative process. Be a doer . . . don't just talk about it. Talent is what your mother talks about. Work is how you get around the bases and score!

When you have discovered a subject that excites you with its possibilities as a painting, stop and think. Turn on that creative, right side of your brain and think music and poetry. Stretch your thoughts away from reality so they become more poetic. Then combine poetry and power with the music of a Beethoven, Brahms, or Debussy. You can interpret music and get yourself into the mood . . . through color. Try it! Look at the examples in the book again. Use them as a springboard to break you out of the clutches of the gravity of reality.

Try to keep twenty-five to fifty unfinished paintings in progress all the time. Fight finishing them. Let them "hatch" for a reasonably long incubation time . . . to give you some time for creative thinking, planning, and dreaming. Don't be in a rush. Enjoy them! The artist (and exceptional colorist) Wolf Kahn once said he fights finishing a painting. Put off final decisions about your work, too.

Keep your cool if a painting gets bounced by a jury or two. Don't blow a fuse or break out into hives. Just put it on the shelf to study at a later date. Don't get angry . . . just get better and better!

Learning to paint is like learning the piano. Once you learn your scales and to read sheet music, the rudiments of your craft, you can only get better. Of course, like a pianist, you also have to practice every day.

And don't lose yourself in the process of earning a living. Everyone has to pump gas at first . . . I pumped mine in the graphics and color fields and kept my painting alive through many years . . . then took off with the paint flying. Just remember to listen to your inner self. Don't worry about what your neighbors think. Keep exploring. Don't settle for an early success, an early selling binge, an early gallery connection . . . so you're locked into a style you can never change. Keep yourself open to being you. Don't sell your soul, just *paint*.

Design and Poetry.

It is always the design that we are after . . . design in your drawings and paintings . . . and music and poetry in your color. Learn to travel with your sketchbook with you, always alert, looking for a painting. It's when you least expect it that the winner will pop up. Be ready to grab it! The drawings and paintings in this book are offered as an attempt to help you see better the things that will appeal to you, to your inner mind . . . your artist's or mind's eye. Learn to respond to the sights that call to you. Take liberties and shift things around to get a better design. Try to make better shapes, better patterns, than what you're looking at. But keep the essence of what stopped you. Ask yourself, before you touch carbon pencil to paper, what it was that stopped you . . . that sent up the flare that kindled your desire to draw. Learn to

recognize those subtle intuitive urges when they speak to you. Learn to listen!

You'll also spend endless hours in academic preparation, getting yourself saturated with learning about painting, drawing, color . . . all the stuff it takes to get you in orbit. And you'll spend endless hours searching in the museums, thrilling in the galleries at the work of artist after artist, hanging on every word of your art instructor, in every workshop you can attend. The Taoists say that it is only after you have acquired all academic learning that you can become intuitive and truly creative. Remember, you are the master of your own interpretations. Don't be afraid to experiment, to make changes. Do the things you feel a call to do . . . listen to your inner voice . . . dare to be different. If you're faced with the green trees and grass of summer, don't be afraid to start the colors of fall foliage in June. Also, vary the location of your center of interest. Don't do the obvious. And accentuate some areas and diminish others through light and shadows, even though your subject may be bathed in light that goes flat across. By beginning your interpretations with a single-weight contour line . . . a flat, two-dimensional pattern . . . you are free to direct the light source. It may not always come from the direction of the sun, as reality dictates. Put it where the design will best be served. Invent!

Finding Yourself as an Artist.

Your subjects are everywhere. No matter where you live — your hometown may be best. Diebenkorn found years and years of material right around his Ocean Park studio and the Whitney Museum showed it. Wyeth found a lifetime of material in two simple rural areas, painting what he saw with his inner eye and mind . . . and the Metropolitan Museum of Art showed it. And Turner filled his sketchbooks with single-weight, unshaded drawings of landscape subjects that caught his eye . . . and the Tate Gallery in England showed it. You don't have to go far to find subjects worth painting . . . subjects that can make you famous, too.

At times, a single whiff of a subject is all you'll need for your excitement to surge. You may not have your sketchbook with you, or you may not be able to stop at that particular moment . . . but you will have your memory. Learn to use it . . . to cultivate it. It's easy and practical. Ask yourself what stopped you. Color? Light? Shapes? What? Remember that fleeting first impression. That was what Monet was after . . . and that's why Bonnard never painted outdoors, but just worked from memory, recorded in his fast, simple, emotional sketches. And he used his imagination (what an imagination!) with color, too. So did Monet, who did many paintings of Rouen Cathedral, inventing his own color, making his own interpretations.

And so we come full circle to the essential lesson . . . to draw and paint every day. Make your sketches from intuition, then paint from these sketches, not from the reality. Paint your inner voice . . . don't copy nature. Of course, you can learn from other artists, too. But then blaze your own trail. There is great joy in painting and solving problems . . . and it is in the solving that you will surface as yourself. If you paint and sketch enough, you will come up with a style or technique as individual as your own voice and handwriting. Remember this . . . and believe it!

APPROACH COMPLEMENTARY COLORS

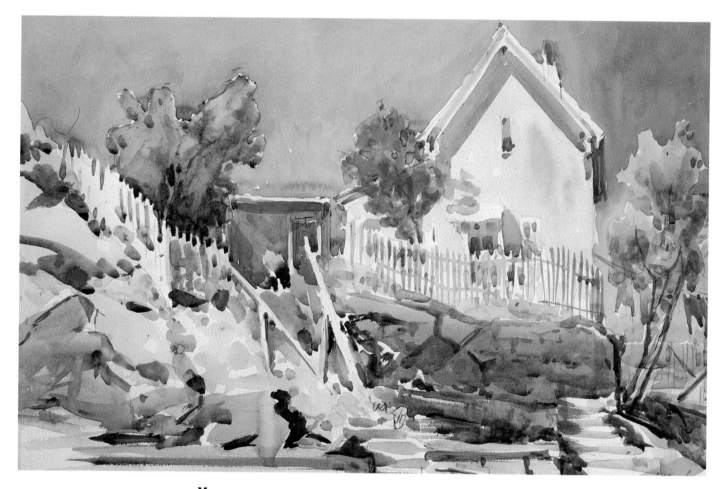

Yellow Cottages (Gloucester).
The pink roses and green hedge are not opposite on the color
wheel, but they are flattering to each other. The blue sky, shades
toward purple-blue . . . the yellow shades toward orange-yellow,
so that each area enhances the other.

The white picket fence angle repeats the right eave.

The left eave is also repeated.

The sky piece has a good negative shape.

The quiet sky allows the busy rocks and picket fence to exist.

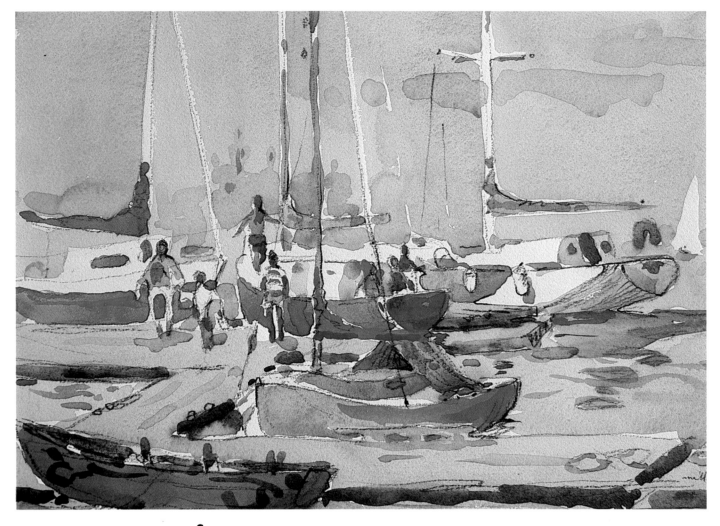

Sunday Yachts.
Cendre blue (FB) with cobalt violet and Davy's gray. Lay in one
wash of this sky color right down into the sea.

Paint *around* the whites.

Lead the eye with color.

Block out color at left with the thumb and squint technique.

Use these same colors in your next still life.

NVENT COLOR IN STILL LIFES

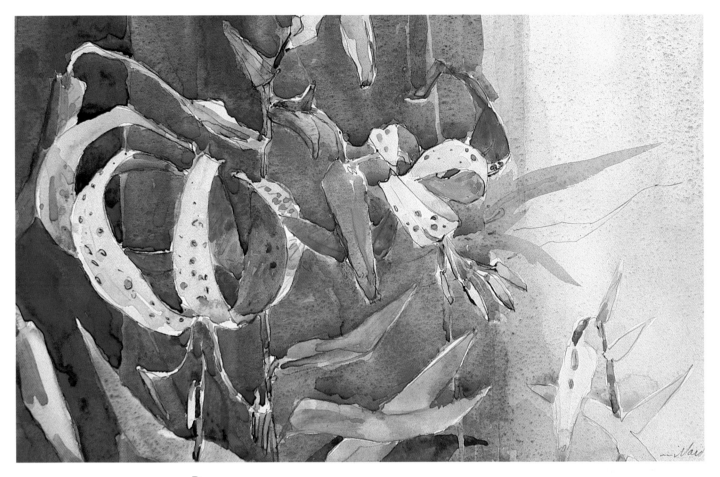

Be **Innovative with Color.**
Try the colors of a marine painting, for example, *Sunday Yachts*, in a still life.

Invent the background strips.

Create blue/purple-blue color combinations.

Create warm/cool color combinations.

Mix warm colors: pink, orange, burnt sienna, rose doré (R), alizarin (R).

Do the background with clear water and paint left on your palette from the day before.

CREATE THE FEELING OF LIGHT

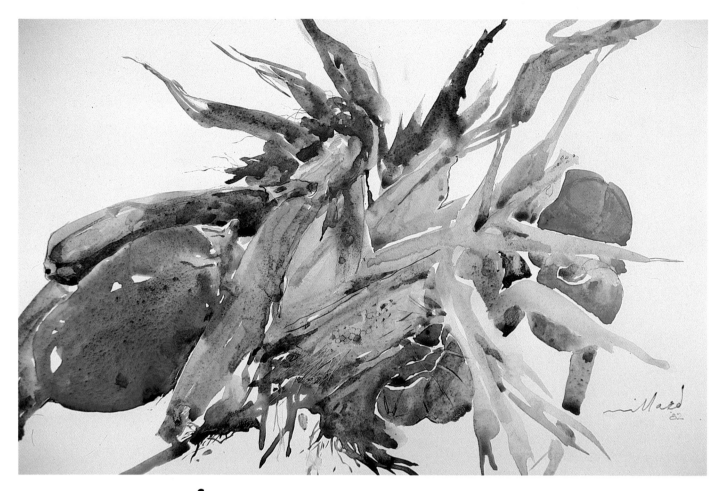

Summer **Vegetables.**
Without shadows or chiaroscuro . . . through color. To see what I mean, divide the painting vertically in half (close one eye, hold up a thumb, squint), blocking first one side, then the other. This white background is an incredible negative shape. But don't get in the habit of using white backgrounds all the time . . . or it will reveal a weakness in your ability to make good backgrounds. Notice:

Deep colors give a feeling of shadow.

Bright colors make you feel the sunshine.

Purple and green are secondary colors.

Red and green are complementary colors.

TRY PAINTING DIRECT

Pink Turnips and Carrots.
The simplest of sketches done in brown ink . . . with a wood pen!
The Aquabee sketchbook holds color nuances remarkably well.

Here's your 40 color palette at work . . . count the myriad mixes:
naples yellow with mauve . . . cendre (FB) with cobalt violet.

Invent color, but be a perennial student of art books, galleries,
museums.

Here are the three secondaries . . . doing most of the work!

A primitive subject with yummy color!

HOW CLOSE DO YOU WANT TO APPROACH REALITY?

A Walk in the Pines.
Again, try painting direct. No drawing.

Hold your brush way back at the end.

These colors keep the viewer in dreamland.

The shadows and figures bring you closer to reality.

TURN OFF THE LEFT (REALITY) SIDE OF YOUR BRAIN

Bowdoinham Fantasy, Maine.
Outline with orange watercolor, not pencil . . . you're painting
direct again.

Fly into high-key brilliance with a lavender-pink cloud.

Go with invented orange to burgundy-red foliage (in the middle
of summer).

Use telephone poles to reinforce other slim, stabilizing verticals.

Mix Naples yellow with colors to obtain absolutely priceless
mixtures.

Use the finger tip and squint method to block out that foreground
shadow.

PUT ON YOUR FAUVES HAT...GET OUT YOUR WINGS!

Soho Poppies.
This is direct painting on 90-lb paper. This is more brilliant than 140-lb or 300-lb paper. Soak and stretch it over wood canvas stretcher bars.

A taut, dry surface is exhilarating to use.

Paint! Dare! Slash and drip!

Soho Poppies (Detail).
This can be your ticket to Soho! Take this up into a 12' x 8' acrylic, put on your old jogging suit, and shovel on the paint! (Your own design, of course . . . in case you were taking me literally.)

Have fun!

BIBLIOGRAPHY

On Watercolor

Cohn, Marjorie B. *Wash and Gouache: A Study of the Development of the Materials of Watercolor.* Cambridge, Mass.: Fogg Art Museum; Harvard University, 1980

Edwards, Betty. *Drawing on the Right Side of the Brain.* Los Angeles: J.P. Tarcher and New York: St. Martin's Press, 1979.

Hawthorne, Charles W. *Hawthorne on Painting,* introduction by Edwin Dickinson. New York: Dover, 1938, 1960.

Henri, Robert. *The Art Spirit,* edited by Margery A. Ryerson. Philadelphia: Lippincott, 1923, 1960.

Kautzky, Ted. *Ways with Watercolor.* New York: Van Nostrand Reinhold, 1963.

Liberman, Alexander. *The Artist in His Studio.* New York: The Viking Press. Out of print, but should be available in any large public library.

Meyer, Susan. *Forty Watercolorists and How They Work.* New York: Watson-Guptill (out of print).

On Drawing

Cummings, Paul. *American Drawings, The 20th Century.* New York: The Viking Press. Out of print, but available in any large public library.

Fogg Art Museum. *Dry Brush and Drawings of Andrew Wyeth.* Cambridge, Mass.: Fogg Art Museum; Harvard University.

Goldstein, Nathan. *The Art of Responsive Drawing.* 2nd ed. Englewood Cliffs, N.J.: Prentice-Hall, 1977.

Nicolaides, Kimon. *The Natural Way to Draw: A Working Plan for Art Study.* Boston: Houghton Mifflin Co., 1941. Paperback ed. 1975.

Slive, Semour ed. *Drawings of Rembrandt.* 2 vols. New York: Dover, 1965.

On Color

Guillaud, Jacqueline and Maurice. *Claude Monet au temps de Giverny.* Paris: Centre Culturel du Marais.

Millard, David Lyle. *Bonnard.* Masters of Color Series. New York: Tudor Publishing and Paris: Braun & Cie.

————. *Bonnard dans sa Lumiere.* Saint-Paul, France: Fondation Maeght.

Robbins, Daniel. *Jacques Villon.* Cambridge, Mass.: Fogg Art Museum; Harvard University, 1976. This book lists several color systems and includes information about his use of geometrics.

Rood, O.N. *Modern Chromatics.* New York. 1881.

Russell, John. *Vuillard.* New York: N.Y. Graphic Society (out of print).

Wildenstein, David. *Monet 's Years at Giverny: Beyond Impressionism.* New York: Abrams, 1978.

On Painting Styles

Buechner, Thomas S. *Paintings and Drawings by David Levine and Aaron Shikler.* New York: Brooklyn Museum, 1971.

Comini, Alessandra. *Egon Schiele.* New York: Braziller, 1976.

————. *Gustave Klimt.* New York: Braziller, 1975.

Gowing, Lawrence. *Vermeer.* New York: Harper & Row.

A Walk in the Pines, 138
Abstracting, 23
American Artist, 48, 56, 57
Art Student's League, 48

Beethoven, 48, 128, 129, 132
Blacks, 10, 28
Bonnard, 132
Botticelli, 33
Bottlescapes, 91–95
Bouquet in a Crystal Vase, 68
Bowdoinham Fantasy, Maine, 138–139
Brahms, 48, 132
Braque, 116, 117
Bridgeman, 21
Brushes, 57
Busy scene, organizing, 17
Byzantine art, 12

Calligraphy, 65
Cameras, 57
Carbon painting, 27
Carbon pencil, 10
Carlsen, 111
Center of interest, 132
Central Park Library, 23
Chardin, 32, 35, 96, 106, 111
Chevannes, 34
Chiaroscuro, 93, 113, 128
Circles, 124
Color
 adding, 45
 analogous, 99
 around white, 67
 bleeding, 64, 65
 building, 60–61
 combinations, 81
 complementary, 133
 creating impact with, 82
 Cubist, 117
 designing with, 99
 fastness, 54
 getting acquainted with, 50
 granulation, 54
 intensifying, 59
 inventing, 76, 120
 mixing, 50
 monochrome, 111
 and music, 48
 organizing, 50
 palette, 48–49
 understated, 134
 washes, 64
Composition, 72, 86, 119
Contrasts, 46
Coogan, 53
Cropping, 61, 68, 81, 102, 108–109, 135
Cubist ideas and color, 116–117
Curie, 117

Darks, 21, 28, 66, 78
Debussy, 47, 52, 132
de Chavannes, 32
Degas, 16, 32, 71, 81

della Francesca, 32, 33
Design, 10, 21, 24–45, 27, 31, 40, 58, 70, 78, 84–85, 101, 127, 132
Details, 80, 116
Diebenkorn, 132
Distilled water, 55
Drama, creating, 16
Drawing techniques, 10
Duchamp, 116, 117

Easels, 57
Edges, 106
Edison, 117
Elements, harmonizing, 88–89
Emotions and creativity, 79

Feeling and mood, capturing, 10
Figure studies, miniature, 38
Finger test, 84, 85
Fishing Boats, Pigeon Cove, 134–135
Flint, 53
Florals, 68–69, 100–105
Fog, 31
Ford, 117

Gauguin, 32, 34
Geometric structure, 32–37, 84, 109, 117
Glair, 53
Gloucester Fishers, 117
Granulation, 54
Graphite pencil, 10
Grieg, 52
Guiding the eye, 60, 77

Harvard Fogg Museum, 56
Hunter's Moon, 36–37

Ideas, developing into a painting, 40, 96–97
Ink, 57, 65
Intuitive stroke, 114
Involving the viewer, 61

Japanese woodblock effect, 124
The Junkman, 58

Kahn, 132
Khachaturian, 82

Lamotte, 48
Leading the eye, 19
Light, 28, 58–59, 62–63, 66, 124
Liszt, 64
London Gallery, 53
Luminosity, 26, 31, 58, 59, 68

Manet, 32
Masking fluid, 57
Materials and equipment
 brushes, 57
 camera, 57

easel, 57
 ink pen, 57
 masking fluid, 57
 paints, 48–49
 palette, 57
 papers, 55–56
 travel equipment, 57
 water, 55
 water jug, 57
Memory, working from, 42–43, 98
Mildew, 57
Mondrian, 35
Monet, 32, 104, 132
Mood, capturing, 30–31, 79
Moore, 27
Morandi, 94
Moving target, 22
Museum of Fine Arts, Boston, 20, 32
Music, 48, 128

Naming paintings, 15

Ocre Iris, 105
Oil painting, 97
On the Road to Agra, 62–63

Painting locations
 Bangkok, 25
 Boston, Massachusetts, 31
 Cannery Row, 80
 Chinatown, 78
 Harbors, 74–75
 India, 62–63
 Jackson Falls, New Hampshire, 16
 Maine village, 31
 New York City, 14–15
 Riviera, 13
 Rockport, Massachusetts, 17
Palette, 57
Paper
 handmade, 56
 stretching, 55, 56
 watercolor, 55–56
Parallelograms, 33
Pasteur, 117
Paton Prize, 129
Patterns
 forms within, 71
 light and shade, 118
 linear, 12–13
 and rhythms, 47
People, 20–23, 58–59, 62–63
Perspective, 19
Photographs, use of 100, 110, 126
Picasso, 116
Poetry of the Pines, 137
Porter, 121
"Pushing" light with receding darks, 66
Pythagoras, 32, 36–37

Rabatment, 33, 34, 35, 37
Reality, freedom from, 16, 139

Reflection marks, 68
Rembrandt, 32, 33, 104, 117
Rimsky-Korsakov, 67
Rhythm, 47, 118

Serkin, 48
Shapes
 black and white, 27, 31
 figures and subject as one, 46
 negative, 20, 21
 searching for, 126
 singling out major, 62–63
 two–dimensional, 10
Shellac, 55, 56
Shimmer, 63, 71
Silhouette effect, 117
Simplifying, 84, 86
Sizing, 55
Sketchbook, 38
Sketching
 developing into paintings, 44–45
 emotional, 15, 128
 felt pen, 15
 figures in miniature, 38
 intuitively, 127
 loosely, 42
 memory, 23
 process, 10
 speed, 14
Smudging, 26, 27, 31
Splayed lines, 35
Steinbeck, 80
Still life, 70–71
Subject, abstracting and enhancing, 80, 87
Summer Vegetables, 136–137

Taoists, 132
Tchaikovsky, 10, 52, 66
Three–dimensional effect, 19
Tone, 13, 26, 61, 107
Townscapes, 76–77
Translucency, 91
Transparency, 92
Travel equipment, 57
Turner, 26, 132

Value, 60, 110
Vermeer, 35
Viewpoint, 18, 90, 111
Villon, 32, 116
Vuillard, 32

Washes
 granular, 53
 value, 60
 wet, 64–67
Water jug, 57
water, purity of, 55
Whites, 88–89, 102
Working in series, 91
Wyeth, 28, 132

Yellow Cottages (Gloucester), 133